Biopolitical Media

This book presents a historical account of media and catastrophe that engages with theories of biopolitics in the work of Michel Foucault, Giorgio Agamben, Michael Hardt, Antonio Negri and others. It explains how responses to catastrophe in media and cultural criticism over the past 150 years are embedded in biological conceptions of life and death, contamination and immunity, race and species. Mediated catastrophe is often understood today in terms of collective memory and according to therapeutic or redemptive accounts of trauma. In contrast to these approaches this book emphasizes the use of media to record, archive and analyze physical appearance and movement; to capture viewer attention through shock; to monitor and control bodies in economies of production and consumption; to enmesh social relations in information networks; and situate subjects in discourses of victimhood, immunity, survival and resilience. Chapters are focused on historical case studies of early photography, Nazi propaganda, colonial stereotypes, Hiroshima, the Holocaust, the Cold War and the war on terror.

Allen Meek is a Senior Lecturer in Media Studies at Massey University, New Zealand. He is the author of *Trauma and Media* (Routledge 2010). He has recent chapters on trauma, catastrophe and biopolitics in *The Fourth Eye: Maori Media in Aotearoa* (2013) and *Film on the Fault Line* (2015).

Routledge Research in Cultural and Media Studies

For a full list of titles in this series, please visit www.routledge.com.

Biopolitical Media

Catastrophe, Immunity and Bare Life

Allen Meek

Routledge
Taylor & Francis Group

NEW YORK AND LONDON

First published 2016
by Routledge
711 Third Avenue, New York, NY 10017

and by Routledge
2 Park Square, Milton Park, Abingdon, Oxon OX14 4RN

Routledge is an imprint of the Taylor & Francis Group, an informa business

Library of Congress Cataloging-in-Publication Data

Meek, Allen, 1961-
Biopolitical media: catastrophe, immunity and bare life / by Allen Meek.
 pages cm. — (Routledge research in cultural and media studies; 80)
Includes bibliographical references and index.
 1. Psychic trauma and mass media. 2. Mass media—Psychological aspects.
 3. Biopolitics. I. Title.
P96.P73M43 2015
302.23—dc23 2015026689

ISBN: 978-1-138-88706-0 (hbk)
ISBN: 978-1-315-71440-0 (ebk)

Typeset in Sabon
by codeMantra

Contents

Introduction

Images of war, mass destruction, genocide, terror and disaster have long held a prominent place in modern media but we remain uncertain about their psychological or cultural impact. What we do know is that a range of claims, assertions and discourses have been circulating around media, catastrophe and shock at least since the eighteenth century. Does the witnessing of catastrophe in the media challenge us to expand our empathy to all humanity and to confront the horrors of the present and the past? Or does it form part of a system of power that terrorizes the public and numbs their capacity to respond? Liberal humanist accounts of media affirm both of these possibilities. Approaching media in terms of biopolitics allows us to understand how mediated catastrophe functions in an apparatus that aims to preserve, protect and enhance lives that are deemed worth living. There are many different ways that media capture and direct human attention, imagination, energy, movement and productivity. Images of catastrophe play a specific role in defining and negotiating the limits and boundaries of life.

In the opening pages of *Discipline and Punish* (1975), Michel Foucault described in sickening detail the torture and execution in Paris in 1757 of Damiens the regicide. Foucault contrasted the spectacle of punishment by sovereign power with the new disciplinary power of the prison in which the individual's behavior is prescribed for every hour of the day. The following year, in the first volume of the *History of Sexuality*, Foucault discussed a third form of power, biopolitics, which administers and regulates the biological existence of entire societies. This preservation of collective life also demands the killing of populations who pose an external or internal threat. Wars are now "waged on behalf of the existence of everyone" (*History* 137). The genocides perpetuated by modern states have been largely conducted out of public view, but the world was given a glimpse of the horrors of mass death with the Allied liberation of the Nazi camps in 1945. Since then numerous wars, political struggles and new media technologies have led to ongoing transformations in the visibility of state violence. Foucault proposed that underlying this shifting dynamic was a deeper logic in which "the power to expose a whole population to death is the underside of the power to guarantee an individual's existence" (*History* 137). Although he was referring to weapons of mass destruction, this statement also describes

the ways that media suspend the subject between the ever-present threat of catastrophe, the promise of immunity, and the production of bare life.

> Today it is possible for anyone with Internet access to witness atrocities in which human individuals are butchered like animals. In the series of videos produced by Islamic State the victims are dressed in orange jumpsuits, evoking the prisoners held by the United States at Guantánamo Bay. The decapitation by the masked man is carefully staged for the camera. At first this execution appears to be a display of traditional sovereign power, as an individual is put to death in the name of a religion, a state and a people. But this use of contemporary media for propaganda participates knowingly in a global economy of images and employs an aesthetics of shock that is an established feature of consumer culture. These videos appear to reassert the traditional sovereignty of God and state but they function as a form of biopolitical media.

Biopolitical theories require us to think about media beyond its uses, its social impact, its representations, its ownership and control, or its technological development and to consider how media record, monitor, analyze, classify and harness life as biopower. This book argues that our understanding of media's biopolitical scope and functions has been obscured by humanist and vitalist conceptions of visual experience. Looking in particular at media representations of, and intellectual responses to, catastrophe we can see how biopolitics provokes a crisis for the autonomous individual and liberal democracy. Understanding how media discourses and practices, mediated experiences and critical conceptions of media are all embedded in biopolitics allows us to grasp what is at stake politically in the everyday mediation of life and death. Media form part of an apparatus of immunity that promises to insulate us from actual destruction. This immunizing function of media prohibits more active forms of political engagement and agency.

The term biopolitics first appeared in the early decades of the twentieth century but it was not used in critical theory until Foucault's lectures at the Collège de France in the 1970s.[1] Foucault proposed that biopolitics was a new form of power that emerged in the eighteenth century and took the biological life of populations as its object of knowledge and control. Foucault's conception of biopolitics has subsequently been developed and transformed in the writings of Giorgio Agamben, Roberto Esposito, Michael Hardt and Antonio Negri and others.[2] There are important differences in the ways that these various thinkers approach the question of biopolitics. This book takes a synthetic approach to their work and uses certain key concepts— catastrophe, immunity, and bare life—to develop an historical analysis of modern visual media. Foucault's account of race, Agamben's reexamination of sovereignty, and Esposito's stress on immune systems converge around the common theme of catastrophe.

The word "catastrophe" inevitably invokes terrifying, disruptive and exceptional events. Modern technological media, however, have transformed such events into everyday occurrences for participants in global consumer

WHAT WE LOSE, HERE, IS MODERN VISUAL STUDIES' CONTRIBUTION TO BIOPOLITICS!

culture. Media representations of catastrophe form part of a political economy of visual spectacle and viewer attention that has reconfigured earlier conceptions of destruction and suffering. Human gestures conveying pain, horror, distress and grieving have been captured by the media apparatus and employed to both mobilize and disorient the public. Images of violence and catastrophe function as spaces where threats to the body politic are negotiated, neutralized and refashioned to sustain and intensify the lives of those who see them.

Foucault argued that in modern societies race serves as a "biological caesura" (*"Society"* 255) dividing populations between those who deserve to live and those who must die. The Nazi 'Final Solution' has become the most widely recognized example of biopolitics leading to genocide (partly due to their own media apparatus and visual documentation of their crimes), but we can see this caesura continuing to operate in the contemporary apparatus of security and military intervention in liberal democracies. Western nations identify biological enemies who must be controlled through surveillance, incarceration and violent destruction. The constant threat of catastrophic destruction also requires a system of psychic defense and security. As Walter Benjamin explained in the 1930s, visual media function in modern societies as part of what he called (after Freud) a "protective shield" against shock (4 318). Just as a national security system is supposed to protect its citizens against hostile foreign agents or military invasion, media insulate individuals and populations from intrusive stimuli that may cause psychological disturbance or distress. This insulation is achieved through measured doses of the same distress-provoking stimuli. This book follows Esposito's insistence on immunity as fundamental to biopolitics and aligns his arguments with Benjamin's insights about shock and trauma. The peculiar logic of immunization, as Esposito explains, is that it incorporates the threatening agent into the host body in order to neutralize its destructive capacity.

Catastrophes make visible the reduction of human experience to mere biological existence, or what Agamben calls "bare life." Images of bare life can cause shock, anxiety or apathy. The most famous modern example is the spectacle of mass death and starvation after the liberation of the Nazi death camps, but we might also think of today's ever increasing numbers of refugees and political detainees. Images of those who are forced to exist without food, housing, health care or protection from violence and abuse are a familiar feature of our mediascape. Images of mass death or of human life reduced to mere survival confront the viewer with the threat of their own potential destruction or the radical reduction of their pleasures, freedoms, independence and well-being. Catastrophe is supposed to happen to other people.

The immunizing functions of media have undergone a number of historical transformations. Early uses of photography to document social deviance or racial difference defined membership in, and exclusion from, the political community on biological grounds. Again the Nazi state presents the most

@ VIRILIO, DELEUZE, OTHER VOICES MISSING ... NARROWS THE TRAJECTORY

dramatic example of propaganda and entertainment disseminating racist images. The delegitimizing of racial ideology after World War II switched attention to the figure of the survivor. Surrounded by images of violence and catastrophe in photojournalism and television news, the consumer subject also lived in the historical shadow of Auschwitz and Hiroshima. The idea of cultural trauma that began to be popularized in the 1970s—for example, in the television miniseries *Roots* (ABC 1977) and *Holocaust* (NBC 1978)—shifted the discourse of community from exclusion of biological enemies to identification with those who suffered from the violence perpetrated by modern states. But there remains a fundamental disconnection between the image of bare life and liberal humanist conceptions of the individual.

The survivors of catastrophe are invoked by politicians, media professionals and public intellectuals as traumatized collectives who need to participate in acts of mourning, commemoration and retribution. In this way therapeutic discourses define imagined communities in terms of mental health and resilience. Trauma narratives also provide dramatic situations allowing for emotional identification with, and collective participation in, specific historical events such as the Holocaust, the bombing of Hiroshima, the Vietnam War and the 9/11 attacks. The politics of memory, in which positions of guilt and innocence are assigned to different national and ethnic groups, serves as a dominant frame for interpreting catastrophe, leading to a competitive or hierarchical model for evaluating human suffering (Rothberg 2–3). Cultural trauma sustains the biological caesura and political immunity by other means. As a liberal humanist discourse it cannot resolve the exclusionary claims made by different communities.[3]

Trauma studies has been criticized for its Eurocentrism and its persistent focus on events such as the Holocaust or the 9/11 attacks as catastrophes for Western societies (Craps 45–47) and this tendency is shared by much biopolitical theory. Agamben and Esposito repeatedly turn to the Nazi state as the extreme example of modern biopolitics. There remain, however, important justifications for these preoccupations. The following chapters show how Nazi biopolitics extended earlier tendencies in nineteenth century science and colonialism, but also manifested new forms of power that were unable to be acknowledged in postwar discourses about totalitarianism and crimes against humanity. This book follows the lead of Agamben and Esposito in exploring the continuities and differences between Nazi biopolitics and postwar liberal democracy.

Some of the kinds of images of atrocity that even the Nazis kept secret are now deliberately transmitted to the world. The Internet creates new challenges for states attempting to police flows of information and today explicit images of torture and execution have reappeared in everyday life. New articulations of mediated immunity construct the image itself as a living entity and a biological threat. As images become more virulent, the discourse of immunity intensifies. Other commentaries suggest that the spectacle of human suffering has come to resemble the captivity and slaughter of

animals which the public has apparently learned to ignore or consume without distress (Keenan 270). Indeed the mass incarceration, enslavement and extermination of human populations has a close historical relation to the lives and deaths of animals in industrialized societies. As Nicole Shukin has shown, there are also important links between the industrialized slaughter of animals and the emergence of cinematic spectacle (92). The human/animal relation, or "creaturely" life, will be an ongoing concern in the following chapters. (The hugely important question of natural disaster and ecological catastrophe will remain beyond the parameters of my discussion.) Before developing these themes further the next section will introduce and compare the different arguments developed by some of the key theorists of biopolitics.

Theorizing Biopolitics

In *Bios* (2004) Esposito gives an account of the historical emergence of biopolitics in modern political philosophy (16–24). In the early decades of the twentieth century various thinkers rejected the liberal model of democratic participation and proposed a model of the state as a living entity with its own anatomy, physiology, instincts, drives and pathologies and threatened by diseases and parasites. This early, often explicitly racialized, biopolitics was later discredited by association with Nazism. Esposito sees the turn in postwar biopolitical discourse to a universal humanism, however, as a denial and evasion of its real implications. The third wave came in the 1970s when the International Political Science Association began research on biology and politics. The decisive shift that Esposito sees in this discourse is that it understands politics not as an attempt to resolve problems posed by nature (such as unequal access to resources) but as simply an extension of genetically coded impulses. Esposito explains the crucial distinction between American political scientists, who argue that politics is a direct expression of human nature, and Foucault's insight that politics does not express biological life but aims to capture and harness it as biopower. Foucault explained how conceptions of normality, health and political rights in modern societies—both so-called totalitarian states and liberal democracies—require the confinement or destruction of those *other* populations who are defined as deviant, infectious, or stateless. Agamben and Esposito have shown in different ways how this logic of social inclusion and exclusion deconstructs as every member of society faces the constant threat of transforming into a disposable form of life.

Foucault

In *The Order of Things* (1966) Foucault proposed that the modern life sciences and political economy that emerged in the late eighteenth and early nineteenth centuries together brought about a revolution in the relation between biology and politics. This period saw the reconceptualization of Life, Labor and Language as "quasi-transcendentals" (*Order* 272). New forms of

systematic knowledge based on abstract concepts and underlying structures overtook established modes of categorizing and tabulating representations. The taxonomy of life forms gave way to synthetic knowledge. Foucault explained how modern biological science conceived of Life as a generative power in nature, just as Labor was conceived as a productive force in the economy. In the natural history of the classical period Life had no autonomy outside a system of classification that divided nature into animal, vegetable and mineral. Modern biology makes the difference between these categories less important than the Life that is manifest in an infinite multiplicity of forms. Similarly economists in the classical period derived value from trade, exchange and circulation. Now productive capacity, biological reproduction and genetic identity have all become the concern of modern politics and economics. In his later research Foucault went on to consider the ways that the modern state initiated new strategies for monitoring and controlling biological life through the organization of sexuality, illness and death (Cooper 5–7).

According to the classical idea of politics, everyday life belonged to the private sphere, the household of the citizen, his family and slaves. Foucault's conception of biopolitics names the historical overcoming of this boundary separating private from public concerns, when life becomes the direct concern of political power. Biopolitics is not simply an extension of power into the private domain but a fundamental transformation of the relation between politics and life. Whereas traditional sovereign power demands the ultimate submission of the political subject, at the pain of death, biopower seeks to control, monitor and optimize life through science, medicine, technology and social engineering. New forms of knowledge, such as statistical aggregates and demographic norms also separate biological life from the individual subject, making it the general property of populations and species.

Foucault distinguished biopolitics from sovereignty, which holds the power of life and death over its subjects, and disciplinary power, which molds the body through everyday practices and discourses such as those of monastic life, military training, schooling and physical education. Biopolitics takes as its object the survival, health, and death of entire populations; it amasses knowledge in archives and through demographic research and analysis. Foucault's primary interest was in the ways that modern populations become subject to statistical norms and biological categories. In the closing pages of the first volume of *The History of Sexuality* he did, however, briefly mention genocide and nuclear weapons as extreme manifestations of this new form of power. The question of catastrophe remained undeveloped in Foucault's account of biopolitics but it is central to Agamben's.

Agamben

Agamben has adopted Foucault's pioneering conception of biopolitics and explicitly connected it with modern totalitarian states and, more specifically, the Nazi Final Solution. The reduction of human populations to a state of

"bare life," leaving individuals and groups available to be exterminated, finds its definitive expression in the concentration camp. Agamben proposes that "the politicization of bare life as such ... constitutes the decisive event of modernity" (*Homo Sacer* 4). Following a Foucauldian conception of power as not merely punitive but also positive, bare life is not to be understood only as social exclusion but as a human condition actively produced by biopower. In the classical world natural life was not conceived as part of the *polis* but belonged to the *oikos*, or private sphere. What Foucault called biopolitics referred to the incorporation of biological life into the machinations of the modern state (*Homo Sacer* 1–3).

The figure of *homo sacer* that Agamben recovers from ancient Roman law is defined by being available to be killed but not sacrificed. Sovereign power establishes itself through this fundamental violence. The modern conception of the sacredness of life actually originates in the subjection of life to sovereign power but today is "completely emancipated from sacrificial ideology" (114). For this reason, Agamben rejects the term "Holocaust" to describe the Nazi attempt to exterminate the Jews. What characterizes modern biopolitics, as opposed to its ancient forms, is that the distinction between bare life and political life becomes increasingly blurred: *homo sacer*, once a marginal figure, has become the prototype for a general condition in which biological life is increasingly administered by the state. Modern democracies, which seek to guarantee the rights and freedoms of the individual have, through the same processes, allowed life to become increasingly subject to biopolitical control.

It is not the goal of this book to resolve all of the tensions between Foucault's and Agamben's different accounts of biopolitics. I tend to agree with Sergei Prozorov's comment that it is "not very productive to read the difference between Foucault and Agamben as a 'debate' in which one is expected to take sides; there is rather a difference of perspective" (99). Whereas Foucault's account of biopolitics stressed the proliferation of new forms of power beyond the traditional monarchy or state, Agamben restores biopolitics to the domain of sovereign power. As Jessica Whyte puts it, sovereign power is "always-already biopolitical" (27). For Agamben the very distinction between *bios* and *zoe* is biopolitical. What happens in the modern period is that this distinction collapses and bare life changes from the exception to the rule. Biopolitics incorporates natural life through the positing of nature as a realm distinct from the *polis*. Following a similar logic to Claude Levi Strauss's famous nature/culture opposition and Jacques Derrida's subsequent deconstruction of that opposition, Agamben redefines biopolitics as the making significant of life within a linguistic and political order. As Agamben points out, in classical philosophy the idea of "life" is never defined as such but rather is divided through caesurae and conceptual oppositions such as human/animal or animal/organic (*Open* 13). The human is not defined by an essential quality but by dividing it from what it is not.

Agamben argues that we must abandon the idea that the suspension of civil liberties and the extension of surveillance on civilian populations are

aberrations of liberal democracy. These practices only make explicit the fundamental structures of sovereign power, the state of exception and the dependence of law upon violent force. Under the state of emergency or in a totalitarian society there is nothing that cannot be subject to the force of law. Natural violence is embodied in the absolute power of the sovereign. Modern democracies have also extended sovereign power through the Declaration of the Rights of Man and the post–World War II discourse of human rights. At the same time as they claim to protect and safeguard life these declarations and discourses have drawn life further into the domain of sovereign power. Struggles for democracy and human rights must address this aporia in the Western political tradition.

Esposito

Esposito develops an account of biopolitics that both shares and departs from Agamben's positions. Like Foucault and Agamben he notes that the classical categories of law, sovereignty and democracy have been displaced by the concept of life. For example, "human rights" is premised on the "simple fact of being alive" (13). The extension of politics to the entire domain of life goes beyond the territorial limits of traditional sovereign power. The classical understanding of natural life, as distinguished from political life, no longer holds. Nature is not a preexisting domain from which emerges political structures or struggles, but is itself a site produced through political struggle:

> Life as such doesn't belong either to the order of nature or to that of history. It cannot be simply ontologized, nor completely historicized, but is inscribed in the moving margin of their intersection and their tension. (*Bios* 31)

Power no longer simply dominates people or territories from on high, extracting taxes, service and sacrifice of life from its subjects. Governmental power responds to the demands of populations, provides public services and administers public health and promises to deliver wealth and happiness to is citizens. And yet the modern biopolitical state also produces the greatest catastrophes and destruction of life.

Esposito departs from Agamben by stressing the fundamental importance of the immune system, which he explains with reference to Derrida's account of the *pharmakon*. The *pharmakon* is both poison and remedy, the potentially dangerous agent that is nevertheless incorporated into the host body in small enough amounts to inoculate it against disease: it "draws death into contact with life and exposes life to the test of death" (*Immunitas* 127). If the power over life and death, as both Foucault and Agamben agree, is the foundation of sovereign power then the limit or threshold where life passes into death is negotiated by the immune system. The sovereign decision over who may be allowed to live and who must die is mediated by a system of

representations. Images of death or the threat of death are incorporated by the living in an attempt to preserve their lives.

Esposito rejects Agamben's account of bare life as the foundation of biopolitics and proposes instead the model of immunization:

> The purpose of biopolitics is not to distinguish life along a line that sacrifices one part of it to the violent domination of the other—but on the contrary, to save it, to protect it, develop it as a whole. (*Immunitas* 139)

Esposito's argument on this point falsifies Agamben's position. Whereas it is true that Agamben focuses on the catastrophic impact of biopolitics he also argues that bare life is not a question of violent domination of one group by another, but rather describes the state of life produced by biopower. To survive and to be protected within the biopolitical system is also to be reduced to mere biological existence and to lose the autonomy of the individual citizen as conceived by classical politics. The following chapters will show how the political immune system produces bare life as a necessary feature of its economy. The most striking recent example of this is the intensification of national security after 9/11 (discussed in Chapter Five). The war on terror has led to the arrest and incarceration of ever greater numbers of people whose lives are suspended without political rights and relocated outside their sovereign territories. If the camp, as Agamben proposes, is the *nomos* of the modern, then there is no immunity without camps. On the other hand, those who apparently enjoy the freedoms of liberal economy must accept the price of more pervasive surveillance, paranoia and militarization of social life. We can propose then that, contra Esposito, bare life is the price of immunity.

Hardt and Negri

Michael Hardt and Antonio Negri emphasize the "*productive* dimension of biopower" (27) and stress the importance of media. In the contemporary global economy production is increasingly organized and expressed through communications industries that "integrate the imaginary and symbolic within the biopolitical fabric" (33). As modern power goes beyond disciplinary structures and regimes to intervene directly in biological and corporeal existence it also creates new forms of resistance, insubordination and revolt. What they call the "multitude" is a "collective biopolitical body" (30). Biopolitics has a positive sense for Hardt and Negri that is not developed by Foucault, Agamben or Esposito and they criticize these thinkers for failing to grasp the distinction between biopower and biopolitics (*Commonwealth* 57–58). For Hardt and Negri biopolitics is a life of innovation and freedom that produces events that disrupt the normative system of biopower. The following discussion will not pursue Hardt's and Negri's understanding of the opposition between biopolitics and biopower,

as is not developed in this way by Foucault, Agamben or Esposito. The particular focus of this book finds more value in Hardt's and Negri's emphasis on the importance of media.

Hardt and Negri propose a historical transition from disciplinary societies to societies of control, whose central modes of operation include communication technologies and information networks. In economic terms this has meant a shift in Western societies from factory labor to intellectual and communicative labor, including "the production and manipulation of affects" (*Empire* 30). This has been accompanied by the rise of multi- and transnational corporate power and nongovernmental organizations (NGOs) that propagate the new discourses of universal needs and human rights. In this way the "victims" of poverty, "natural disaster," terror and war are integrated into the global biopolitical economy.

According to Hardt and Negri, empire is a new form of geopolitical sovereignty and the people, as citizens of the nation-state, is replaced by the multitude that is governed through "the bomb, money, and ether" (*Empire* 345). Weapons of mass destruction create a new horizon of species extinction, reducing the possibility of war between states. The global financial system also now dictates terms to national monetary structures and institutions. The term "ether" refers to information networks that ever extend the global reach of capitalism. In *Multitude* (2004), Hardt and Negri propose that modern biopower is constituted by the possibilities of absolute destruction demonstrated at Auschwitz and Hiroshima and through the widespread use of torture today. Despite their claims for a positive biopolitics of the multitude, catastrophe remains at the horizon of their account of power.

Biopolitical Media

Biopolitics is not a new term in the discussion of media and the following chapters will cite the innovative scholarship of Allan Sekula, Jonathan Beller, W.J.T. Mitchell, Nicholas Mirzoeff and others who have developed biopolitical perspectives on visual media.[4] The particular focus of this book on catastrophe acknowledges the influence of Agamben and Benjamin on its themes and concerns. Unlike Foucault, Agamben has written directly about modern media on various occasions. What Agamben sees as the commodification of human experience in the media image resonates with his account of biopolitics as reducing individuals to a state of bare life. Foucault's emphasis on surveillance and Agamben's "Notes on Gesture" provide two useful entry points into biopolitical media (both discussed in Chapter One). Photography made it possible to record the smallest and most intimate of details about human individuals, to preserve this visual information in archives, and to submit it to systematic analysis. Film could break down the physical movements of humans and animals into previously invisible gestures that facilitated a new machinic conception of industrial labor and production.

Digital media have further integrated technology and biology through the capturing of life as an image and the capturing of media viewers as living subjects. Pasi Väliaho writes of biopolitical images that "express and take hold of the potentials of life," particularly through digital media that "we interact with, play with, operate with; images that ... require gestural manipulation and cognitive engagement" (*Biopolitical Screens* 7). This immersive, rather than contemplative, relation to images began with the emerging consumer culture of the nineteenth century. As Jonathan Crary explains, the technological recording of images and sounds made possible the mass production of audiovisual commodities and the capture and management of viewer attention (31). Early uses of moving pictures for time and motion studies combined with research on responses to sensory stimuli, directly influencing theories of cinematic montage (Beller 4). In a post-Fordist, post-cinematic culture biopolitical images circulate in an apparatus that incorporates digital information networks, high-tech weaponry, and neoliberal economics.

The following chapters outline a history of biopolitical media as a sequence of transformations in the ways that the image is used and understood. In the late nineteenth century photography and film were used by pioneering figures such as Alphonse Bertillon, Frances Galton, Jean-Martin Charcot and Jules Étienne Marey to record and analyze human physiognomy, gesture and movement. This visual information played its role in the policing of criminals and the therapeutic treatment of those deemed mentally ill. Photographs and moving pictures defined and categorized human individuals as "types" that were seen as representative or symptomatic of tendencies in the general population. Anthropologists also developed hierarchies of racial types using photographic evidence. This use of photography formed part of the biopolitical management and control of modern urban populations.

In the early decades of the twentieth century this visual typology, which had previously been the domain of scientists, experts and gentleman scholars, influenced the stereotypes of mass entertainment and propaganda. Industrial mass production required the analysis of workers' movements in the interests of greater efficiency and profit. Marey's studies of movement were extended in Frederick Winslow Taylor's scientific management of labor. Not only Hollywood but also Soviet and Nazi cinema adopted Taylorist principles in their productive processes and their drive to capture audiences' attention. Sergei Eisenstein applied the principle of shock, based on Pavlov's experiments on responses to stimuli, in his theory and practice of montage (Beller 123). Nazi propaganda made the typology of race, mental illness and physical disability a justification for its genocidal policies.

These uses of the mass media apparatus by the state in the interests of race and class war were delegitimized after the Allied victory in World War II. The media image could no longer be overtly used in a liberal democracy

to identify those who were less than human or needed to be eliminated from society. The liberation of the Nazi camps and the bombing of Hiroshima and Nagasaki gave rise to a new "traumatic" account of catastrophe recorded by photography and film and made available to (or hidden from) the public. This traumatic perspective on the catastrophic effects of biopolitics was voiced in a language of universal humanism that often failed to acknowledge the continuation of biopolitics in the Cold War. America's propaganda war around the fear of the bomb and covert experiments in mind control were the darker side of liberal democracy that, as Naomi Klein has argued, has since become a more open feature of the neoliberal politics of fear and "disaster capitalism" (6).

A new visual language of catastrophe—particularly in television news—has redefined the viewer in terms of psychic survival and immunity. Images of famine, war, natural catastrophe and mass displacement abound in mass media but the Western viewer is never to forget that these are conditions suffered by those who live outside the world of the consumer subject, who sustains his/her immunity through physical separation and what Robert Lifton has called "psychic numbing" (*Death* 14). Since the 9/11 attacks the biopolitical role of media has become more explicit and overt. Detainment without legal or political rights, use of torture, the deployment of high tech weaponry to kill civilians abroad and the militarization of the police at home have all become more openly visible features of neoliberal societies.

The threat of terrorist attack and immersion in a globalized media environment has made the discourse of immunity more difficult to sustain. The proliferation of digital technologies and information networks has prompted new anxieties about images as a life form in their own right. Like terrorist cells, images are thought to infiltrate and contaminate the social body and, through mediated networks, go viral (Mitchell 20). This threatening agency and vitality attributed to the image articulates a further displacement of the liberal subject. The language of traumatization had already pathologized the media viewer. Now the digital image, along with genetic science, embodies a power that potentially replaces human life altogether.

Scientific conceptions of biological life continue to change, but political rights are assumed to be immutable and universal. This problem can be further extended to include the impact of rapidly changing technologies of communication and representation. Once life came to be conceived in terms of biological species it became inevitable, argued Foucault, that wars would be waged against enemy populations in the name of race. As Michael Dillon and Julian Reid explain, this is part of a larger shift that conceives of human life as "biohumanity" (20). More recently, digital technologies and genetic science have prompted the reconceptualization of life as information. Biopolitics demands the killing and disposal of forms of life that threaten life deemed worthy of promoting and preserving. Enemy populations become the object of technological surveillance and destruction

insofar as they pose threats to the security of the bio-polis. The species life of the liberal subject has become an image that is transmitted and interrupted, implanted and infected, according to the logistics of technological and biological war and terror.

Catastrophe

In order to understand this catastrophic logic of biopolitical media, the following chapters follow Agamben's lead in reading Foucault along with Benjamin and Arendt. Foucault separated biopolitics from sovereignty in order to focus on the production of normality and deviance and the incorporation of biological life into political economy. Agamben, however, sees biopolitics as part of a longer history of sovereignty originating in Western antiquity and culminating in the Nazi death camps. Agamben's emphasis on the authoritarian state overshadowing the agency of the individual in liberal democratic societies has been criticized as prohibiting a more complex account of biopolitics as a political economy of life (Lemke 60). But if we use Agamben's catastrophic theory of modernity to look at media representations then the question of political economy reappears in a new context. With the emergence of mass media the Kantian idea of catastrophe as sublime spectacle is overtaken by the everyday experience of shock. Images and narratives of extreme violence and destruction compete to capture the attention of the viewer. So if Foucault's account of biopolitics as normalization should be distinguished from Agamben's account of sovereign power, a new synthesis of these two perspectives may be ventured around the question of media and the biopolitics of catastrophe and shock. This involves building on Agamben's original synthesis of Foucault and Benjamin.

Along with the biopolitical regulation of life, labor and production in the eighteenth century came another cultural development that is not mentioned by Foucault: a new conception of catastrophe. The Lisbon Earthquake of 1755 killed 60,000 people and dominated headlines throughout Europe in subsequent months. Lisbon was the first modern mediated catastrophe, with newspapers featuring eyewitness accounts and graphic descriptions of the dramatic events. Like today's disasters it captured the public imagination and prompted international assistance and relief. The earthquake also provoked responses from some of the most brilliant writers in eighteenth century Europe, including Voltaire, Rousseau, Goethe and Kleist (Regier 357–359). The rise of the natural sciences and the Enlightenment conception of progress, including economic rationalization, made the Lisbon catastrophe disturbing in a philosophical sense. No longer was mass destruction a sign of God's wrath, prompting moral repentance. Instead scientific reason would need to provide an explanation (Nieman 247). As economic production had become aligned with biological survival in a new, epistemological sense, the sudden and arbitrary cessation of life demanded a new conceptualization.

At the same time as biological life began to be understood as something to be harnessed, managed and directed toward specific goals, Immanuel Kant reconceptualized the impact of the massive destruction of life beyond human control as the sublime. In his *Critique of Judgement* (1790) Kant argued that sensory perception needed to become a unitary experience in order for the individual subject to reconstitute his/her sovereignty in the face of intense stimuli. Only the reconstitution of a transcendental subject based on the aesthetics of the sublime could attune human response to the catastrophic destruction of Life as a transcendental concept. As Jonathan Crary explains, however, the nineteenth century "saw the steady demolition of Kant's transcendental standpoint" (14). The emergence of pathological conditions, including traumatized hysteria and psychotic breakdown, lead to new functionalist, productivist and therapeutic conceptions of the subject. Biological life was progressively integrated into the capitalist economy. The invention of photography and cinema allowed the shaping of a new consumer subject who would respond to ever more constant streams of visual stimuli. Contemporary with these developments was the philosophy of life (Lebensphilosophie) articulated by Friedrich Nietzsche, Henri Bergson and others that sought to recover a healthy life from the decadence of modern society and retain an autonomous experience of the natural world. Influenced by Georg Simmel's sociology of urban life, Benjamin criticized the emphasis of *Lebensphilosophie* on absorbed contemplation and concentration and argued that they had become impossible in a consumer culture dominated by shock and distraction (4 314).[5]

Kant's account of the sublime was premised on the ability of the human subject to overcome immediate fear and terror and to be able to reflect calmly on one's feelings. Like the natural sciences, Kantian aesthetics reaffirmed reason in the face of a potentially overwhelming force. Gene Ray points out that in the twentieth century the sublime was no longer limited to natural disasters but became associated with manmade catastrophes such as the Nazi death camps and bombing of Hiroshima and Nagasaki. As Susan Nieman comments: "Before contemporary warfare nothing but an earthquake could kill fifteen thousand people in ten minutes" (255). Philosophers had attempted to reaffirm human reason after Lisbon, but after Auschwitz and Hiroshima rationality itself can be seen as the source of destructive power on a scale previously unimaginable.

The extension of manmade catastrophe has also produced a technological and discursive apparatus for managing public reponse. The notion of catastrophe as sublime aesthetic experience has been replaced by mediated catastrophe. Actual death and destruction has become available in the form of images allowing for voyeuristic fascination, psychological projection and vicarious experience. Philip Hammond writes of the "humanitarian spectacle" (37) through which Western media present the military and aid interventions of their governments as in the interests of universal human values. This self-presentation of Western power follows the logic of "newsworthy" events: dramatic, "moving"

narratives with clearly defined heroes, villains and victims. This humanitarian spectacle is only one of the current stand-ins for the great ideological struggles of the Cold War. Media representations construct other nations in crisis as chaotic scenes of suffering and violence without meaning except for their evident need of rescue by the West. Hammond has proposed that these humanitarian interventions are examples of "Western narcissism and the search for meaning" (49), in which the West attempts to recover its sense of moral purpose.

Thomas Keenan points out that images of catastrophe no longer function as a moral provocation but as a medium of intervention, a weapon in a struggle for dominance and a contest for public engagement measured in audience ratings. The event is now constituted not only by its media coverage but by media as an active agent: the "image constitutes a field of action" (278). The immediacy of audiovisual action and drama replaces critical reflection and rational response. A highly competitive media environment and enhanced technological capabilities have gradually made unexpected and violent events a potent source of viewer attraction. Elia Katz and Tamar Liebes argue that media events as planned, ceremonial occasions have been overtaken by disaster, terror and war (159). But after 9/11 can we really distinguish catastrophes from preplanned events? Before the war on terror, Cold War simulations of nuclear attack and wartime strategies of mass deception had already undermined this distinction.

In earlier societies organized through traditional sovereign power, wars were fought by those temporarily enlisted for battles and campaigns. Modern disciplinary power, through development of standing armies, was also maintained through the separation of military personal from civilians. In both forms of power the experience of war remains largely outside or removed from the civilian domain. The age of advanced communications media has also been an age of total war premised on the direct or virtual participation of entire populations. In the twentieth century propaganda, censorship and psychological warfare became an essential feature in the pursuit of military dominance. The integration of media images and technological weaponry is part of what Dillon and Reid call the "liberal way of war." Wars are fought to preserve the particular forms of life that different groups or societies value: "war does not exist outside the complex discursive institutions and practices that constitute a certain form of life" (15). Thus different conceptions of life give rise to different discourses about fear and danger. The liberal way of war that is waged in the name of "freedom and democracy" also seeks to preserve certain forms of life and destroy others.

Catastrophe is not so much represented by the media as constituted as a biopolitical event. Allen Feldman has theorized how this biopolitics of catastrophe has developed in the global media environment since the 9/11 attacks and the subsequent invasions of Afghanistan and Iraq:

> Aggressive technologies of image making and image juxtaposition, whether used by "terrorists" or the state apparatus, do not simply

refract or record an event, but become the event by materially tran-
scribing a political code onto the built environment, cultural memory
and the politicized body, and by immersing spectator-participants in
fear provoking simulations of space-time actuality.

(Feldman 164)

The threat of destruction is mapped onto geographic and social territories and
evaluated in terms of its psycho-biological impact. Feldman is not the only
commentator to discuss the 'war on terror' in terms of an economy of fear.
W.J.T. Mitchell compares the capabilities of new digital media to reproduce
images to the spread of a biological virus. The war on terror, proposes Mitchell,

has been fought by means of images deployed to shock and traumatize
the enemy, images meant to appall and demoralize, images designed to
replicate themselves endlessly and to infect the collective imaginary of
global populations.

(Mitchell 2–3)

This war of images began with the American media coverage of the 9/11
attacks and continued with the invasion of Iraq, and was manifest in images
such as the videos produced by Osama bin Laden and the photographs taken
of inmates in the Abu Ghraib prison. Victims of war, genocide, terror and
disaster may be seen as "disposable" by those who decide their fate, but media
transmit images to viewers who register that their fate may yet become ours.

A similar logic can be seen in neoliberal responses to the victims of
"natural disaster." Henry Giroux has discussed the aftermath of Hurricane
Katrina as an example of what he calls the "*new biopolitics of disposablity*"
(175). Decades of deregulation, funding cuts to welfare, and privatization
of public wealth have led to a situation where the most vulnerable members
of society—the poor, the sick, the elderly, the unemployed—have become
regarded as dispensable. The state, having renounced responsibility for the
survival and well-being of the weak or disadvantaged, now seeks to make
them disappear into prisons and ghettos. Following Foucault, Giroux sees
biopolitics as justified primarily by racist discourses. The African American
population of New Orleans has long been the subject of racial prejudice,
persecution and neglect. In the neoliberal economy entire sections of the pop-
ulation who are excluded from consumerism—through long term poverty,
sudden catastrophe, or both—also become excluded from political rights.

The immunity produced by the inoculating effects of shock, first recog-
nized by Benjamin in the 1930s, is now sustained through digital media and
information networks imagined as both life enhancing and threatening. The
media image is seen as a field of action, a biopolitical event, or an agent of
traumatization that overtakes and governs the lives of human individuals.
As the vitality and virulence of the image has grown, human life has been
reduced to a naked exposure to power.

Bare Life

Foucault never theorized the role of technological media in changing forms of power. Agamben has written on the media, although his commentaries on this subject have so far attracted relatively little attention.[6] Agamben has argued that technological media replace the autonomous gestures of the human individual with fractured movements and fragmentary images. This critical conception of the media can be related to his argument that the modern state has reduced the individual to a condition of bare life or biological existence. In both instances Agamben's catastrophic history of modernity owes much to Benjamin's proposal that "exposure to shock has become the norm" (4 318) in advanced capitalist societies. This brutalization of human perception corresponds to the alienation of labor in industrial production. Benjamin also wrote of the political "state of emergency" in which the rights of citizenship are suspended, as "not the exception but the rule" (4 392). This state of emergency in Agamben's reading of Benjamin is the biopolitical production of bare life.

Although he does not cite him on this question, Agamben's ideas about media often appear to be directly indebted to Benjamin's writings. For example, Agamben writes in *The Coming Community*:

> the glorious body of advertising has become the mask behind which the fragile, slight human body continues its precarious existence ... Advertising and pornography, which escort the commodity to the grave like hired mourners, are the unknowing midwives of this new body of humanity. (*Coming Community* 50)

Agamben proposes that the human body persists as a form of bare life, displaced and concealed by the media image: the body as commodity. This passage also echoes the opening section of Benjamin's essay "The Storyteller," concerning the return of soldiers from the battlefront in World War I:

> For never has experience been more thoroughly belied than strategic experience was belied by tactical warfare, economic experience by inflation, bodily experience by those in power. A generation that had gone to school on horse-drawn streetcars now stood under the open sky in a landscape where nothing remained unchanged but the clouds and, beneath those clouds, in a force field of destructive torrents and explosions, the tiny, fragile human body. (3 144)

Benjamin's account of the war includes the psychological and cultural impact of combat trauma: "men who returned from the battlefield had grown silent" (143–144). Agamben suggests that what Benjamin identified as the decline in the value of experience in the early twentieth century is extended through the commodification of the body in mass media. The

invention of moving pictures reconfigured the distinction between the private domain of everyday life (*zoē*) and political engagement in the public sphere (*bios*). The cinema produced a new language of gesture, of bodies in motion, that engaged the spectator at the neurological levels of the nervous system and vital bodily functions such as cardiovascular rhythms (the skillful use of montage can increase our heart rate). Benjamin thus compared the impact of early cinema to that of the industrial worker whose corporeal rhythms were forced to adjust to the pace and abrupt movements of the machine. The gesture is similarly removed from the autonomy of the actor and decomposed into fragmentary images (Väliaho, *Mapping* 17–20).

Agamben pursues these connections further in his discussions of the cinema of Guy Debord. According to Debord's concept of the spectacle, it is communication itself which has been commodified; it "disarticulates and empties, all over the planet, traditions and beliefs, ideologies and religions, identities and communities" (*Means* 84). In place of these older forms of social identity the spectacle produces empty images of collective life. For Agamben the gesture is not an expression of the identity of the human subject but is a concrete and particular action that is the inverse of the commodity's spectacular appearance. What Agammben calls a "generalized catastrophe in the sphere of gestures" (*Means* 50), along with the media transmission of catastrophe, finds concrete expression in Debord's films. In *Society of the Spectacle* (1973), images of aerial bombing, assassinations, political protest and police brutality are juxtaposed with images from advertising, Hollywood films and pornography. Other images include Europeans on vacation or at the beach, fashion parades, striptease, urban environments, weapons of mass destruction, Soviet leaders at military parades, Fidel Castro on television, the stock exchange, trade union meetings and strike action, the Watts race riots and the street battles of May '68. The solicitation of attention through everyday images of violence and catastrophe along with glamor and sexuality confronts us with the complete incorporation of life into its commodity form.

Crary points out that although Foucault dismissed Debord's theory of spectacle, both Debord and Foucault "outline diffuse mechanisms of power, through which imperatives of normalization and conformity permeate most layers of social activity and become subjectively internalized" (74).[7] Visual spectacle operates as a form of noncoercive power, which isolates the subject as viewer but integrates him/her into a virtual community of conformity and control. One of the ways that media images can be seen as explicitly biopolitical is through recording the process of killing. Digital media techniques have made it possible to bypass the taboos against showing violent death that still remain partly in place in the mainstream media of television and newspapers. Whereas death and dying have long been made visible to a mass public by photography, video can now show the killing of humans in ways that return to the brutality of animal slaughter: cutting, slashing,

hacking the flesh and bone of living creatures. The image of bare life poses a threat that is an integral part of the biopolitical media economy. This threat is also recognized and responded to by media functioning as part of the apparatus of immunity.

Immunity

In *Bios*, Esposito proposes that immunity marks the intersection of life and law: in biology it means the ability of an organism to protect itself from contamination whereas in law it means the exemption from obligations and responsibilities. Immunity is the "power to preserve life" (46) and therefor it is fundamental to biopolitics. Power does not negate life as an external force but is intrinsic to survival. Whereas other theorists such as Donna Haraway have discussed immunity in the context of biopolitics, what is original about Esposito's argument is his stress on the opposition between *immunitas* and *communitas*. Communities bind their members through shared obligations. Immunity is the release from these obligations. Immunity defines borders that protect individuals and groups from the threat posed by other individuals and groups. To be immune is to not have things in common with others, but this is only possible insofar as it assumes the idea of community. Immunization is not so much a "defensive apparatus" as an "internal mechanism" that "separates community from itself" (52).

What is distinctive about immunity in the modern period is that traditional symbolic orders, such as theology and sovereignty, are weakened and social and political identity must find new ways to protect itself from intrusive threats. Sovereignty places limits on individuals' desires and aggressive impulses and thus protects the individual from him/herself. In modern secular societies a new form of sovereignty emerges in which individuals are immune from shared obligations and responsibilities. Social life is privatized. The liberty of the individual in modern societies has become increasingly dependent upon the power of the state to guarantee his/her freedoms. The individual's liberty is protected by a large and complex apparatus of insurance and security. Through its dependence on police, surveillance, coercion and incarceration liberal individualism must exclude entire populations from the freedoms enjoyed by the privileged few. The security apparatus employs media technologies to record, monitor and archive biological information and harvests data about populations from social networks and other media use. The immunity of the media user is achieved at the price of high levels of surveillance, paranoia and the ever-present threat of catastrophe.

Pieter Vermeulen has argued convincingly for seeing the notion of collective trauma as forming part of the immunitary paradigm. The possibility of trauma defines human vulnerability. Vermeulen notes the similarities between Esposito's account of immunity and Freud's account of trauma as a force that penetrates the protective shield of consciousness. Like Esposito's "internal mechanism" of immunization, Freud's protective shield is not

a defensive apparatus attached to consciousness but is developed through the processes by which consciousness mediates external stimuli. By consciously anticipating and registering the shocks of everyday experience, the mind is able to regulate and control its vulnerability to stress and disturbance. Consciousness attempts to remain immune from traumatic disruptions by absorbing smaller shocks and building up its internal capacity for resistance and self-protection.

Benjamin adapted Freud's conception of the protective shield in his own theorization of shock as the "norm" (4 318) in modern culture. In the industrial age the camera becomes an extension of the nervous system's protective shield. Photography isolates a moment in time and makes it available to conscious scrutiny. Film makes shock a "formal principle" (328) through montage. Photojournalism and television news produce images and simulated experiences of surprising and disturbing realities that can be consumed in a controlled way, allowing the individual to regulate his/her sense of vulnerability and anxiety or allowing mass media to regulate and manipulate collective responses to stimuli.

Today older theological or philosophical conceptions of suffering related to a sense of loss, injustice and evil have been largely replaced by psychological and psychiatric understandings of human experience as driven by biological processes. The widespread use of the term "trauma" is symptomatic of this shift. Although psychological trauma is often understood as an analogy for a physical wound, the two concepts, explains Allan Young, are actually linked genealogically. The "discovery" of traumatic memory was based in the scientific observation of physical symptoms. The first cases of psychological trauma were caused by railway accidents and the impact of a physical shock that did not leave evidence on the body but instead was registered through a disturbance of the nervous system, giving rise to compulsive behaviors (246–247). The physiological damage caused by fear, or fright, further embedded psychological and emotional factors in biology. The diagnosis of trauma emerges from medical science but its physical traces have disappeared and traumatized behavior is now understood as a symptom of neurological disorder.

Trauma is biological, but its location in the nervous system makes it one step removed from the physical world. For this reason it also becomes closely associated with the modern media of photography and film, which record traces of the physical world but also constitute a new virtual dimension of human experience. In *The Empire of Trauma*, Didier Fassin and Richard Rechtman discuss this convergence of psychiatric therapy and media coverage in the adoption of trauma as the central paradigm for understanding the 9/11 attacks. As they point out, there is a slippage between the sense of trauma as a psychological disturbance and its "metaphorical extension disseminated by the media" (2) in which an entire nation can be said to have experienced a traumatic event.

Vermeulen suggests that we see trauma discourses as "technologies that mobilize the negativity of trauma in a mitigated form for the sustainment

of life" (150). Thus the preoccupation with trauma since the 9/11 attacks can be seen as a reaction to the pressures of globalization, which potentially breaks down social, cultural and political borders and also raises the obligation to interact with others. The memory of trauma potentially serves a self-regulating immunitary function but can also be mobilized for the purposes of crisis activation and the state of emergency that suspends political rights and consolidates sovereign power. The repetition of "traumatic events" as media images functions as an alarm that activates defensive and hostile responses.

Organization and Overall Argument

The following chapters show how biopolitical media have developed from the emergence, in the late nineteenth century, of photographic archives and proto-cinematic studies of movement, through the racial stereotypes of European colonialism and genocidal war conducted by the Nazi regime, to the postwar construction of collective trauma around the memories of Hiroshima and the Holocaust, and the convergence of digital information and biosecurity in the post 9/11 war on terror. This is also a history of the ways that Western European conceptions of human performance, productivity, health and survival were tested in colonial Africa and found their extreme expression in the Third Reich. After the war the threat of mass destruction that hung over all human populations lead to new practices of mass psychology and therapeutic conceptions of the body politic. In the age of global information networks the media image itself has come to embody a threat to the survival and well-being of the consumer subject. Each chapter elaborates key theories and arguments about biopolitics in the context of mediated catastrophe. This theoretical discussion is then carried forward into an analysis of specific media texts, usually documentary photographs and films.

Chapter One explains how the modern visual media of photography and film emerged in a cultural milieu defined by research in the natural sciences. Alphonse Bertillon used photography to establish an archive of criminal physiognomy, Étienne-Jules Marey produced the first studies of human and animal motion and Jean-Martin Charcot used photography to document hysteria. Facial portraiture in photography was put in the service of racial comparisons and hierarchies, or what Allan Sekula has called the "biotype." Early photography played an important role in what Foucault identified as the production of the biological norm. In a similar way Agamben has shown how the moving image appropriates gesture by recording, analyzing and simulating movement. In both photography and film we see the displacement of the sovereign individual by visual data. Marey's research formed the basis of time and motion studies of human labor and the principles of Fordist mass production. Charcot inspired Freud's first formulations of psychoanalysis. Trauma became, through Benjamin's theory of shock, a defining feature of industrial modernity. The new visual media also became part of the Nazi apparatus of genocide.

As a specific case study the chapter discusses the notorious Nazi propaganda film *The Eternal Jew*, which uses the technique pioneered in eugenics, of comparing the physiognomy of different racial groups. The film also includes a long sequence denouncing the "barbarism" of the Jewish slaughter of animals. In *The Open*, Agamben has discussed how the Western philosophical tradition has defined human life by distinguishing it from animal life and through what he calls the "anthropological machine" (33). Nazi biopolitics, in which the state for the first time assumed full power to decide who was biologically fit to live, adapted the industrial slaughter of animals to dispose of "subhuman" populations. The obsessive "othering" of the Jews around the practice of slaughter therefore assumes not only a grotesque historical irony but also reveals the importance of the human/animal distinction in the biopolitics of catastrophe. The chapter pursues this question further with respect to the "throat cutting" gesture in Claude Lanzmann's *Shoah*. Agamben's account of gesture allows us to see how Holocaust survivors and witnesses transmit conceptions of human/animal life that have not always been noted in discussions of this film. The chapter concludes with a discussion of contemporary decapitation videos produced in the Middle East as a negation of the human/animal distinction through ritualistic slaughter.

Chapter Two discusses the shift in conceptions of modern visual media in the 1920s and 30s from medico-scientific discourses to those of mass media and propaganda. Media was used to document the biological basis of political identity and economic productivity, but scientific research also became the basis for managing and manipulating public perception. The Nazi state popularized racial theory and made it the basis of national identity and mass mobilization for war. Little of Nazi ideology, however, was entirely original and it shared, as Zygmunt Baumann and others have argued,[8] many assumptions with racial and evolutionist thinking that was widespread in the late nineteenth and early twentieth centuries. In the state of emergency that justified Hitler's absolute power, the state could now put into practice theories of racial hygiene and eugenics through mass enslavement, extermination and medical experiments on human subjects. Photography and film were used extensively to document this biopolitical refashioning of occupied Europe.

This chapter also introduces Benjamin's theory of natural history as an influence on Agamben's account of biopolitics. In Benjamin the violence of sovereign power is made visible in the interpenetration of historical and natural existence, or what Eric Santner has discussed as "the creaturely." For Benjamin transformations in the technical apparatus of communication and representation manifest this catastrophic logic by disrupting established conceptions of culture and nature. To Benjamin photographs resembled petrified fossils whereas film revealed nature in perpetual motion and transformation. Neither of these visions of the new media fitted the ideologies of race and class embodied in the biotype. Benjamin's vision of photography as physiognomic detail applied natural history in an antithetical spirit to biometric calculation, eugenics and Nazi racial essentialism. This dissociation

of physiognomy from racial theory is evident in Benjamin's endorsement of August Sander's photography, which combined the documentation of social class and the natural environment in ways that confounded the stereotypes reproduced in popular media and propaganda. This chapter closes by returning to Benjamin's account of shock and relating it to Esposito's conception of immunity. Again Benjamin's media theory offers a strong counterpoint to the Nazi incorporation of photography into the apparatus of genocide as they documented their own processes of mass killing.

Chapter Three begins with a discussion of Hannah Arendt's highly original analysis of Nazism's roots in European Imperialism, which has attracted widespread interest in recent scholarship.[9] Arendt argued that racial ideology legitimized colonization while creating a new category of subject people without the rights of citizens. This category was later extended to the Jews and other "subhumans" in Europe. Unfortunately Arendt's analysis is distorted by her own racist assumptions about the cultural inferiority of non-Western peoples. She argues that the "traumatic" encounter between European and African lead to the cultural and political degeneration of European settlers. Michael Rothberg has criticized both Arendt and Agamben for failing, in different ways, "to think the colonial encounter as a biopolitical event" (62–63). But can the "biopolitical event" be understood as a traumatic encounter? This book argues that the preoccupation with trauma is itself symptomatic of a failure to acknowledge how biopolitics undermines liberal humanist conceptions of the individual. Cultural trauma narratives respond to historical events in which individual human life has been overtaken by institutional and technological power, but the very conception of trauma is often embedded in essentialist notions of the human. A few years after Arendt's book, Alain Resnais's film *Night and Fog* also gestured toward the historical relation between colonialism and Nazism but failed to explore its larger implications. This film, too, has often been interpreted in the context of trauma and Holocaust studies.

In the postwar period both Sartre and Fanon attempted to release psychology from this Eurocentrism. Rejecting the Freudian unconscious, Sartre developed instead the notion of "bad faith" as a conscious disavowal of reality. The subject is defined by active choices as a response to specific historical situation. Influenced by Sartre, Fanon developed a psychology determined by colonial inequality and oppression. For Fanon colonial trauma was a product of the internalization of racist stereotypes, thereby implicitly emphasizing the important role of media images and narratives in establishing biopolitical hierarchies. He rejected colonial ethnopsychiatry as premised on biological racism. Reversing Arendt's argument, Fanon understood colonial trauma as based in the native's exclusion from being recognized as fully human. Chapter Three explores these arguments in relation to the unveiling of Arab women for erotic postcards and identity photographs in French Algeria. The chapter closes with a discussion of these issues in Harun Farocki's experimental documentary *Images of the World and the*

Inscription of War, which juxtaposes photographs of Jews in Auschwitz with those of Algerian women: both the stateless person and the colonized subject are documented in photographs that codify them in racial biological terms. Farocki makes the relation between colonialism and Nazism explicit in ways that *Night and Fog* was unable to do.

After World War II racist ideology was discredited. The shocking evidence of the Nazi death camps and the subsequent Nuremberg Trials and founding of the United Nations lead to the establishment of new universalist paradigms about human rights, crimes against humanity and genocide.[10] Under the justification of the Cold War, however, the United States extended new forms of mass propaganda, misinformation and secret experiments on mind control. This period also demanded the public "forgetting" of the Nazi genocide, ignorance of Japanese biological warfare, and the concealment of the ecological catastrophes caused by nuclear weapons. The delegitimizing of racial ideology in the post–World War II period required the establishment of moral universals that disguised more fundamental anxieties about human survival and geopolitical desires for global power during the break up of European colonialism.

Chapter Four discusses this postwar culture of fear and trauma as a new form of "biopolitical imagination." Robert Lifton's research on brainwashing in Communist China and the survivors of Hiroshima led him to propose "psychic numbing" as a collective response to catastrophe. Lifton's research was used as the basis for a documentary film of survivor testimony, *To Die, To Live*, (directed by Holocaust survivor Robert Vas). Norman Mailer speculated on the "psychic havoc" caused by the concentration camps and atom bomb and saw a model for cultural resistance in African Americans, who had the longest experience of this oppression. In her 1965 essay "The Imagination of Disaster" Susan Sontag argued that B grade science fiction films of the 1950s and 60s embodied the historical trauma of nuclear destruction. In different ways all of these postwar American intellectuals attempted to incorporate the historical experience of genocide and nuclear weapons into a new collective identity. In doing so they inadvertently reproduced some of the biopolitical conceptions of the human that had led to these catastrophes.

In *On Photography* (1977) Sontag described the impact of first seeing in 1945 the photographs of the Nazi death camps. Sontag's notion of the "photographic inventory of total horror" echoed Lifton's work on Hiroshima. Both Sontag and Lifton also argued that the intense media coverage of the Vietnam War had numbed public responses to atrocity. Sontag's comments on the Belsen photographs have been seen by subsequent scholars such as Barbie Zelizer and Marianne Hirsch as part of the entry of the Holocaust into collective memory. But if we resituate them in the context of postwar cultural criticism they can be seen as part of a broader attempt to articulate the biopolitical implications of historical catastrophe.

The final chapter looks at conceptions of catastrophe in the post 9/11 period drawing on Esposito's account of immunity and Hardt's and Negri's

theory of empire. Esposito explains immunization as "a protective response in the face of a risk" (*Immunitas* 1). The risk of penetration or contamination by a foreign body or virus might apply to a nation's immigration policy or a computer network, imagined through biological metaphors of host bodies, infections and immune systems. To be immune is to be exempt from obligations to the larger community. But immunity is only established through internalization, in a homeopathic sense, of the external threat; or inoculation through a nonlethal dose of the virus. A similar logic underlies the use of violence in the name of the law or the state: violence is used as a legitimate means of punishing or excluding nonlegitimate violence. The violence perpetrated in the name of the law is itself immune from punishment but it "works by adopting the same thing it aims to protect itself against" (25).

These biopolitical conceptions of identity resonate with W.J.T. Mitchell's notion of the "biopicture" as a term for contemporary media understood in terms of viral contamination. Mitchell stresses the traumatic impact of the biopicture in a "war of images" that is "designed to overwhelm the viewer's defenses" (97). But, following Esposito, we can also see the emphasis on trauma as itself a homeopathic response to the violation of America's immunity from attack. The discourse of the war on terror seeks to reconstitute America's immunity as a superpower while redefining the public as a vulnerable, potentially traumatized population. This account overlaps in some of its assumptions with research, such as that undertaken after the 9/11 attacks, on the psychological distress caused by media images among the general population: collective pathology replaces political participation. The biopicture is a *pharmakon*: both poison and remedy seeking to exercise control while exorcising the possibility of actual destruction.

Post 9/11 discourse resonates with earlier responses to the atom bomb and reconfigures the Cold War threat of mass destruction. The intensive mediation of terror and virtual trauma has taken Kant's spectator to a new level of alienation where collective fear is used to mobilize the biopower of entire populations, with the new enemy defined as a "sleeper cell" that must be removed by a surgical strike. Politics now operates through technological information networks and biological life is conceived as genetic information. Neoliberalism, with its emphasis on individual responsibility, attempts to govern social behavior through the internalization of market values. The fear of impoverishment, natural disaster, or terrorist attack instills in the individual self-governing processes of risk management. Migrant populations are monitored by biometric technologies and detained indefinitely without political rights, host populations are monitored in terms of collective vulnerability and resilience. This new discourse of catastrophe creates opportunities for neoliberal, militarist and neocolonial power. Digital media, however, allow the production of images of explicit violence that cannot be effectively censored by the established mass media apparatus. The book closes with a consideration of whether uses of new media by anti-American groups escapes or extends biopolitical control.

Notes

1. These lectures have been published in series of books including *Psychiatric Power: Lectures at the Collège de France, 1973–74*; *Abnormal: Lectures at the Collège de France, 1974–1975*; *"Society Must be Defended": Lectures at the Collège de France, 1975–76* and *Security, Territory, Population: Lectures at the Collège de France, 1977–78*.

2. Key works By Agamben include *Homo Sacer: Sovereign Power and Bare Life*; *State of Exception*; *Remnants of Auschwitz: The Witness and the Archive* and *The Open: Man and Animal*; by Esposito, *Bios: Biopolitics and Philosophy* and *Immunitas: The Protection and Negation of Life*; by Hardt and Negri, *Empire*, *Multitude: War and Democracy in the Age of Empire*, and *Commonwealth*. See also Donna Haraway, "The Biopolitics of Postmodern Bodies: Constitutions of Self in Immune System Discourse," *Differences: A Journal of Feminist Cultural Studies* 1.1 (1989): 3–43.

3. Agnes Heller argues that today's attribution of cultural trauma to specific nations or ethnic groups is biopolitical. She bases her argument on Arendt's distinction between politics, as free and open debate in the public sphere and pseudo-scientific conceptions of society such as race theory. In the Western European tradition the political body begins where the natural body, with its immediate needs and filiations, no longer holds sway. Civil society forms a sphere of common interest that transcends and forms a buffer against the biological relations of the family. Ideology disguises the interests of specific groups by representing them as the interests of all. Biopolitics no longer requires such dissimulation. As Heller puts it: "It unashamedly speaks from the standpoint of a group that can be identified by biological characteristics or by purely biological aims" (5).

4. See Allan Sekula, "The Body and the Archive," *October* 39 (1986): 3–64; Jonathan Beller, *The Cinematic Mode of Production: Attention Economy and the Society of the Spectacle*; W.J.T. Mitchell, *Cloning Terror: The War of Images, 9/11 to the Present*; and Nicholas Mirzoeff, *Watching Babylon: The War in Iraq and Global Visual Culture*.

5. In the early 1930s Benjamin gave a series of talks on German radio including, on October 1931, a talk on the Lisbon Earthquake in which he discussed Kant's fascination with the earthquake (2: 536–540). He did not connect this, as more recent commentaries have done, with Kant's conception of the sublime.

6. See Levitt, "Notes on Media and Biopolitics"; Murray, *Giorgio Agamben*; and *Agamben and Cinema*. Ed. Gronstad and Gustafson.

7. In *Downcast Eyes*, Martin Jay discusses Foucault and Debord as both contributing to the critique of "ocularcentrism" (384). In their different theories of the panopticon and the spectacle, vision becomes the basis of enlightenment knowledge as power, surveillance and alienation.

8. See for example Bauman, *Modernity and the Holocaust*; Burleigh and Wippermann, *The Racial State*; and Goldberg, *The Racial State*.

9. See King and Stone, *Hannah Arendt and the Uses of History*; Hartouni, *Visualizing Atrocity: Arendt, Evil, and the Optics of Thoughtlessness*; and Rothberg, *Multidirectional Memory*.

10. See King, *Race, Culture and the Intellectuals*.

Works Cited

Agamben, Giorgio. *The Coming Community*. Trans. Michael Hardt. Minneapolis: U Minnesota P, 1993.

———. *Nudities*. Trans. David Kashik and Stefan Pedatella. Stanford: Stanford UP, 2011.

———. "Difference and Repetition: On Guy Debord's Films." Trans. Brian Holmes. *Guy Debord and the Situationist International: Texts and Documents*. Ed. Tom McDonough. Cambridge, MA; London: MIT Press, 2002. 313–319.

———. *Means without Ends: Notes on Politics*. Trans. Vincenzo Binetti and Caesare Casarino. Minneapolis: U Minnesota P, 2000.

———. *Homo Sacer: Sovereign Power and Bare Life*. Trans. Daniel Heller-Roazen. Stanford: Stanford UP, 1998.

———. *The Origins of Totalitarianism*. San Diego, New York, London: Harcourt Brace Jovanovich, 1973.

———. *On Violence*. London: Penguin, 1970.

Arendt, Hannah. *The Human Condition*. Chicago and London: U Chicago P, 1958.

———. *The Open: Man and Animal*. Trans. Kevin Attell. Stanford: Stanford UP, 2004.

Bauman, Zygmunt. *Modernity and the Holocaust*. Cambridge: Polity Press, 1989.

Beller, Jonathan. *The Cinematic Mode of Production: Attention Economy and the Society of the Spectacle*. Hanover and London: UP of New England, 2006.

Benhabib, Selya. *The Reluctant Modernism of Hannah Arendt*. Latham, Boulder, New York, Toronto, Oxford: Rowan and Littlefield, 2000.

Benjamin, Walter. *Selected Writings Volume 3 1935–1938*, Trans. Edmund Jephcott, Howard Eiland, et al., Ed. Howard Eiland and Michael W. Jennings. Cambridge, MA, and London: Harvard UP, 2002.

———. *Selected Writings Volume 4 1938–1940*, Trans. Edmund Jephcott et al., Ed. Howard Eiland and Michael W. Jennings. Cambridge, MA, and London: Harvard UP, 2003.

Burleigh, Michael, and Wolfgang Wippermann. *The Racial State: Germany 1933–1945*. Cambridge: Cambridge UP, 1991.

Cooper, Melinda. *Life as Surplus: Biotechnology and Capitalism in the Neoliberal Era*. Seattle and London: U Washington P, 2008.

Craps, Stef. "Beyond Eurocentrism: Trauma Theory in a Global Age." *The Future of Trauma Theory: Contemporary Literary and Cultural Criticism*. Eds. Gert Beulens, Sam Durant, and Robert Eaglestone. London and New York: Routledge, 2014. 45–62.

Crary, Jonathan. *Suspensions of Perception: Attention, Spectacle, and Modern Culture*. Cambridge, MA: MIT Press, 1999.

Derrida, Jacques. *Writing and Difference*. Trans. Alan Bass. Chicago: U Chicago P, 1978.

Dillon, Michael, and Julian Reid. *The Liberal Way of War: Killing to Make Life Live*. London and New York: Routledge, 2009.

Esposito, Roberto. *Bios: Biopolitics and Philosophy*. Trans. Timothy Campbell. Minneapolis: U Minnesota P, 2008.

———. *Immunitas: The Protection and Negation of Life*. Trans. Zakiya Hanafi, Cambridge: Polity, 2011.

Eyerman, Ron. "The Past in the Present: Culture and the Transmission of Memory." *The Collective Memory Reader*. Eds. Jeffrey K.Olok, Vered Vinitsky-Seroussi, and Daniel Levy. Oxford: Oxford UP, 2011. 304–306.

Eyerman, Ron, Jeffrey C. Alexander, and Elizabeth Butler Breese (eds). *Narrating Trauma: On the Impact of Collective Suffering*. Boulder, CO: Paradigm, 2011.

Fanon, Frantz. *Black Skin, White Masks*. Trans. Charles Lam Markmann. New York: Grove, 1967.

———. *A Dying Colonialism*. Trans. Haakon Chevalier. New York: Grove, 1967.

———. *The Wretched of the Earth*. Trans. Constance Farrington. New York: Grove, 1963.

Fassin, Didier, and Richard Rechtman. *The Empire of Trauma: An Inquiry into the Condition of Victimhood*. Princeton and Oxford: Princeton UP, 2009.

Feldman, Allen. "On the Actuarial Gaze: From 9/11 to Abu Ghraib." *The Visual Culture Reader (3rd edition)*. Ed. Nicholas Mirzoeff. London and New York: Routledge, 2013. 163–180.

Foucault, Michel. *Abnormal: Lectures at the Collège de France, 1974–1975*. Ed. Valerio Marchetti and Antonella Salomini. Trans. Graham Burchell. New York: Picador, 2003.

———. *Security, Territory, Population: Lectures at the Collège de France, 1977–78*. Ed. Michel Senellart. Trans. Graham Burchell. Hampshire, NY: Palgrave MacMillan, 2007.

———. *Psychiatric Power: Lectures at the Collège de France, 1973–74*. Ed. Jacques Lagrange. Trans. Graham Burchell. Hampshire, NY: Palgrave MacMillan, 2006.

———. *"Society Must be Defended": Lectures at the Collège de France, 1975–76*. Ed. Mauro Bertani and Alessandro Fontana. Trans. David Macey. NY: Picador, 2003.

———. *The Order of Things: An Archaeology of the Human Sciences*. London: Routledge, 2001.

———. *The History of Sexuality Volume One: The Will to Knowledge*. Trans. Robert Hurley. Harmondsworth: Penguin, 1998.

———. *Discipline and Punish: The Birth of the Prison*. Trans. Alan Sheridan. London: Penguin, 1991.

———. *The Birth of The Clinic: An Archaeology of Medical Perception*. Trans. A.M. Sheridan Smith. New York: Pantheon, 1973.

Giroux, Henry A. "Reading Hurricane Katrina: Race, Class, and the Biopolitics of Disposability." *College Literature* 33.3 (2006): 171–196.

Goldberg, David Theo. *The Racial State*. Oxford: Blackwell, 2002.

Gronstad, Asbjorn and Henrik Gustafson. "Giorio Agamben and the Shape of Cinema to Come." *Cinema and Agamben: Ethics, Biopolitics and the Moving Image*. Eds. Asbjorn Gronstad and Henrik Gustafson. New York: Bloomsbury, 2014. 1–17.

Hammond, Paul. *Media, War and Postmodernity*. London and New York: Routledge, 2007.

Haraway, Donna, "The Biopolitics of Postmodern Bodies: Constitutions of self in Immune System Discourse." *differences: A Journal of Feminist Cultural Studies* 1.1 (1989): 3–43.

Hardt, Michael, and Antonio Negri. *Commonwealth*. Cambridge, MA: Harvard UP, 2009.

———. *Multitude: War and Democracy in the Age of Empire*. London: Penguin, 2006.

———. *Empire*. Cambridge, MA: Harvard UP, 2000.

Hartouni, Valerie. *Visualizing Atrocity: Arendt, Evil, and the Optics of Thoughtlessness*. New York and London: New York UP, 2012.

Heller, Agnes. "Has Biopolitics Changed the Concept of the Political? Some Further Thoughts about Biopolitics." *Biopolitics: The Politics of the Body, Race and Nature*. Ed. Agnes Heller and Sonja Puntscher Riekmann. Aldershot, Brookfield: Avebury, 1996. 3–15.

Hirsch, Marianne. "Surviving Images: Holocaust Photographs and the Work of Postmemory." *Visual Culture and the Holocaust*. Ed. Barbie Zelizer. New Brunswick, NJ: Rutgers UP, 2001. 214–246.

Jay, Martin. *Downcast Eyes: The Denigration of Vision in Twentieth Century French Thought*. Berkeley: U California P, 1993.

Kant, Immanuel. *Critique of Judgement*. Trans. James Creed Meredith, Oxford: Clarendon Press, 1952.

Kaplan, E. Ann. "Fanon, Trauma and Cinema." *Frantz Fanon: Critical Perspectives*. Ed. Anthony C. Alessandrini. London and New York: Routledge, 1999. 146–157.

Katz, Elia, and Tanar Liebes. "'No More Peace!': How Disaster, Terror and War Have Upstaged Media Events." *International Journal of Communication* 1 (2007): 157–166.

Keenan, Thomas. "Publicity and Indifference: Media, Surveillance, 'Humanitarian Intervention'." *Rethinking Theories and Practices of Imaging*. Ed. Timothy H. Engstrom and Evan Selinger. Basingstoke: Palgrave Macmillan, 2009. 267–297.

King, Richard H. *Race, Culture, and the Intellectuals,1940–1970*. Baltimore and London: Johns Hopkins UP, 2004.

King, Richard H., and Dan Stone, Ed. *Hannah Arendt and the Uses of History: Imperialism, Nation, Race,and Genocide*. New York and Oxford: Berghahn, 2007. 38–53.

Klein, Naomi. *The Shock Doctrine*. Camberwell, Australia: Allen Lane, 2007.

Lemke, Thomas. *Biopolitics: An Advanced Introduction*. Trans. Eric Frederick Trump. New York and London: New York UP, 2011.

Levitt, Deborah. "Notes on Media and Biopolitics: 'Notes on Gesture '." *The Work of Giorgio Agamben: Law, Literature, Life*. Ed. Justin Clemens, Nicholas Heron, and Alex Murray. Edinburgh UP, 2008. 193–211.

Levy, Daniel, and Natan Sznaider. *The Holocaust and Memory in the Global Age*. Trans. Assenka Oksiloff. Philadelphia: Temple UP, 2006.

Lifton, Robert Jay. *Death in Life: Survivors of Hiroshima*. New York: Random House, 1967.

———. *Home from the War: Vietnam Veterans: Neither Victims nor Executioners*. New York: Simon and Schuster, 1973.

———. *Thought Reform and the Psychology of Totalism: A Study of "Brainwashing" in China*. New York: Norton, 1961.

Mailer, Norman. *Advertisements for Myself*. London: Andre Deutsch, 1961.

Mirzoeff, Nicholas. *Watching Babylon: The War in Iraq and Global Visual Culture*. New York and London: Routledge, 2005.

Mitchell, W.J.T. *Cloning Terror: The War of Images, 9/11 to the Present*. Chicago and London: U Chicago P, 2011.

Murray, Alex. "Beyond Spectacle and the Image: The Poetics of Guy Debord and Agamben." *The Work of Giorgio Agamben: Law, Literature, Life*. Ed. Justin Clemens, Nicholas Heron and Alex Murray. Edinburgh UP, 2008. 164–180.

———. *Giorgio Agamben*. London and New York: Routledge, 2009.

Neiman, Susan. *Evil in Modern Thought: An Alternative History of Philosophy*. Princeton and Oxford: Princeton UP, 2002.

Prozorov, Sergei. *Agamben and Politics: A Critical Introduction*. Edinburgh: Edinburgh UP, 2014.

Pugliese, Joseph. *Biometrics: Bodies, Technologies, Biopolitics*. New York and London: Routledge, 2010.

————. *State Violence and the Execution of Law: Biopolitical Caesurae of Torture, Black Sites, Drones*. New York: Routledge, 2013.

Ray, Gene. *Terror and the Sublime in Art and Cultural Theory: From Auschwitz to Hiroshima to September 11*. Basingstoke: Palgrave McMillan, 2005.

Regier, Alexander. "Foundational Ruins: The Lisbon Earthquake and the Sublime." *Ruins of Modernity*. Ed. Julia Hell and Andreas Schönle. Durham, NC, and Indiana: Duke UP, 2010. 357–374.

Rothberg, Michael. *Multidirectional Memory: Remembering the Holocaust in the Age of Decolonization*. Stanford: Stanford UP, 2009.

Santner, Eric. *On Creaturely Life: Rilke/Benjamin/Sebald*, Chicago and London: U Chicago P, 2006.

Sartre, Jean-Paul. *Anti-Semite and Jew*. Trans. George J. Becker. New York: Schocken, 1948.

————. *Colonialism and NeoColonialism*. Trans. Azzedine Haddour, Steve Brewer, and Terry McWilliams. London and New York: Routledge, 2001.

————. "Preface." Frantz Fanon, *The Wretched of the Earth*. Trans. Constance Farrington. New York: Grove, 1963.

————. *Being and Nothingness: An Essay on Phenomenological Ontology*. Trans. Hazel E. Barnes. London: Methuen, 1957.

Sekula, Allan. "The Body and the Archive." *October* 39 (1986): 3–64.

Shukin, Nocole. *Animal Capital: Rendering Life in Biopolitical Times*. Minneapolis, London: U Minnesota P, 2009.

Sontag, Susan. *Against Interpretation and Other Essays*. New York: Farrar, Straus and Giroux, 1966.

————. *On Photography*. London: Penguin, 2008.

Traverso, Enzo. *The Origins of Nazi Violence*. Trans. Janet Lloyd. New York: Free Press, 2003.

Trend, David. *The Myth of Media Violence: A Critical Introduction*. Oxford: Blackwell, 2007.

Väliaho, Pasi. *Biopolitical Screens: Image, Power, and the Neoliberal Brain*. Cambridge, MA, and London: MIT Press, 2014.

————. *Mapping the Moving Image: Gesture, Thought and Cinema Circa 1900*. Amsterdam: Amsterdam UP, 2010.

Vermeulen, Pieter. "The Biopolitics of Trauma." *The Future of Trauma Theory: Coontemporary Literary and Cultural Criticism*. Eds. Gert Beulens, Sam Durant and Robert Eaglestone. New York and London: Routledge, 2014. 141–155.

Welch, David. *The Third Reich: Politics and Propaganda*. London and New York: Routledge, 2002.

Whyte, Jessica. *Catastrophe and Redemption: The Political Thought of Giorgio Agamben*. New York: State U of New York P, 2013.

Young, Allan. "Post-traumatic Stress Disorder of the Virtual Kind: Trauma and Resilience in Post-9/11 America." *Trauma and Memory: Reading, Healing, and Making Law*. Eds. Austin Sarat, Nadd Davidovitch, and Michael Albertstein. Stanford: Stanford UP, 2007. 21–48.

————. "Suffering and the Origins of Traumatic Memory." *Social Suffering*. Eds. Arthur Kelinman, Veena Das and Margaret Lock. Berkeley, Los Angeles, London: U California P, 1977. 245–260.

Zelizer, Barbie. *Remembering to Forget: Holocaust Memory through the Camera's Eye*. Chicago and London: U Chicago P, 1998.

1 The Biotype and the Anthropological Machine

The media image assumes a biopolitical function by transforming independent human agents into biometric information; by isolating physical features or actions and using them to generate statistical norms; by understanding individuals as representatives of racial types, as samples of large populations, as symptoms of pathological tendencies, or as specimens of biological species; and by defining human communities in terms of immunity, resilience, and the threat of viral contamination. Media images function in economies of production and consumption that define individuals and groups in terms of social, political, and biological inclusion and exclusion, health and sickness, productivity and waste. They are also used to identify human populations that should be confined, killed or disposed of.

This chapter explains how the early development of photography and film forms part of what Foucault, Agamben and others see as the incorporation of biological life into systems of surveillance, intervention and control. Agamben has stressed the catastrophic consequences of this form of power, particularly with regard to Nazi biopolitics, but in Foucault's account of modern medical science, criminology, and anthropology we can also discern the origins of new forms of mass destruction. The recording and analysis of visual information was framed by discourses about class and race that were, in turn, used to justify genocide, first in the colonies and later in Europe itself. These discourses that classified different groups on the basis of visual evidence were also driven by what Agamben calls the "anthropological machine" (*Open* 37), which defined hierarchies of race, gender and class with reference to a more fundamental opposition between human and animal. The early photographic and cinematic capture of life included the comparative study of the expressions and movements of humans and animals. As Nicole Shukin has shown, there were also a number of intersections between the development of motion pictures and animal slaughter. The killing of animals is a form of mass destruction, production and consumption that served as a prototype for Fordism but also for the Nazi Final Solution.

Questions of surveillance and visibility are at the center of Foucault's thought. His conceptions of the clinical gaze and panoptical power have influenced important research on photography by Allan Sekula, John Tagg, Jonathan Crary and others. In the following discussion I use Sekula's term "biotype"

to describe the ways that photographic documentation was used to visually display the differences between normal and deviant individuals and groups. The physical particularities of the individual were subordinated to a statistical aggregate based on images accumulated in the photographic archive. Thus photography served what Foucault identified as the shift in the nineteenth century to demographic analysis as a form of social control. In the later sections of the chapter I explain how Agamben extends this analysis to the moving image, which by recording and framing human gesture has destroyed the autonomy of self-expression and eroded the sovereignty of the private individual.

The production of the biotype was driven by the anthropological machine. The classification of different social types only made sense in terms of the biological caesura that divided the human from the less-than-human. Photographic evidence of physical characteristics and the capture of movement on film made life subject to new regimes of knowledge and power. Separating and classifying individuals into types was ultimately about deciding which types threatened the life that was worth living. This chapter considers some of the direct historical links between the emergence of modern visual media, the slaughter of animals and the Nazi exterminations. The later sections of the chapter discuss the role of the biotype and the anthropological machine in the notorious propaganda film *The Eternal Jew* (1940) and the importance of gesture in Claude Lanzmann's documentary *Shoah* (1985). The chapter closes with a discussion of how the human/animal distinction operates in contemporary decapitation videos released on the Internet.

Mediated Life and Death

In the nineteenth and early twentieth century photography and film specifically focused on recording the details of physiognomy and gesture and encoding these physical manifestations of human life with new scientific and political significance. Criminality, mental disease, racial inferiority, and other forms of social deviance were detected through close analysis of visual evidence recorded by the new media. Photography served the accumulation of medical, biological, sociological and anthropological knowledge, providing evidence of physical degeneration, psychic disorders, criminal deviance and cultural inferiority. The establishment of photographic archives was directly related to the increased power of the police and the medical establishment in the nineteenth century. The rapid growth of urban centers and the emergence of the industrial proletariat required new technologies of surveillance and control. Photography was used to record the identity of criminals and the symptoms of the mentally ill. Physical characteristics were visually isolated and separated from the individual person. When gathered together this visual evidence allowed for statistical analysis. The individual became the representative example of tendencies in the larger population: the norm.

Pioneers in these areas of photography and the moving image, such as Alphonse Bertillon, Francis Galton, Étienne-Jules Marey and Jean-Martin

Charcot, were all members of scientific communities and saw their research on new media as similar to genetic analysis or medical diagnosis. Just as the microscope revealed how disease was transmitted by bacteria, photography could reveal social and psychological disorders inscribed in the details of physiognomy and gesture. Visual evidence served the biopolitical governance of populations conceived in terms of normality and deviance, health and disease, sanitation and infection, survival and degeneration. Much of this research using the new visual media was based in the paradigms of biological evolution and Social Darwinism. With the use of photography by Charcot to document hysteria we can also see the relation of the biopolitical image to psychiatry and trauma. Just as the clinical gaze in medicine and psychiatry separated the symptom from the person in order to classify the individual in terms of the disease, populations began to be monitored and analyzed in terms of collective pathologies. These forms of social control were reinforced by technologies of the self in which the individual assumed responsibility for personal hygiene, economic independence, and psychological adjustment.

The increasing importance of surveillance for medicine and public health facilitated the direct intervention of the state into the reproduction and survival of the human species. Francis Galton, a cousin of Charles Darwin, produced a theory of hereditary transmission and formulated the new science of eugenics. He also did experimental research on photography and the biotype. By overlaying photographs of different individuals, Galton produced a new composite image that he believed could show a general tendency of the larger population. Recognizing criminality, deviance and mental disease through visual evidence also became part of the medico-scientific discourse about race, which in turn served as the theoretical justification for murderous wars conducted against enemy populations (Nadesan 186). The superior health, intelligence and fitness-to-live of some racial groups over others was demonstrated in order to justify the colonial adventures of the European nations. Racial difference was recorded in photographs and collected in archives, analyzed by anthropologists, and published in comparative studies. Physiognomy became evidence for racial hierarchies. In order to preserve this physical health and beauty of superior racial types, inferior elements needed to be excluded and, if necessary, eliminated.

Once humanity was defined as a biological species it became logical to justify the killing of those who did not qualify as human or whose deaths were deemed necessary for the health and survival of the species. The anthropological machine that distinguishes human from nonhuman forms part of a larger assemblage of power that also includes the slaughter of animals. Industrial slaughter removed killing from the everyday lives of modern consumers. The invisibility of the mass slaughter of animals also has strong resonances with the ways that many Germans were apparently able to ignore or accept the mass murder of the Jews. One of the implicit justifications for the Nazi genocide, strangely enough, was the supposed barbarism

of the Jewish method of killing animals. The closing sequence of *The Eternal Jew* showed the "horrifying" realities of Kosher slaughter. The audience who were supposed to be shocked by this spectacle were also intended to accept the necessities of exterminating "subhumans." This convergence of cinema, animal slaughter and genocide makes more sense if we see it as part of the new logic of shock and anesthetization in modern mediated experience. Media images of violence and destruction have proliferated, whereas actual death has become a less visible feature of Western societies. The removal of actual killing from public view, along with the media transmission of shock, together produce the immunity of the consumer subject.

The media apparatus seeks to record and monitor human life and to control and direct the attention of the user/viewer. Agamben argues that in early cinema we witness a "catastrophe in the realm of gestures" (*Means* 50): the physical movements and postures of the body were recorded by the new medium and separated from his/her autonomy as a private individual. They now belonged to the increasingly commodified sphere of the moving image. This chapter considers this convergence of Agamben's theories of politics and media with a discussion of his essay "Notes on Gesture" in the context of *Shoah*. *Shoah* has often been interpreted in terms of Lanzmann's insistence that the film's primary aim is the transmission of the survivor's experience to the audience. This conception of the film has seemed to fit the interpretive paradigms of trauma studies, with its emphasis on testimony and witnessing. Agamben's discussion of gesture reveals how Lanzmann's film belongs to a longer history in which human movement is separated from the autonomy of the individual. One gesture in particular—the gesture of throat cutting—assumes a complex significance when placed in the larger context of animal slaughter and industrial genocide. The final section of this chapter discusses the decapitation videos produced in the Middle East and made available on the Internet. Here too we see a convergence of propaganda, shock and slaughter. But we can see that these videos also participate in a larger history in which the visibility or invisibility of death forms an intrinsic part of the media immune system.

Foucault and Biopolitics

The early use of photography to classify social, psychological and racial types is illuminated by Foucault's account of the changing meanings of life and death in relation to sovereign power, disciplinary power and biopower. In *Discipline and Punish* Foucault explained how torture and execution began to disappear from public spectacle at the end of the eighteenth century. During the French Revolution the use of the guillotine at first retained this spectacular quality, presenting revolutionary justice as high drama for the masses. But the use of the guillotine subsequently became less public and was eventually confined within the prison walls. Enzo Traverso notes an important aspect of this historical shift not explored by Foucault: that the

guillotine replaced the executioner, who embodied the power of the king, with a machine. Under the new sovereignty of the secular state the guillotine administered death with speed and efficiency rather than spectacle and ritual. Traverso thus sees a direct line from the guillotine to the industrialization of death in the Nazi genocide. Now "men began to be slaughtered as though they were animals" (Traverso 24). Because it eliminated prolonged torture as a feature of public execution, the guillotine was deemed more "humane."

Foucault's neglect of the machinic aspect of this historical transformation reminds us to include the camera in his account of power. In an earlier series of lectures collected in the volume *Psychiatric Power* (1973–74), Foucault explained the changing forms of power that emerged as part of these historical developments. He proposed that sovereign power was founded on divine right or conquest and maintained through the threat and exercise of violence. It was embodied in ceremonies, gestures, and symbols rather than in individual bodies, excepting that of the sovereign himself. This is the basis of Foucault's distinction between sovereignty and the disciplinary power that emerged in the seventeenth and eighteenth centuries. The sovereign demanded specific services from his subjects but disciplinary power (for example, the army, religious orders, or schooling) sought the "exhaustive capture of the individual's body, actions, time, and behavior" (*Psychiatric Power* 46). Disciplinary power was no longer constituted through occasional rituals, contests and ceremonies but was a constant form of panoptical surveillance internalized through habit, physical exercise and punishment and externalized through record keeping and assessment. It operated through practices, techniques, conduct and applied knowledge and expertise, including the self-regulating behavior of the individual. Through observation, examination and classification it produced homogeneity and conformity.

Disciplinary power confronted a new kind of problem: those who could not be classified by or assimilated into the system. This produced, in turn, new systems of classification for deviants and delinquents. Disciplinary power attempted to take control of the individual subject in every feature of his/her life. The modern individual emerged through disciplinary power. Therefor it is not a question of "liberating" the subject from disciplinary power, as the individual did not exist, in the terms that we now conceive of individuals, in a state prior to discipline. Taking his model of modern surveillance from Bentham's *Panopticon* (1787), Foucault emphasized that as opposed to sovereign power, panoptical power is "only ever an optical effect" and is "without materiality" (77). It is a regime of visibility that produces knowledge about individual subjects. Photography was able to capture the distinctive physical characteristics of the individual as an example of trends in the larger society. In this way the optics of disciplinary power were extended to the biopolitical surveillance of entire populations.

Foucault identified biopower as emerging in the late eighteenth century. Sovereign power is premised on the right to decide over the life and death of the subject but is actually exercised through the right to kill. Biopower,

however, introduced a new right to the state "to 'make' live and 'let' die" (*"Society"* 241). This new technology of power did not exclude disciplinary power but was embedded in it, modifying it toward new ends. Whereas disciplinary power was centered on the body, biopower is applied to "man-as-living-being" or "man-as-species" (242). Biopower is based in demographic analysis of entire populations: birth rate, mortality rates, life expectancy, public hygiene, old age. It uses statistical aggregates to regulate and standardize mass behavior, to manage social and economic risks such as poverty and unemployment, and to maximize "genetic capital."

Biopolitics is the monitoring, analysis, and management of the behavior of populations. As Michael Dillon explains, the modern concept of population departs from both the Christian notion of redemptive community and the liberal notion of civil community ("Security" 181). A population has no political agency in the sense of collective struggle but rather internalizes power through practices of self-regulation and governance. Statistical data about populations were first gathered and used for improving health and controlling deviance. When race emerged in the nineteenth century as a biological category, along with the revolutionary discourse of class struggle, it allowed for the division of society into those who deserved to live and those who deserved to die. In the early twentieth century political scientists, anthropologists and geneticists began to explain the state as an organic entity, the nation as an ethnic entity and society in terms of biological struggles. These formulations achieved their extreme form in the Nazi state but were also promulgated in Soviet Russia and the United States (Lemke 9–14).

Photography and the Biotype

The governing of populations on the basis of biological knowledge found an important tool in the new medium of photography. In the nineteenth century experts in medical science, anthropology, and criminology elaborated systems of visual evidence for physical and psychological health that were applied to entire populations and used to justify the elimination of specific groups. Before the invention of photography the classification of races in eighteenth century anthropology had fostered a preoccupation with physical appearance. Different ethnicities were ranked according to the Western ideal of classical beauty. Johann Kaspar Lavatar's *Essai sur la Physiogonomie* (1781) applied the Greek ideal in the "scientific" study of facial features and attempted to classify national character types through physiognomy. Nobility of soul was revealed in physical beauty while criminal tendencies were manifest in ugliness. In the early nineteenth century the German physiologist Franz Joseph Gall developed the science of phrenology which read character through the shape of the head. This approach became universally used to support racial theories and racist caricatures, particularly of Jews and Negroes (Mosse 24–29). Cesare Lombroso's phrenology of the criminal served in a similar way the policing of the urban masses in Western industrialized nations.

Englishman Francis Galton's photographic studies also used the face as physical evidence of predefined types. Galton wanted to intervene directly in the reproduction of different social classes in order to eliminate inferior types such as "habitual criminals" and "the insane," thereby reducing crime and social deviance to biological disorders (Lalvani 123).

Foucault suggested that biopolitics emerged because traditional sovereign power was no longer able to control the rapidly growing and changing urban and industrial society. The determining of social character on the basis of physiognomy and phrenology formed part of the ideology of industrial capitalism, allowing the propertied classes to make assessments of those they deemed employable, criminal or deviant. The new technological medium of photography was quickly adopted to serve these conceptions of social identity. As Sekula explains, photographic documentation of social deviants played an important role in defining them as constituting a *"biotype"* (16). Both Alphonse Bertillon's and Francis Galton's different projects for visually documenting the criminal relied on the notion of the "average man" in the emerging sciences of statistics and sociology. Large aggregates of social data when graphed revealed a "symmetrical binomial curve as the mathematical expression of a fundamental social law" (21–22). The "average man" embodied ideals of health, beauty and social stability and became aligned with Darwinist evolutionary theory.

In the late nineteenth century the use of photography for the purposes of scientific investigation in physiology, criminology, physics and anthropology produced new forms of visual data about natural life. In the 1880s Bertillon established a photographic archive of recent offenders at the Paris Prefecture of Police. Bertillon organized his photographic records around the statistical distribution of bodily measurements, grouping criminals by shared physical characteristics. Galton produced composite photographs in which different individual faces were overlaid to produce a "type" such as "the criminal," "the scientist" or "the Jew." His visual documentation of biological species and social classes were based in statistical notions of "average cranial diameter" (Ellenbogen 8). His idealization of statistical laws provided a measure of social order when confronted by the unruly "mob" of the industrial urban age.

In both Bertillon's and Galton's uses of photography visual information about human individuals was removed from the natural perception of the human eye. Natural life was taken out of its usual social existence and transformed into statistical information. Bertillon's documentation of criminals required that the subject present their face in a still, composed expression to be photographed from the front and in profile. This presentation of the individual removed him/her from any facial animation typical of everyday social encounters. Facial features were then transposed into a visual code, the recognition of which formed a new part of police skill and experience. Bertillon also pursued a "neutral" representation of the criminal by standardizing focal length and using consistent lighting (Lalvani 109). Through photography the individual body could be reduced to an isolated object of

knowledge. These visual records of facial features were accompanied by records of precise physical measurements, observations and classifications (such as eye color). Individual differences became the basis of the laws of similarity that organized the archive. Facial features, such as noses and ears, could be isolated in photographs and collected in taxonomic series that revealed minute variations. The physiologist Étienne-Jules Marey used models, dressed in black suits marked with white lines, to produce series of high-speed photographs documenting intricacies of human motion previously invisible to the eye. As Josh Ellenbogen has shown, the photographic researches of Bertillon, Galton and Marey all share a common project of removing visual experience from the limitations of natural human perception and aligning it with scientific objectivity and statistical information.

During the same period that Bertillon, Galton and Marey conducted their experiments, Jean-Martin Charcot was also using photography to study the pathological symptoms of hysterical women, laying the foundations of modern psychotherapy and psychoanalysis. Charcot documented his research extensively with photographs of his female patients. These women included the old, the poor, beggars, vagabonds, epileptics and those considered mad. By studying the symptoms presented by the patient and then comparing them with a large number of other cases a general correlation of symptoms could be established. In this way the patients became subjects of the clinical gaze:

> According to Charcot, the "type" is the form of the "whole" of the symptoms, from which an illness comes into existence as a nosological concept. It is "an *ensemble*" of symptoms that *depend* on each other, arranged into a *hierarchy*, which can be *classified* in clearly delimited groups, and which, especially through their character and combinations, can be *distinguished* from the characters of other similar illnesses.
>
> (Didi-Huberman 25)

Photography was used to establish a visual archive of symptoms. The camera embodied the ideal of disinterested observation, a machine for recording and transmitting the truth of the clinical gaze. A special status was attributed to the facial portrait, allowing for a detailed analysis of the physiognomic symptoms of madness. By comparing variations in these facial portraits a composite type could be assembled to aid subsequent diagnoses. The concept of the pathological type was given its literal form in composite photographs that superimposed different individual portraits. The visual documentation of patients at the Salpêtrière was contemporary with the establishment of Bertillon's criminal archive.

The Anthropological Machine

The monitoring and categorization of human populations through photographic documentation was aligned to the biological understanding of social life. These pioneers of early photography saw the new media as making an

important contribution to the growing body of scientific knowledge. The medico-scientific concept of the biotype incorporated the human individual into a new entity: the population. Individuals were measured and evaluated in terms of their relation to statistical and demographic trends, allowing decisions to be made as to their fitness to live. The individual was not seen as an independent political agent but subordinate to the biological needs of the larger social and political body. This classification of different social types was premised on assumptions and arguments about what constituted a properly human life. Galton, the founder of modern eugenics, followed the lead of Charles Darwin who had published his own study of physiognomy using photographic illustrations in 1872: *The Expression of the Emotions in Man and Animals*. Darwin's earlier *Origin of the Species* (1859) had given rise to heated public debate about the evolution of humans from animals, particularly apes. Was the human being a unique species created by God or a development of other species (specifically apes) that were not fundamentally different in a biological sense? The scientific evidence for deciding this question, such as fossils of Neanderthal man, was limited and inconclusive at the time.

This debate quickly spread into anthropology. Defining indigenous peoples as "savages," "aboriginals" or "primitive peoples" shifted the language of European colonialism into an evolutionist frame. The races of the world could now be placed in a hierarchy based on scientific theory (Cain xv–xvi). Yet this hierarchy still sought to distinguish man from animal with reference to the (God-given) "higher faculties" of language, reason and morality. Darwin himself was committed to understanding humans as not fundamentally distinct from other animals. In *The Expression of Emotions* illustrations of animals and discussions of their body postures and facial expressions are juxtaposed with photographs and analyses of human gestures and expressions. Darwin argued that animals could feel and express emotions and make rational calculations and decisions. He tried to show that emotions that were associated with "higher" moral faculties—such as embarrassment and shame—were actually based in biological impulses shared with other animals. Facial muscles used in the expression of human emotion were also found in other animals. Darwin drew his examples from observations and photographs of inmates of mental asylums. He also made use of photographs produced by French neurologist Guillaume Duchenne showing a man being given electric shocks on different parts of his face to induce specific expressions. Darwin interpreted Duchenne's research as showing that human facial expression was not derived from "higher faculties" but had evolved over time from various arbitrary causes. He also drew on various eyewitness accounts of "natives" in the European colonies. Although his research was embedded in institutional power and social inequality, Darwin did attempt to challenge the hierarchical basis of biological racism and speciesism.

Darwin's arguments attempted to intervene in what Agamben has called the "anthropological machine": the discursive operation that produces the oppositions man/animal and human/inhuman. For Agamben the anthropological

machine must always already assume humanity as a distinct species and it must exclude the nonhuman as the state of exception. But the category of the fully human remains empty—depending on a "missing link"—because the human and animal are always mutually constituted through the caesura that divides them. The biopolitical consequence of this missing human essence is the life that exceeds the classical opposition between natural and political life: bare life. Biologically inferior life must be designated in order to constitute what is considered fully human. The anthropological machine:

> functions by excluding the not (yet) human and already human being from itself, that is, by animalizing the human, by isolating the nonhuman within the human: *Homo alalus*, or the ape-man. And it is enough to move our field of research ahead a few decades, and instead of this innocuous paleontological find we will have the Jew, that is, the nonman produced within the man ... (*Open* 37)

Nazi anthropology defined humanity in terms of four principal biotypes that ranged "from the superman (Aryan) to the anti-man (Jew), passing through the average man (Mediterranean) and the subhuman (Slavic)" (Esposito, *Bios* 129). But there is no need to jump from Darwin to Nazi anti-Semitism in order to see the genocidal implications of the anthropological machine: it was already fully operational with European imperial conquest and colonization. While European scientists debated the correct relationship between man and animal and between civilized and savage, those deemed less than human were killed in their millions.

Social Darwinism and eugenics made race the defining term in human identity. Photography provided "objective" scientific evidence of racial difference. Criminals, hysterics and other deviants were racialized, insofar as they were seen as a threat to the health of the dominant group. Just as the "dying races" had been exterminated in Africa, Asia, the Americas and the Pacific, so would these deviant or degenerate groups need to be disposed of. As entire sections of the population came to be defined as *homo sacer*, potentially *anyone* might fund him/herself in that category. Once the visual evidence of a photograph was used to establish criminal deviance of an individual it could then be applied to entire subgroups of the population. Once the Jews, for instance, were identified as an alien race then they could also be collectively criminalized.

Animal Slaughter and *The Eternal Jew*

These uses of photography by criminologists, psychiatrists and anthropologists were characteristic of the development of the medium in the nineteenth century. During this period the production and interpretation of photography was often limited to specific intellectual and institutional contexts and remained the domain of the expert. Middle class professionals and those

with political influence and power were free to speak of the lower classes, the poor, the mentally ill and the colonized as potential threats to public safety, health and hygiene. Those controlling the camera directed their gaze at these passive entities and situated them in discourses and practices of power/knowledge. As John Tagg explains, this hegemony exercised by the scientific elite gradually shifted in the early twentieth century into the realm of mass politics. By the 1930s, argues Tagg, documentary photography formed part of a mass political mobilization. The surveillance and documentation of illness, class and race had created a visual language that would be taken up and transformed in the new mass media of newspapers, magazines, and cinema. Tagg does not discuss the uses of documentary photography by the Nazi state, but this remains the most extreme example of a commitment to Social Darwinism, eugenics, racial purity and genocide, all of which underpinned a program of propaganda undertaken by the Third Reich on an unprecedented scale. The single most notorious example of this racist propaganda is the film *The Eternal Jew* (1940).

In *Eternal Treblinka*, Charles Patterson explains how comparing Jews to animals can be traced back to early Christianity and was continued in the rhetoric of the Reformation and modern European philosophy and scholarship. Hitler drew on this long tradition of anti-Semitic discourse, along with its modern biological inflection comparing Jews to vermin, bacteria and bacilli. The most notorious sequence from *The Eternal Jew* juxtaposes images of swarms of rats with crowds in a Jewish ghetto. Defining the Jews as subhuman made it easier to exterminate them like pests. But it was actually the industrialized process of animal slaughter, rather than the killing of vermin, that became the model for the Final Solution.

The gradual concealment of animal slaughter from public view, the industrialized process of killing and the ever-increasing numbers of living creatures that are killed (today reaching the billions each year) has provoked inevitable comparisons with the Nazi genocide. The brutality and scope of the killing demands that those who work in the meat industry desensitize themselves to animal suffering while the meat consumer learns never to think of the killing process that remains out of view. This particular dissociation of death from life serves as an important model for the peculiar logic of catastrophe, immunity and bare life in modern media and consumer culture. Henry Ford claimed that his idea for assembly-line production was inspired by a visit to a Chicago slaughterhouse. Ford was also an active publisher of anti-Semitic literature including an anthology called *The International Jew* (translated into German as *The Eternal Jew*). Hitler was a fervent admirer of Ford (Patterson 72–75).

The Nazi state applied biopolitics in the most extreme forms yet seen and also used the new mass media of magazines, movies and television to disseminate biopolitical images. Nazi media is discussed in more detail in Chapter Two, but I want to now briefly consider the Nazi documentary film *The Eternal Jew* because of the ways that it brings together images of the

biotype with those of animal slaughter. The film sets out to show the "true racial character" of the Jews, arguing that the largely assimilated Jew familiar to Germans is unlike those in the large Jewish communities to be seen in the newly occupied territories of Poland. Documentary images show Jews crowded into ghettos, often living in poverty and squalor. The spoken commentary declares that these images "prove" that this race is a "plague that threatens the health of the Aryan people." Confinement in the ghetto was the first step towards separating this section of the population from the rest and preparing them for subsequent deportation and destruction—although these facts are not mentioned or shown in the film. *The Eternal Jew* was produced during the period when plans for the "Final Solution of the Jewish Problem" were being put in place.

The film also contrasts Jews with Aryans in terms of the economy of production and labor: Aryans craft objects and work in industry and agriculture whereas Jews are "parasites" who only deal in merchandise and money. The film presents physiognomy as evidence of deceitfulness and avarice and shows Jews pursuing power and influence in business and politics and through radical dissent: they are "foreign bodies in the organisms of their host peoples." The film names individuals and families who are rich and successful in business, politics and the arts and gives statistics for the numbers of Jewish state prosecutors, judges, lawyers, doctors and merchants. Average incomes of Jews are compared with other Germans. The film's narration suggests that Jews are ruthlessly ambitious and greedy, exploiting their host nations for the accumulation of private wealth. Large sections of the film consist of still photographs of highly successful Jewish individuals while other sequences track along rows of Jewish faces in the ghettos. All of these images are to be taken as "evidence" of racial degeneracy.

The film concludes with a sequence showing the Kosher slaughter of animals. This section of the film seems to have attracted little attention in critical scholarship but when considered in the context of biopolitics and the anthropological machine the sequence becomes highly significant. The voice over advises sensitive citizens not to watch and describes the scenes as "horrifying" but necessary to show despite accusations of "bad taste." Cows and sheep are shown having their throats cut and being left to bleed to death. Some of these animals look directly into the camera as they die. The film then goes on to describe Jewish defenses of their practices of slaughter against the Nazi campaign to have it banned. In April 1933 Hitler passed a law banning Kosher slaughter on the grounds that it was "inhumane" and "uncivilized" and requiring that all warm-blooded animals be anesthetized or unconscious before they were killed.

The selection of specific animals that can and cannot be consumed, along with distinctive practices of slaughter and food preparation, plays an important role in both Judaism and Islam. The slaughter of animals in both religions is ritualized and sacred and the method of slaughter defines the food as pure or impure. Ritual slaughter is an expression of the sovereign

power that maintains the religious identity of different communities. Indu
trialized slaughter, by contrast, forms an intrinsic part of the modern bio-
political concern with the health of human populations and the efficient
killing and consumption of animal populations. What is pure and impure in
modern capitalism takes on a specifically biological sense. The development
of industrialized and sanitized slaughter, along with the reform movements
for humane slaughter, contributed to the secularization of killing in Western
societies. But the rejection of ritual slaughter can be traced back to the early
centuries of the Christian church and became an ongoing part of anti-Se-
mitic discourse (Freidenreich 102, 110). The Nazi campaign against Kosher
slaughter as inhumane thus participated in a long anti-Semitic history and
was a direct attack on the sovereignty of Jewish law.

There is an obvious and grotesque irony in the fact that this state that
undertook the most merciless forms of mass killing of humans insisted on
the humane slaughter of animals (we have all heard of Hitler's vegetari-
anism and Himmler's attractions to Buddhism). But as with their argu-
ments for the survival of the fittest and racial purity, Nazi ideas about
humane slaughter were not unique or original but reproduced widely
accepted ideas of the time. For example, in Britain the Council of Justice
to Animals and Humane Slaughter Association during the 1930s produced
the film *Slaughter House* documenting different forms of animal killing
and arguing that the animal needed to rendered unconscious, comparing
the process to a human anesthetized during an operation. Some of the
sequences in this film are interchangeable with those used in *The Eternal
Jew*. The sequence on animal slaughter in *The Eternal Jew* is not just
about using shocking or offensive images to associate with the negative
stereotype of a particular group but is integral to the biopolitical logic of
the film's overall argument.

The mass destruction of animals that has become a hidden, everyday
feature of industrial capitalism preceded the use of industrial technolo-
gies in the service of human genocide. Nicole Shukin has argued that the
"biopolitical production of the bare life of the animal other subtends ...
the biopolitical production of the bare life of the racialized other" (10).
One of the sites where the industrial slaughter of animals intersected with
the Final Solution was the discourse about "humane" killing. The "cruel
torture" of animals in Kosher slaughter becomes, in *The Eternal Jew*, an
implicit justification for the availability of the Jews to be slaughtered. The
film closes with Hitler's speech to the Reichstag in 1939 in which he warns
that if the Jews plunge the world into another war it will mean the destruc-
tion of the Jewish race in Europe. Nazi ideology did not oppose the killing
of animals, only the supposed barbarism of the Jewish method of slaugh-
ter. Esposito proposes that Nazism did not so much "bestialize" man as
"anthropologize" the animal (*Bios* 130). The Nazi state prohibited cruelty
to animals, implying that those who were designated for extermination
were *less* than animals.

Agamben and Gesture

The use of photography and film to produce the biotype was directly aligned by the Nazi state with the actual destruction of human populations. Images of different individuals were used as evidence of their place in a biological hierarchy and of their fitness to live. Physiognomy and expression were used to incriminate entire populations. Cultural practices could also be used as anthropological evidence of primitive savagery. Another aspect of human life to be captured and harnessed by the media apparatus was gesture.

Agamben has proposed that a key concept in Foucault's understanding of power is the apparatus (*dispositif*), "a heterogeneous set that includes virtually anything, linguistic and nonlinguistic, under the same heading: discourses, institutions, buildings, laws, police measures, philosophical propositions, and so on" (*What Is an Apparatus?* 2–3). The apparatus is the network of power relations established between these heterogeneous elements. Agamben traces the origins of this term to Hegel's notion of historical religion as "the set of beliefs, rules, and rites that in a certain society and at a certain historical moment are externally imposed on individuals" (4). These historical elements constrain the freedom of man. Agamben wants to develop the distinction between these historical forms and a more primary existence of living beings (or creatures) before their capture by the apparatus. The third term is the subject which is produced through the relation of life and the apparatus. The problem for Agamben is that in advanced capitalist society apparatuses have proliferated to the extent that the individual cannot sustain independent social and political agency. For example, media technologies "capture" the individual user and transform him/her into a merely statistical entity recoded in a digital archive.

Agamben develops these themes further in his essay "Identity without the Person," in which he traces the origins of the word persona to "the ancestor's mask of wax that every patrician family kept in the atrium of its home" (*Nudities* 46). In ancient Rome slaves had no persona. In the nineteenth century a decisive shift takes place as identity becomes linked to photographic information, particularly through police mug shots of criminals. This is also the period when fingerprints begin to be classified. Agamben proposes:

> For the first time in the history of humanity, identity was no longer a function of the social "persona" and its recognition by others but rather a function of biological data, which could bear no relation to it. Human beings removed the mask that for centuries had been the basis of their recognizability in order to consign their identity to something that belongs to them in an intimate and exclusive way but with which they can no longer identify. (*Nudities* 50)

This is the transformation of social identity into "naked life, a purely biological datum" (50). More recently this has been extended through the recording of biometric and genetic information. Because it is not possible to

develop an ethical relation to biological information, as it was to one's social mask, the "new identity is an identity without the person" (52). As with every apparatus, Agamben proposes, capture by biometric identification offers its own form of human happiness—in this case to be freed from the burden of guilt associated with any social persona. The "virtual intimacy" (53) promised by the Internet and social media provides a substitute for, and escape from, earlier forms of the persona.

Agamben sees gesture as the capacity of the individual subject to communicate through embodied posture and movement and thereby to express a coherent individual self. Echoing Benjamin's analysis of the destruction of the aura by technical reproduction, Agamben argues that the individual gesture was overtaken by the emerging mass media of the late nineteenth century. The gesture that belonged to the individual was broken down into fragmentary images through photography and film. In his essay "Notes on Gesture" (1992), Agamben proposes that by the end of the nineteenth century the Western bourgeoisie had "lost its gestures" (*Means* 48). He links this transformation to the clinical studies published by neurologist Gilles de Tourette in 1886. For the first time ordinary human gestures were subject to scientific analysis. Agamben suggests that Tourette's analysis of the human step "is already a prophecy of what cinematography would later become" (49). The passage that Agamben cites from Tourette's studies resonates strongly with Benjamin's account of the optical unconscious, in which the camera reveals "what happens during the split second when a person actually takes a step" (4: 266). Tourette's studies of footprints anticipated Étienne-Jules Marey's and Edward Muybridge's later photographic studies of human motion. What would come to be called Tourette Syndrome described a breakdown of the individual's capacity to control his/her gestures; as Agamben puts it this was symptomatic of a "generalized catastrophe of the sphere of gestures" (50). Deborah Levitt suggests that we add to Agamben's list of Tourette, Muybridge and Marey, all of whom contributed to this crisis of individual agency the comparative photographic studies of criminal physiognomy by Bertillon and the industrial time and motion studies conducted by Frederic Taylor (177).

Agamben's notes on gesture also have a bearing on Charcot's studies of hysteria. The hysteric seemed possessed by the uncontrollable, compulsive gestures that became the object of the clinical gaze and, according to Foucault, a new object of scientific knowledge: the neurological body. This was a body that could only be understood through close attention to the minutiae of its movements and behaviors, which were interpreted as pathological symptoms. At Charcot's clinic the gestures of hysterics were extensively documented in photographs, many of which were made available to the public in published albums. (Albert Londe, the photographer who worked at the Salpètrière, was a friend of Marey and introduced chronophotography into the studies of patients.) We can discern, then, in Agamben's "Notes on Gesture" an historical link between the biotype and

the traumatized subject. The scientific analysis of human motion in moving pictures also allowed the promotion of human action as visual spectacle, but both tendencies in the new image culture were "traumatic" in the sense of destroying earlier forms of autonomy and agency. The impact of the image on the spectator also becomes tied to the problem of shock and attention in commodity production and consumption.

Human Motion, Shock and Industrialized Slaughter

Marey's use of the chronophotographic gun, a high speed camera that could capture the slightest details of human movement, makes him a key figure in the biopolitics of media. Marey (1830–1904) trained as a doctor and specialized in medical research on cardiology and blood circulation, which he combined with his interests in the mechanical functions of hydraulics. He saw the human body as a machine and set out to discover the laws that govern physiological processes. This led him to the study of movement. But the intricacies of human movement were not visible to the human eye. The invention of the camera provided the machine that could record movement in all its microscopic detail. Marey's early research involved graphing the cardiographic motions of a horse. In the 1860s he turned to the study of human and animal locomotion. He adopted the zoetrope, a moving cylinder that produced the visual illusion of movement, and transformed it from a form of children's entertainment to an instrument for scientific research. Using a series of drawings Marey was able to reconstruct the precise motion of a horse's trot and gallop. Marey's book *La Machine Animale* (1873) included numerous studies of animal and insect movement and flight, thereby drawing the natural world into what would become the apparatus of Taylorism, Fordism, and mass entertainment. As Jussi Parikka comments: "The disappearance of animals from the actual living worlds of urbanized Western societies was paralleled by the incorporation of animal effects and intensities in the emerging media technologies of modernity, cinema at the forefront" (17).

The first photographic studies of horses in motion were produced in 1878 by Edward Muybridge, an Englishman who had emigrated to America. In 1881, at Marey's invitation, Muybridge demonstrated his photographic research in Paris to much public acclaim. Marey developed his own prototype for photographically recording rapid motion, which he called *chronophotographie*, or time photography. Marey's photographic techniques were used in studies that measured expenditure of energy in mechanical labor. These new attempts to monitor biopower were associated with the promotion of physical education and sport in the interests of public hygiene and economic productivity. Marey's photographic studies decomposed movement into discrete gestures and transformed individual actions into graphic information. He made use of the latest developments in multiple-lens cameras and the data generated by his research was used by the French

army to determine the physical endurance of the soldier and by the French Olympic team to train its athletes. Friedrich Kittler points out that Marey's chronophotographic gun was indirectly based on the Gatling gun:

> The history of the movie camera thus coincides with the history of automatic weapons. The transport of pictures only repeats the transport of bullets. In order to focus on and fix objects moving thorough space, such as people, there are two procedures: to shoot and to film. In the principle of cinema resides mechanized death as it was invented in the nineteenth century: the death no longer of one's immediate opponent but of serial nonhumans. Colt's revolver aimed at hordes of Indians, Gatling's or maxim's machine gun … at aboriginal peoples.
>
> (Kittler 124)

The recording of movement was quickly drawn into apparatuses of disciplinary power and subsequently into the monitoring and control of entire populations, first in the colonies and subsequently in the factories of advanced industrial nations. August Chauveau, who became the director of the Institute Marey after Marey's death, conducted studies on muscular fatigue. His pupil, Jules Amar, conducted further such studies on inmates of a prison in Algiers, requiring the prisoners to carry weights up to the point of exhaustion. In 1914 Amar published the results of his research in his book *Human Motor*. As a scientist Marey was interested in using the camera to analyze movement, not to produce an illusion of movement for the purposes of entertainment. Nevertheless, Marey's serial images of bodies in motion became the earliest filmed images to be screened for the public. The Lumière brothers were familiar with Marey's work and solved the problem of how to project moving images. Marita Braun argues that the attempt to position Marey's work in competing narratives about the invention of cinema have obscured the real nature and importance of his research. As a physiologist, Braun proposes, Marey's greatest legacy is the scientific management of labor.

In his study of this history of labor management (also called *The Human Motor*) Anson Rabinbach describes the attempt in the nineteenth century to "harmonize the movements of the body with those of the industrial machine" (2). This view of the worker as an extension of the machine formed a central part of the productivist ideologies of Taylorism and Fordism, which were also to be espoused by European fascism and Soviet Communism. Photography allowed the worker's gestures to be broken down and fragmented, undermining the autonomy of productive labor. Efficiency became understood as the domain of management, based on the analysis of the worker's movements removed from the site of production. The worker lost control of the pace and output of his/her activities. Skill and experience was now subordinated to surveillance and analysis. Centralized planning and control sought to quantify and standardize labor. Frank Gilbreth, who

worked with Taylor, extended the research of pioneers such as Marey and Muybridge through photographic studies of worker's movements. The visual records of skilled workers' gestures established standards for others to follow.

Marey's chronophotographic studies of animals in motion formed a precedent for Taylorist time-motion studies of industrial labor. But the visual recording of the previously invisible movements of living creatures was historically bound to their mass destruction. The often noted application of Taylorism in Henry Ford's production of automobiles tends to forget the fact that Ford modeled his assembly-line production on those used in abattoirs since the mid-nineteenth century. Nicole Shukin proposes that the new technologies of mass slaughter constituted an early instance of "moving pictures":

> The lineaments of cinema can arguably be glimpsed in the animal disassembly lines of Chicago's stockyards, where animals were not only produced as meat but also consumed as spectacle. Under the rafters of the vertical abattoir there rolled a moving line that not only served as a technological prototype for automobile and other mass modes of production but also excited new modes of visual consumption.
>
> (Shukin 92)

At the World's Columbia Exposition in Chicago in 1893 the public could see Muybridge's zoopraxiscope, a photographic device showing animals in motion, along with Edison's kinetoscope motion picture camera. But they could also take guided tours of the Chicago stockyards. The complicity of animal slaughter with cinematic consumption goes deeper still, as Shukin notes the use of gelatin, extracted from animal skin, bone and tissue, acts as a central ingredient of photographic and film stocks.

The catastrophe in the realm of gestures identified by Agamben forms part of what he sees as the reduction of populations to a state of bare life and the ultimate catastrophe of industrial slaughter applied to human beings. The fact that assembly line production has its origins in the disassembly of animals forms one of the founding conjunctions of media, biopower and modern catastrophe. Enzo Traverso comments that it is an "irony of history" (40) that Taylorism was aimed at maximizing production while it was also applied in the Nazi process of extermination. But we must learn to see the process of taking life, essential to founding and maintaining of sovereign power, as also fundamental to modern biopolitics and the industrial economy.

The Paris slaughterhouse La Villette was opened in 1867 and played its part in the Second Empire's drive for urban modernity—the world of boulevards, arcades and department stores famously described by Benjamin in the *Passagenwerk*. Baron Haussmann incorporated the *arrondissement* also called La Villette into the city and it was characterized by industrial production, poverty and crime (Claflin 28). Mass slaughter of animals thus became a fixture of the modern metropolis. Slaughterhouses also play an

important role in biopolitics because their modernization is directly related to concerns about public health and hygiene. The gradual concealment of animal slaughter in the nineteenth century and its separation from the marketplace insulated the consumer from one of the most fundamental forms of socially acceptable violence. The ancient traditions of animal sacrifice and the everyday practices of killing and eating animals were now subject to a reorganization, a making-invisible of animal death. Meat consumption was sanitized and animal slaughter became part of the unconscious of modern urban societies.

The disappearance of animal slaughter from public life, along with the massive increase in levels of animal destruction and consumption, serves as an important case study of the reorganization of perceptions of violence in modern societies. Benjamin described how the big city dweller became immune to the shocks constantly directed at human perception by industrial technologies, rapid changes in the urban environment, and mass media. The cost of this immunity is what psychologist Robert Lifton would later call "psychic numbing." One way to extend Benjamin's theory today is to understand shock in terms of biopower. Jonathan Beller has theorized how the relation between the capitalist economy and human attention works in the case of modern media:

> The cinematic organization of attention yields a situation in which attention, in all forms imaginable and yet to be imagined (from assembly-line work to spectatorship to internet-working and beyond), is that necessary cybernetic relation to the *socius*—the totality of the social—for the production of value for late capital. At once the means and archetype for the transfer of attentional biopower (its conversion into value and surplus value) to capital, what is meant today by "the image" is a cryptic synonym for these relations of production.
>
> (Beller 4)

The monitoring, control and exploitation of human attention as biopower includes the administering of shock that demands attention but also numbs emotional and intellectual responses to violence and catastrophe. The power of the media to shock has the potential to capture human attention but also to render it unresponsive, requiring continual intensification of visual and aural impact in order to achieve the required effect.

As Jonathan Crary has explained, human attention has been subject to a series of historical transformations. In Western societies since the nineteenth century this has meant learning to focus on isolated and reduced forms of stimuli disconnected from the larger sensory environment. Just as factory workers were required to attend to specific tasks separated from the production of complete artifacts or salable goods, so did modern viewers learn to look at artworks and media texts in new ways. In the early nineteenth century, argues Crary, vision was reconfigured as embodied in the individual

observer, the subject of disciplinary power. Attention became increasingly central to social control and inattention became a social problem. Defective attention was seen as leading to cognitive failure, disruptive behavior, and deviant sensibilities. By the late nineteenth century attention had been reconceptualized as requiring exclusion of stimuli, blotting out parts of the sensory environment. Laboratory experiments were conducted measuring the capacity of individual attention to specific audiovisual stimuli.

Beller compares Ivan Pavlov's experiments with controlling physical and emotional reflexes with Taylor's *Principles of Scientific Management* (1911), which aimed to regulate human cognition and behavior for the purpose of more efficient industrial production. Just as Pavlov attempted to manipulate animal behavior by controlling sensory stimuli, Taylor attempted to manipulate human behavior through the management of industrial processes. For Pavlov the nervous system was a "medium for the translation of signaled stimuli into responses" (Beller 123). His conception of human behavior was machinic, governed by a logic of cause and effect. Taylor's concept of scientific management sought to make human productivity available for social control. Sergei Eisenstein followed Pavlov and Taylor in his conception of cinema audiences as composed of interchangeable components who could be collectively motivated by a common ideological goal and the use of visual shock.

Pavlov's experiments on dogs included electric shocks. Allan Young explains how the human subjects of shock treatment learned to associate pain with other environmental factors. Sensory stimuli associated with the memory of the shock later caused the victim to relive the distressing experience. The victim was thus conditioned to respond in two possible ways: by following routines that sought to avoid the upsetting stimuli, or assuming a completely passive attitude (psychic numbing). Young notes a third possible reaction which he links with posttraumatic stress disorder: victims seek out circumstances that repeat the original trauma. The distressing memory produces endorphins that tranquilize the subject, leading to addiction to repetitive behavior ("Suffering" 257–258). In this way the solicitation of attention through shock functions in a biopolitical economy of the image and produces a traumatized spectator-subject.

Beller proposes that the proliferation of visual media over the past 150 years has impacted the social imagination to the point where "the entire history of modernity stands ready for a thorough reconceptualization as the consequence of the trauma of filmic practice" (6). With the incorporation of visual experience in the organization of both labor and leisure in industrial societies, argues Beller, the subject encounters his/her self-image in a technological form that ruptures earlier linguistic structures. The capture of human attention is "traumatic," giving rise to an endless series of media images that hold the spectator in place as the member of an imagined community or social network.

The recording and analysis and subsequent prescribing and management of workers' movements formed part of a biopolitical apparatus that included

the capture of viewer attention. The violence that was being channeled into the industrialized slaughter of animals and technological warfare was also an ingredient in capturing and directing the attention of media viewers. The "traumatic" dimension of this historical shift included the loss of autonomy in human labor but also an addiction to stimuli that previously might have been seen as distressing or intrusive. The "traumatic" image assumed a narcotizing function, numbing the consumer subject in an increasingly hyper-stimulating environment.

Throat Cutting in *Shoah*

Whereas modernists like Eisenstein embraced Taylorism and pursued the scientific management of audience response through visual stimuli, subsequent filmmakers have attended to the traumatic consequences of the industrialization of experience and perception. Alain Resnais used experimental montage in *Night and Fog* (1955) to convey the traumatic shock of the Nazi camps (discussed further in Chapter Three). This montage of archival images was accompanied by survivor Jean Cayrol's commentary, which often paused to meditate on the inadequacy of these images to communicate the experience of the victims. Rejecting any use of archival images in his long documentary *Shoah*, Claude Lanzmann turned instead to the embodied testimony of survivors and witnesses to recover the horrors of the mass extermination process. I now want to use Agamben's conception of the cinematic gesture to develop a new reading of one specific gesture in *Shoah*. As Sue Vice notes, although the film is about extreme events it reveals them in the form of the ordinary details of everyday life. Eschewing many of the conventions of documentary, including narrative voiceover, archival footage and musical soundtrack, *Shoah* employs staging that "enables authenticity of recall" (Vice 27). One medium of this return of the past in the immediacy of the present is gesture.

Lanzmann recovers a gesture never recorded previously on film that nevertheless had been repeated countless times during the process of mass murder and could now be recalled by the few surviving witnesses: the gesture of the forefinger drawn across the throat made by the Polish farmers standing by the railroad tracks outside the Treblinka death camp and seen by the Jews imprisoned in the boxcars. The gesture is enacted by the Polish witnesses creating an uncanny effect. Departing from the grainy black and white photographs and film footage that we usually associate with the Holocaust, the events are reincarnated in the gesture of the farmer who again stands in the same field where he worked and recalls, as if it were yesterday, events from thirty years earlier. The gesture is part of the long memory of an individual and located in a place and society that appears in *Shoah* to have changed little since the time of the exterminations. Perhaps there is an even longer history of anti-Semitism also invoked in this gesture. The farmers use a gesture that conveys the process of agricultural slaughter: cutting an animal's throat. But this will not be the fate of the human

victims to whom the gesture is directed, most of whom will be killed in the gas chambers. So there is a disconnection between the gesture, performed as part of agricultural labor, and the industrial machinery of death that has already captured the victims. The throat cutting gesture is not fully part of the machinic speed and scope of mass murder, yet in its repetition for a "captive audience"—both those in the trains and those who later witness the gestures on screen—it does participate in this biopolitical economy.

The testimony of the Polish farmers in *Shoah* shows how the Nazi machinery of death formed part of everyday life and was witnessed as a familiar spectacle of mass deportation and killing of humans—as unremarkable as if these were cattle cars going to the slaughterhouse. As in the sequence on Kosher slaughter in *The Eternal Jew*, there is a disturbing irony in the juxtaposition of the traditional killing of animals with the industrialized process of genocide. The throat cutting gesture performed for the camera in *Shoah* and the recording on film of animal slaughter both have a biopolitical significance that exceeds the very different intentions of the filmmakers. These very different, indeed antithetical, films both show how life and death are embedded in technologies and economies of production, consumption and destruction. Both films also can now be related retrospectively to the return of capital punishment as visual spectacle in the decapitation videos released on the Internet.

Necropower and Decapitation

Achille Mbembe, like Agamben, has emphasized the power over life and death as the essence of sovereignty. He contests theories of sovereignty that conceive of society in terms of relations between self-conscious autonomous individuals exercising freedom of choice and engaging in rational communication. This "normative" (13) reading of sovereignty does not take into account the instrumental uses of reason employed to dominate and destroy human populations. Mbembe extends Foucault's conception of racism, in which human populations are subdivided into groups through the establishment of a biological caesura, in his own theory of "necropower" (27). The most radical example of modern necropower is the Nazi state with its explicit policies and bureaucratic administration of human extermination. But Nazi violence can be seen as part of a larger history that includes colonialism, imperialism and racialization of class conflict in industrial urban societies.

The power over life and death is extended through the recording and repeating of images of killing. The spectacular use of torture and execution that Foucault associated with traditional sovereign power is transformed in industrialized, technologically mediated societies. The visibility or invisibility of death takes on a biopolitical significance. When the Japanese photographed their mass executions—including decapitations—of the Chinese in Nanking the visual documentation was an extension of mass terror. It was only when the images were published in the world press that they began to

see them as damaging their international standing. Photographs of atrocity in non-Western countries quickly became available in Western newspapers, but the realities of mass death and destruction in World War I were censored by European governments. Only later did the German anarchist Ernst Friedrich produce his montage of war photographs, *War Against War!*, which included mass executions, mass graves of soldiers stripped of clothing and belongings, victims of the Armenian genocide, and portraits of soldiers with hideous facial injuries. The publication of these previously censored images was intended to mobilize antiwar sentiment. Needless to say, his activities were later suppressed by the Nazis. The post–World War II period has seen an ongoing struggle between state censorship and open publication of atrocity images. While the horrors of the Nazi death camps were widely publicized, visual evidence of the effects of the bombing of Hiroshima was confiscated and hidden. Photojournalism and television news showed American atrocities in Vietnam but the media coverage of the Falklands and Gulf Wars was tightly controlled. The Internet has once again transformed the political struggle over the visibility of atrocity.

In the contemporary era, global hegemony is maintained through technological superiority in weaponry, mobility and communications. Territories need no longer be conquered and administered as in the era of European colonialism and imperialism, but are subjugated through high-speed military exercises that destroy the enemy's infrastructure and inflict "collateral damage" on whatever human populations get in the way. As sovereign territories are attacked and destroyed, they fragment into mobile and transitory multitudes of refugees and stateless people. But political movements of resistance against Western economic and military power, particularly in the Middle East, have developed strategies of propaganda and terror that oppose high-tech weaponry with older forms of violence. Public execution on video functions as a reassertion of Islamic sovereignty within the technological apparatus of Western capitalism (I discuss these videos further in Chapter Five).

Several decapitation videos were released on the Internet in 2004. Before this an earlier video had shown Daniel Pearl, a reporter, lying on the ground having his throat cut and head removed with a large knife. The decapitated head was then lifted and shown to the camera. The 2004 examples follow a more formal presentation. The victim is clothed in orange robes (evoking the prisoners in Guantánamo Bay). Prisoner Nick Berg is first shown sitting in a chair addressing the camera. The video then cuts to show the prisoner sitting on the floor with five hooded men standing behind him. One reads out a statement. Then the prisoner is lain on the floor, held down and decapitated with a knife. The head is then raised and shown to the camera. Another video presented archival news images of children killed or maimed by American bombs, after which the prisoner Paul Johnston is killed in the same manner as Nick Berg. Other victims include Eugene Armstrong, Jack Hensley, Kenneth Bigley and Shosei Kody. The videos showing their deaths

are very graphic, recalling the slaughter of animals. The decapitated heads are placed on the torsos of their lifeless bodies.

In 2014 the presentation of decapitation changed in a series of videos produced by ISIS. In these videos the prisoners are again clothed in orange gowns. They appear in front of a desert landscape with a single hooded figure standing behind them. The video includes a clear statement that the execution is a response to Barack Obama's authorizing of military operations against Islamic State. The prisoner reads a statement. James Foley denounces U.S. foreign policy as the cause of the deaths of innocent civilians. The video cuts at the moment of execution and then shows the decapitated head. It seems significant the two of the victims. David Haines and Alan Henning, were both British aid workers. Their execution clearly associates Western humanitarianism with the apparatus of military intervention. The prisoners denounce British Prime Minister David Cameron for his coalition with the United States. Pater Kassig, an American aid worker, is also executed.[1]

Biopolitical power quantifies and evaluates life in terms of species. One of the most fundamental ways it does this is by defining the distinction between man and animal, which also serves as basis for formulating racial difference. Society, conceived in terms of superior and inferior races is "purified" and made healthy by expelling or killing "lower" forms of life. At first there appears to be something different going on in the decapitation videos produced in the Middle East: the Western victims are slaughtered like animals, and yet the ritualized style of killing reasserts the traditional sovereignty of Islam and makes a claim for legitimate statehood. The Western prisoner is killed to atone for the acts of his own country's government. The decapitation is presented as an act of political justice and retaliation against the crimes of the enemy state. As a propaganda image the decapitation video is horribly eloquent and stands in clear contrast with the often careless or deliberate destruction of innocent civilians by Western weapons of mass destruction. For Western powers enemy populations must be eliminated when they constitute a threat to the body politic. The violence perpetrated by Western governments against enemy populations is usually deliberately concealed from the public.

The terms of biopolitics have been transformed under the changing conditions of the global economy and information networks. Corporations, financial and political institutions, along with new forms of resistance to these entities, now work in ways that are increasingly multi- or transnational. The borders between nations have sites of greater instability and anxiety, resulting in new forms of monitoring and surveillance. The ability of video texts to cross state borders and to openly challenge state sovereignty is a significant new feature of the political imagescape. The destruction and disposal of enemy populations often kept invisible by corporate media is now faced with focused images of acts of violence that wield symbolic power and redefine the relation between, life, death and media. As we have seen in this chapter, however, the act of killing and spectacle have a complex historical

relationship. Western viewers have long been accustomed to shocking images aimed to capture their attention. The decapitation videos appear to restore traditional sovereign power but they intervene in a biopolitical mediascape. In doing so they reproduce the terms of bare life against which they claim to present a symbolic challenge.

Note

1. Most of these execution videos are available to be viewed on the Web on LiveLeak. com and other sites.

Works Cited

Agamben, Giorgio. *Homo Sacer: Sovereign Power and Bare Life*. Trans. Daniel Heller-Roazen. Stanford: Stanford UP, 1998.

———. *Nudities*. Trans. David Kashik and Stefan Pedatella. Stanford: Stanford UP, 2011.

———. *What Is an Apparatus? And Other Essays*. Trans. David Kashik and Stefan Pedatella. Stanford: Stanford UP, 2009.

———. *The Open: Man and Animal*. Trans. Kevin Attell. Stanford: Stanford UP, 2004.

———. *Remnants of Auschwitz: The Witness and the Archive*. Trans. Daniel Heller-Roazen. New York: Zone, 2002.

———. *Means without Ends: Notes on Politics*. Trans. Vincenzo Binetti and Caesare Casarino. Minneapolis: U of Minnesota P, 2000.

Amar, Jules. *Human Motor: or the Scientific Foundations of Labour and Industry*. Trans. Elsie P. Butterworth and George E. Wright. New York: Dutton, 1920.

Arendt, Hannah. *The Human Condition*. Chicago and London: U Chicago P, 1958.

Beller, Jonathan. *The Cinematic Mode of Production: Attention Economy and the Society of the Spectacle*. Hanover and London: UP of New England, 2006.

Braun, Marta. *Picturing Time: The Work of Etienne-Jules Marey (1830–1904)*. Chicago and London: U Chicago P, 1992.

Cain, Joe. "Introduction." Charles Darwin, *The Expression of the Emotions in Man and Animals*. Eds. Joe Cain and Sharon Messenger. London: Penguin, 2009. xi–xxxiv.

Claflin, Kyri. "La Villette: City of Blood (1867–1914)." *Meat, Modernity, and the Rise of the Slaughterhouse*. Ed. Paula Young Lee. Durham, NH: U New Hampshire P, 2008. 27–45.

Crary, Jonathan. *Suspensions of Perception: Attention, Spectacle, and Modern Culture*. Cambridge, MA: MIT Press, 1999.

Darwin, Charles. *The Expression of the Emotions in Man and Animals*. Ed. Joe Cain and Sharon Messenger. London: Penguin, 2009

Didi-Huberman, Georges. *Invention of Hysteria: Charcot and the Photographic Iconography of the Salpêtrière*. Trans. Alisa Hartz. Cambridge, MA; London: MIT Press, 2003.

Dillon, Michael. "Security, Race and War." *Foucault on Politics, Security and War*. Ed. Michael Dillon and Andrew W. Neal. Hampshire, NY: Palgrave MacMillan, 2008. 166–205.

Ellenbogen, Josh. *Reasoned and Unreasoned Images: The Photography of Bertillon, Galton, and Marey*. University Park: Pennsylvania State UP, 2012.

Felman, Shoshanna, and Dori Laub. *Testimony: Crises of Witnessing in Literature, Psychoanalysis and History*. New York: Routledge, 1992.

Foucault, Michel. *Discipline and Punish: The Birth of the Prison*. Trans. Alan Sheridan. London: Penguin, 1991.

———. *Security, Territory, Population: Lectures at the Collège de France, 1977–78*. Ed. Michel Senellart. Trans. Graham Burchell. Hampshire, NY: Palgrave MacMillan, 2007.

———. *Psychiatric Power: Lectures at the Collège de France, 1973–74*. Ed. Jacques Lagrange. Trans. Graham Burchell. Hampshire, NY: Palgrave MacMillan, 2006.

———. *"Society Must be Defended": Lectures at the Collège de France, 1975–76*. Ed. Mauro Bertani and Alessandro Fontana. Trans. David Macey. New York: Picador, 2003.

———, *The History of Sexuality Volume One: The Will to Knowledge*. Trans. Robert Hurley. Harmondsworth: Penguin, 1998.

Friedrich, Ernst. *War Against War!* Seattle: Real Comet Press, 1987.

Hardt, Michael, and Antonio Negri. *Commonwealth*. Cambridge, MA: Harvard UP, 2009.

———. *Multitude: War and Democracy in the Age of Empire*. London: Penguin, 2006.

———. *Empire*. Cambridge, MA: Harvard UP, 2000.

Hirsch, Joshua. *After Image: Film, Trauma and the Holocaust*. Philadelphia: Temple UP, 2004.

Kittler, Friedrich. *Optical Media: Berlin Lectures 1999*. Trans. Anthony Enns. Cambridge, UK: Polity, 2010.

LaCapra, Dominick. *History and Memory after Auschwitz*. Ithaca, NY, and London: Cornell UP, 1998.

Lalvani, Suren. *Photography, Vision, and the Production of Modern Bodies*. New York: State U New York P, 1996.

Lanzmann, Claude. *The Pantagonian Hare: A Memoir*. Trans. Frank Wynne. London: Atlantic, 2012.

Lemke, Thomas. *Biopolitics: An Advanced Introduction*. Trans. Eric Frederick Trump. New York and London: New York UP, 2011.

Levitt, Deborah. "Notes on Media and Biopolitics: 'Notes on Gesture.'" *The Work of Giorgio Agamben: Law, Literature, Life*. Ed. Justin Clemens, Nicholas Heron, and Alex Murray. Edinburgh UP, 2008. 193–211.

Lundemo, Trond. "Montage and the Dark Margin of the Archive." *Cinema and Agamben: Ethics, Biopolitics and the Moving Image*. Ed. Asbjorn Gronstad and Henrik Gustafson. New York: Bloomsbury, 2014. 191–205.

Mbembe, Achille. "Necropolitics." Trans. Libby Meintjes. *Public Culture* 15.1 (2003): 11–40.

Mitchell, W.J.T. *Cloning Terror: The War of Images, 9/11 to the Present*. Chicago and London: U Chicago P, 2011.

Mosse, George L. *Toward the Final Solution: A History of European Racism*. London: Dent, 1978.

Nadesan, Majia Holmer. *Governmentality, Biopower, and Everyday Life*. New York and London: Routledge, 2008.

Pacyga, Dominic A. "Chicago: Slaughterhouse for the World." *Meat, Modernity, and the Rise of the Slaughterhouse*. Ed. Paula Young Lee. Durham, NH: U New Hampshire P, 2008. 153–166.

Parikka, Jussi. *Insect Media: An Archaeology of Animals and Technology*. Minneapolis: U Minnesota P, 2010.

Patterson, Charles. *Eternal Treblinka: Our Treatment of Animals and the Holocaust*. New York: Lantern, 2002.

Rabinbach, Anson. *The Human Motor: Energy, Fatigue, and the Origins of Modernity*. Berkeley, Los Angeles: U California P, 1990.

Sekula, Allan. "The Body and the Archive." *October* 39 (1986): 3–64.

Shukin, Nocole. *Animal Capital: Rendering Life in Biopolitical Times*. Minneapolis, London: U Minnesota P, 2009.

Tagg, John. *The Burden of Representation: Essays on Photographies and Histories*. Minneapolis: U Minnesota P, 1988.

Taylor, Frederick Winslow. *The Principles of Scientific Management*. New York: Harper and Row, 1911.

Traverso, Enzo. *The Origins of Nazi Violence*. Trans. Janet Lloyd. New York: Free Press, 2003.

Väliaho, Pasi. "Biopolitics of Gesture: Cinema and the Neurological Body." *Cinema and Agamben: Ethics, Biopolitics and the Moving Image*. Ed. Asbjorn Gronstad and Henrik Gustafson. New York: Bloomsbury, 2014. 103–120.

———. *Mapping the Moving Image: Gesture, Thought and Cinema Circa 1900*. Amsterdam: Amsterdam UP, 2010.

Vice, Sue. *Shoah*. Hampshire and New York: Palgrave MacMillan, 2011.

Young, Allan. "Suffering and the Origins of Traumatic Memory." *Social Suffering*. Eds. Arthur Kelinman, Veena Das, and Margaret Lock. Berkeley, Los Angeles, and London: U California P, 1977. 245–260.

2 Natural History and Nazi Media

The Nazi state is notorious for its deployment of mass media for the purposes of propaganda, social control and the dissemination of racist ideology. Agamben and Esposito have discussed the Third Reich as the most extreme application of biopolitics by a modern state[1] but have not included media in their analysis. Understanding Nazi uses of media as part of the biopolitical apparatus allows us to move beyond some of the interpretive frames that have dominated discussions in this area. Nazi media have long served as a paradigmatic example of propaganda in a totalitarian state.[2] The Nazis also extensively documented the destruction of the Jews and these images are now most often viewed in the context of commemorating the Holocaust.[3] Almost all of the photographs and films that document the Final Solution were produced by the perpetrators. This has prompted debates about the role of the images witnessing these events and whether they can adequately communicate the experience of the victims.

To approach Nazi media as biopolitical is to inquire into the relations between catastrophe and technology, and the uses of media to preserve immunity and to produce bare life. None of these aspects of media are unique features of totalitarian states or the Holocaust, but continue to play a key role in contemporary capitalist democracies. This chapter considers some images produced by the Nazi state and extends the analysis of biopolitical media through a dialogue with Walter Benjamin's theory of natural history. Benjamin's meditations on media, catastrophe and creaturely life provide important perspectives on both Nazi propaganda and the documentation of the Final Solution. Benjamin's writings, approached through theories of biopolitics, allow us to see Nazi media as part of a longer historical continuum from the nineteenth century to the present day. Chapter One showed how the media transmission of shock was related to research conducted on animals and the spectacle of industrialized slaughter. The production of the media viewer as a "traumatized" subject is based on the dependence on excessive stimuli to maintain attention and the spectacle of mass destruction to reinforce a sense of immunity. Benjamin wrote that fascist aesthetics had extended these forms of self-alienation to the point where the subject "can experience its own annihilation as a supreme aesthetic pleasure" (4 270). In contrast to the Nazi idealization of the master race and its suicidal obsession with political immunity, Benjamin showed how natural life

is embedded in technological change and historical catastrophe. His writings contain a meditation on the failure of biology to serve as a basis for politics and explain how media images emerge from the historical relation between technology and creaturely life. His insights on modern visual media, produced under the threat of his own destruction by the Third Reich, revealed problems and possibilities that remain with us today.

Benjamin and Biopolitics

Agamben has shown how the apparently very different theories of Foucault and Benjamin are linked through the question of sovereignty: Foucault provided an account of the historical transition from traditional sovereignty to disciplinary power and biopower, but Benjamin grasped the relation between the political state of emergency and historical catastrophe. When Hitler legislated emergency powers in 1933 he assumed absolute sovereign power over the German nation. In his final essay "On the Concept of History" (1940), Benjamin wrote of a need to bring about a "real state of emergency" (4 392) in the struggle against fascism. This is because the sovereign power that declares a state of emergency is "not the exception but the rule" (392). Agamben extends Benjamin's claim by arguing that sovereign power was always already biopolitical. The violence that underpins sovereign power and its visibility remains a central feature of global politics today. For these reasons Nazism continues to provide instructive examples of biopolitical media and Benjamin's writings continue to suggest fruitful ways to understand their significance.

This chapter proposes that Benjamin's conceptions of natural history and creaturely life are central to his widely influential writings on modern media. Although the question of natural history has been explored in Benjamin's work, particularly by Susan Buck-Morss and, more recently, Eric Santner and others,[4] it has not yet received much attention in film and media studies. In fact the widely discussed and often cited passages about photography and film in Benjamin's essays on mechanical reproduction and Charles Baudelaire have their roots in earlier of his writings that explicitly use natural history as a model for understanding historical catastrophe and technological change. For Benjamin the impact of rapid technological change is always potentially catastrophic, but media produce images that also serve as a protective shield against deeper sensory or psychological damage. Benjamin's writings on media address all of the central problems and concerns of this book: the historical experience of catastrophe; the production of immunity by the media apparatus; and the reduction of the political subject to bare life.

As Foucault explained, the emergence of modern biology marked the end of natural history. Natural history had attempted to classify natural forms, but biology would seek to understand the more fundamental life forces that animated these forms. Although natural history had become a somewhat archaic term by the 1930s, Benjamin (and, under Benjamin's influence, Theodor Adorno)[5] remotivated it as a part of a critique of modernity. In

particular Benjamin used the concept of natural history to show how human perception is impacted by technological change, which he compared to geological shifts and catastrophic upheavals. For Benjamin natural life was subject to the forces of history and catastrophic change that discarded systems of knowledge like fossilized forms of life. Benjamin's focus on historical catastrophe undermined the claims of biology as a basis of politics. Biology was used by the Nazis to justify the natural superiority of particular groups and the destruction of "degenerate" elements in the population. They used the new media of photography and film to disseminate images of those deemed fit or unfit to live. Whereas the Nazis defined various groups as "subhuman," Benjamin developed the notion of "the creaturely" to describe the ways that life is engendered by historical and political forces.

This chapter pursues two particular trajectories through Benjamin's natural history of media: it looks at how specific images reveal the inscription of history on natural or creaturely life and it shows how Benjamin's concept of history as catastrophe is linked to his theorization of modernity and shock. Benjamin's analysis of how the modern metropolitan subject is immunized against shock by media is a clear example of how natural life adapts to non-natural environments and to the technological enhancement of perception. Darwin's evolutionary theory was used to support Eurocentric narratives of historical progress and racial superiority and to justify Nazi genocide. Benjamin's natural history of media showed how narcissistic images of the master race were embedded in a technological apparatus and a catastrophic unleashing of unmastered technological power.

Nazi propaganda disseminated images of physical beauty and collective mobilization. Through photography and film the physical force of the body, previously celebrated in painting and sculpture, was made visible for a new mass public. This also helped to draw natural life in an unprecedented way into the political realm. Benjamin perceived the catastrophic implications of this aestheticization and biologization of politics. Although he did not live to see them, the images that the Nazis produced of their own tortures, massacres and processes of extermination revealed the camera's role in the biopolitical production and destruction of bare life. Benjamin's analyses of photography and film as functioning as a protective shield against shock allows us to see the images produced by the perpetrators of the Final Solution in their larger natural-historical context. Biopolitical images of the master race were designed to both conceal and justify the naked violence unleashed by the genocidal state. Today we can see the idealized Aryan body and the bodies of Nazism's victims as both forms of bare life.

Natural History and Biopolitics

In order to grasp the importance of Benjamin's criticism for a biopolitical understanding of modern media we need first to consider the historical relationship between natural history and biology and the influence of biological

science on modern thought. Jean Baptiste Lamarck first proposed "biology" as a term for the science of life in 1802, marking what Foucault called an epistemic shift from "natural history." This earlier study of nature was concerned primarily with the taxonomy of life forms. Biology moved beyond this mode of classification by analyzing the underlying laws that shape life itself. In medicine there was a corresponding shift from classifying disease to diagnosing the vital forces in the patient's body. The life of both the individual and society were reimagined in terms of an overall organic unity. The philosophical movement that emerged from this epistemological revolution was vitalism (Rose 42–43). The concept of Life as a dynamic force became central to modern biology. Vital energies were thought to animate and exceed the limits of individual organisms. The emergence of genetic science, questions of hereditary characteristics and arguments in favor of eugenic interventions led to a shift of focus from individual bodies to large populations.

This biological conception of Life as a vital force animating entire populations influenced modern European philosophy. In the late nineteenth century Nietzsche characterized the modern European masses as following a morality of the herd-animal, whereas those pursuing the will-to-power behaved like beasts of prey. Nietzsche was aligned in proto-fascist thought with Social Darwinist notions of the triumph of the life instinct and the higher species. In opposition to the rise of socialism, Nietzsche espoused a biological conception of history in which the strong, predatory type triumphed over the weak, anxious moralist. The strength of the superior races lay in their ability to draw on the their primal instinct for violent domination. Aspects of Nietzsche's philosophy anticipated the period of high imperialism and were eagerly adapted by the Nazis to justify their genocidal policies (Woods 32–37).

Nazi biopolitics was also influenced by Social Darwinism. Darwin's theory of evolution undermined the distinction between the historical and natural worlds by showing that nature itself developed over time rather than simply repeating cycles of birth, death and seasonal change. Darwin's theory, however, was distorted by the ideology of Social Darwinism, which applied the theory of evolution to justify capitalism and imperialism as the natural state of social relations and explained the dominance of specific social groups in pseudoscientific terms. Hannah Arendt explained Darwin's true significance for rethinking the relation between nature and history:

> Darwin's introduction of the concept of development into nature, his insistence that, at least in the field of biology, natural movement is not circular but unilinear, moving in an infinitely progressing direction, means in fact that nature is, as it were, being swept into history, that natural life is considered to be historical. (*Origins* 463)

Arendt noted the influence of Darwin on Marx as part of her argument that the ideologies of racism and class struggle both justified absolute power and

terror in the name of the laws of natural and historical progress. Foucault developed a similar point when he described the emergence of biopolitics in the eighteenth century. This new form of power was applied not so much to the individual as to the human species (*"Society"* 242). Entire populations were viewed as sources of productive energy that could be weakened by physical illness, injury or mental pathologies. Foucault emphasized the collecting and analysis of information and the formation of predictions and policies that led to interventions in the biological health of populations. Biopower is regulatory, controlling and normalizing. For Foucault this inevitably inclined the state toward racism:

> It is a way of separating out the groups that exist within a population. It is, in short, a way of establishing a biological-type caesura within a population that appears to be a biological domain. (*"Society"* 255)

Foucault formulated biopolitics in terms of classification and categorization, bound to forms of social inclusion and exclusion, whereas Arendt stressed the historical narratives of evolution and struggle in mass ideologies. Both saw modern power as embedded in biological conceptions of racial difference.

The importance of Benjamin's contribution to this rethinking of nature and history, biology and power, lies in his attention to the fragmentary, microscopic forms in which life manifests the traces of social and political change. As opposed to the heroic, monumental images of Nazi racism, Benjamin illuminated the zones where nature and culture, human and animal became indistinct. Like a natural historian, Benjamin's gaze was fixed on the fossils of biological life that merged with the ruins of culture. He invoked landscapes disfigured by the traces of catastrophe. The capture of natural life by historical change is manifest in images that must be removed from narratives of historical progress and species survival in order to reveal the distinctive variations and possibilities of creaturely life.

The connections between Benjamin's theories and Nazi biopolitics were first noted by Agamben with reference to Benjamin's critique of sovereignty and political violence (*Homo Sacer* 63–67, *State of Emergency* 52–64). Underlying this historical relation between Benjamin's thought and Nazism is the late-nineteenth and early-twentieth century movement *Lebensphilosophie*—the philosophy of life (or vitalism) that was transformed by Nazi discourse into biopolitics. Nitzan Lebovic has argued that theorists of biopolitics such as Foucault and Agamben have tended to neglect *Lebensphilosophie*, despite its extensive influence on Nazi racial politics. *Lebensphilosophie* has its roots in nineteenth-century philosophy and was radicalized after World War I by theorists on both the right and left, including Ernst Jünger, Martin Heidegger, Georg Simmel, Ludwig Klages and, of course, Benjamin. The crisis of democracy in 1920s Germany was reflected in these thinkers who challenged liberal humanist assumptions with more dynamic visions of instinct, existence, and technology.

Benjamin's natural history of media is one of the things that distinguish his approach from Marxist ideology critique, despite the influence of Georg Lukács on his thought. For Lukács *Lebensphilosophie* and Nazi racial theory were understood as ideological reactions against the advance of socialism and democracy: vitalism and racism were irrational and pseudoscientific and inherently opposed to rational and progressive social change. Racism served as an apology for imperialism and thereby also for capitalism and was used by Nazi propaganda as part of a cynical manipulation of reactionary impulses. The dogmatism of racial theory was the basis of its hold on the imagination of the masses. Whereas Lukács opposed vitalism to socialist enlightenment, Benjamin rejected any model of history as progress. Natural history and creaturely life revealed human culture and representation as manifesting processes of decay and mutation but also utopian potential.

There is little evidence in Benjamin's writings of any direct critique of European racism. An unexpected confirmation of Benjamin's thought for understanding biopolitics, however, can be found in Foucault's account of race. Foucault stepped away from the question of ideology and mass psychology and explained the Nazi state as a unique combination of absolute sovereign power and the technologies of biopower. But for Foucault racism was by the nineteenth century already a feature of a more general restructuring of society. Foucault distinguished two discourses on race: the first (which he sees emerging in the seventeenth century) was related to the struggle of nationalist movements against the Austro-Hungarian and Russian empires; the second was a discourse of class struggle that was nevertheless based on a conception of evolution and survival of the fittest. The first was waged on behalf of decentered groups, whereas the second became the discourse of centralized power. Once the second discourse of biological-social racism was established then, in Foucault's phrase, "society must be defended" against biological threats of degenerate elements. The other tradition, which Foucault calls the discourse of racial struggle, broke with the mode of sovereignty that had identified the people with the monarchy. History conceived as a racial struggle turned instead to what Benjamin called the "tradition of the oppressed" (4 392) and as Foucault noted was "much closer to the mythico-religious discourse of the Jews" (71): a counterhistory that drew from the Bible to articulate its opposition to the injustices and despotism of sovereign power.

This counterhistory challenged the legitimacy of sovereign power by revealing the violent struggles upon which it is founded. The idea of revolution, argued Foucault, is bound to this counterhistory. Against the tradition of the oppressed the Nazi state aligned Jewish culture with the claims of the dead and Aryan culture with the affirmation of life. From the Nazi perspective, explains Lebovic:

> *Lebensphilosophie* viewed Jewish thought as a destructive epistemology opposed to the ontology of life (or its fragmented temporality), a negative power much greater than any natural and instinctive violence.

Taken from this set of concepts, the figure of the Jew becomes the most decisive element for an ontology of biopolitical images.

(Lebovic 205)

Esposito develops this point further in his account of Nazi biopolitics:

> All those authors who have implicitly or explicitly insisted on the bio-political characterization of Nazism converge around this thesis: it is the growing implication between politics and life that introduces into the latter the normative caesura between those who need to live and those who need to die. What the immunitary paradigm adds is the recognition of the homeopathic tonality that Nazi therapy assumes. The disease against which the Nazis fight to the death is none other than death itself. What they want to kill in the Jew and in all human types like them isn't life, but the presence in life of death … (*Bios* 137)

For Benjamin the tradition of Jewish messianism combined with revolutionary politics presented an alternative to the violence of sovereign power and the biopolitical control of life. Against the Nazi model of vitality overcoming degeneracy, Benjamin remotivated the petrified traces of life, its decayed materiality and creaturely mutability.

Benjamin and the Creaturely

In Benjamin's writings questions of natural history, technological media and totalitarian power converge, allowing us to see the political incorporation of biological life in the "image worlds" of early photography and film. The Third Reich presented its subjects with a spectacular self-image in the new media of photography and film. The projection of giant images of the Nazi leadership and mass movement made possible by the cinema defined a new collective identity. The question of creaturely life that runs through Benjamin's various writings challenged this biological narcissism.

Darwin's evolutionary theory led to a reconceptualization of the relation between humans and animals. Instead of unchanging species, life was seen as composed of "historical creatures" (Richards 10). Once animals had been recognized as the biological ancestors of humans, the notion of animal instincts buried in the human unconscious became possible—thus Darwin's profound influence on Freud. This undermined the Enlightenment emphasis on reason as the distinguishing feature of human cognition. The understanding of humans as driven by instinctive anxieties and impulses also supported approaches to mass media as a form of social control. As Akira Lippit has noted, however, the relation between technological media and animal life is more complex than any simple model of "repression" or "manipulation":

> One finds, by the latter half of the nineteenth century, a set of terms—animal, photograph, unconscious—coalescing to form a distinct

topology. Each term defines or portrays a distinct locus of being that cannot be inhabited by the subject. It is, nonetheless, a place of being or becoming. Animals and photographs can be seen as resembling versions of the unconscious.

<div style="text-align: right">(Lippit 177)</div>

She goes on to mention Benjamin's notion of an "optical unconscious" as forming part of this constellation of concepts. What is distinctive about Benjamin's intervention in this conceptualization of the unconscious is his historical understanding of technology. For Benjamin, along with other thinkers of the period such as Jünger, Heidegger and Jacob von Uexküll, media technologies exceed and potentially undermine the limits of human consciousness and individual subjecthood. For Benjamin technology did not so much control life as allow it to mutate into new forms.

Although Benjamin shares with other thinkers of the '20s and '30s a concern with the unconscious forces shaping perception, he does not celebrate the survival of the fittest but considers how human life is embedded in the materiality of both nature and culture. Like animals that adapt to the environment, humans transform and extend their perceptions through technologies such as the camera. The "optical unconscious" was created through the ability of the camera to enlarge reality and expose microscopic detail previously unavailable to the human eye. Just as the microscope revealed forms of biological life that were previously unknown, the camera—in close-ups and slow-motion—showed human life dressed in clothing, inhabiting domestic environments, and enclosed by architecture.

Against the subjection of the individual to the metanarrative of species evolution, Benjamin returned to the more proper scientific impulse of uncovering the life history of texts, artifacts and representations revealed in microscopic detail. In the decayed and disintegrating remains of human society and culture the historical processes of transformation and struggle had left their traces. Benjamin looked for these traces in premodern taxonomies of natural life at the same time as he responded to modern technological developments in media and optics. The 1930s saw the revelation of new visual worlds of microscopic detail, which in biology meant a shift of attention to the molecular level of life (Rose 44). The photographers whose work Benjamin celebrated, such as Karl Blossfeldt and August Sander, exhibited a mix of archaic and futurist tendencies: they presented their studies of plant and human physiognomy as a natural history of types, but their gaze was also formed by the technological capabilities of photography to enhance human perception.

Eric Santner explains the idea of the creaturely in Benjamin as a product of "the threshold where life becomes a matter of politics and politics comes to inform the very matter and materiality of life" (*Creaturely* 12). Creaturely life is produced by sovereign power and the boundary marking the inclusion or exclusion in social and species life—the site where the human subject is inscribed in the political and symbolic order. In Benjamin's conception of

natural history the symbolic order can become dissociated from social life, surviving in the form of enigmatic ruins. The ruin persists as the trace of historical catastrophe, revealing the violence through which the political order inscribes itself on the bodies of the living. Just as the processes of biological evolution could be discerned in the fossils of animal and plant life, the political transformations of the human subject can also be excavated in the remains of social and cultural life. These ruins and remains have also eroded the boundary between nature and culture and reveal, through a reverse process of decay, the capture of life by institutions, technologies and discourses of power.

Benjamin was defining his philosophical and political position in the context of German Romanticism. The German *Naturephilosophie* of the eighteenth century, influenced by Kant, Schelling and Goethe, understood nature as composed of organic archetypes. Nature was a "cosmos": "a harmoniously unified network of integrally related parts" (Richards 10). Rejecting both the mechanistic model of Newtonian science and the notion of a divine plan, *Naturephilosophie* saw nature as self-generating and historically dynamic. The Romantic aesthetic concept of the symbol corresponded to the archetypal ideal in *Naturephilosophie*. According to Benjamin, allegory replaced the organic conception of the symbol with "a landscape of death and devastation" (Hanssen 68), its petrified emblems recalling the taxonomies of premodern natural history. Benjamin's first book, a study of German *Trauerspiel* rediscovered the aesthetics of allegory as a historical vision of the world. In allegory the image of the ruin embodied a hermeneutic enigma requiring interpretation. Processes of destruction and decay situated the material object in the concrete but transitory historical world.

Santner proposes that allegorical interpretation fixes on enigmatic signifiers that assume meaning with respect to the biopolitical thresholds and caesuras that define social and species inclusion and exclusion (*Creaturely* 30–35). The creaturely should therefore not be understood as a regression to unconscious animal instinct but as a form of excess or excitation produced with respect to the biopolitical threshold between human and animal. Technological media, by recording physical movement, expression and sound, play their part in producing creaturely life. Recorded behavior and communication exceeds the natural perceptual capacity of the human senses, producing a technical replication that confounds previous conceptions of "human nature." Media recordings exceed the very limits of human life by surviving beyond the death and decomposition of the bodies from which they originated.

For Benjamin life was animated by constant movement and becoming. His vision was contemporary with Marey's early recordings of animal and human motion. Benjamin applied his discoveries of natural history in the *Trauerspiel* to the new technological media of photography. As we saw in Chapter One, photography was quickly enlisted into the recording of

physiognomy in order to classify the criminal, the deviant and pathological type of modern mass societies. But for Benjamin, photography revealed "material physiognomic aspects, image worlds, which dwell in the smallest things" (2 512). In the same way the camera could capture human motion and reveal "what happens in the split second when a person actually takes a step" (3 117).

Photography and Natural History

In his "Little History of Photography" (1931) Benjamin argued that this new technology captured those aspects of reality that exceed both the intentions of the photographer and the natural perceptual capacity of the viewer (2 512). He aligned this "optical unconscious" with the microscopic study of cellular tissue. In a brief discussion of Karl Blossfeldt's detailed photographs of plants, Benjamin commented that they resembled architectural forms and religious artifacts: through the technological effect of the close-up they created a new zone of indistinction between nature and culture. Blossfeldt's still, symmetrical, black and white studies reduced the plants to geometrical forms and structures. His photography was linked to the tradition of herbaria, in which dried plants are preserved and cataloged, and botanical systems of classification. Thus Blossfeldt's images were both radically new at a technical level but also strangely archaic and nostalgic, invoking a mode of observation and preservation that predated genetic science.

There is no obvious evolutionary narrative informing Blossfeldt's photographs. Each plant specimen appears equal to any other: there is no hierarchy based on relative beauty or fitness to survive. Blossfeldt avoided the most popular flowers and focused instead on plants that were often seen as weeds and "he gathered them along country tracks or railway embankments, or from other similarly 'proletarian' places" (Adam 26). Each plant was intrinsically interesting and complex, possessing its own integrity. They appear somehow metallic and sculptural yet remain organic. Under the gaze of his camera familiar, ordinary plants became exotic and surreal. The minute becomes monumental. Blossfeldt's images recall those of a private collector or amateur enthusiast rather than a biologist. His studies, rather than idealizing plants in the tradition of painted still-lives or flower arrangements, recorded the effects of aging, wilting, and drying out. He also focused his camera on parts such as pods, tendrils and buds rather than impressive blooms. For Benjamin these images of natural life became allegorical objects. In his book review of Blossfeldt's best-selling book *Art Forms in Nature* (1928), Benjamin commented that while the microscope revealed the previously invisible and apparently alien world of the plant cell, Blossfeldt's photographs allowed us to see nature as a limitless source of artistic form. In this case technology played a redemptive role, healing the wounds by which science and industry have dominated the natural world. Benjamin grasped the estranging—yet, at the same time, immersive—effect

of Blossfeldt's photography. As he puts it, in Blossfeldt's book "we, the observers, wander amid these giant plants like Lilliputians" (2 157).

What was at stake for Benjamin in the pioneering work of artists like Blossfeldt was the recovery of the image world before it was dominated by technology and fully commodified for the market. The study of plant forms was for this reason comparable to the study of human physiognomy. The invention of photography challenged the aristocratic monopoly on image making, particularly portraiture. But the result of this shift of power was not a complete democratization of image production. Rather it led to new gestures and discourses that reinforced middle-class articulations of social status. The gradual commercialization and popularization of photography involved an ever-growing demand for individual and family portraits, as Suren Lalvani explains:

> In effect, a moral icon was being cultivated, due less to the special char-
> acteristics of the camera as an insight machine, than to photographs
> operating within discourses of physiognomy, which gave them a set
> of typologies by which to orchestrate and adjust posture, expression,
> and lighting. In examining the photographs of the nineteenth century
> Victorians, we become acutely aware of the conventions of display
> regarding both dress and arrangement of the body in portraiture; we
> are confronted by an elaborate set of signs that symbolically evoke the
> bourgeois cultural ideal.
>
> (Lalvani 52)

The photographic portrait of the bourgeois individual and family was to serve as a model that the working classes should aspire to emulate. Normative ideals included patriarchy, domesticity, propriety and respectability. This production of the self-image was to be contrasted with the "blunt frontality with which the criminal, the insane, the poor ... and the colonial subject are forced to confront the camera's gaze" (66) during the same period.

Benjamin discovered a different story in the photographic recording of the human countenance. The first individuals who were photographed retained a reserve and privacy that later disappeared with the standardization and professionalization of portrait photography produced for the middle class. The third moment came with the avant-garde of the 1920s, who for the first time record the physiognomy of the working class as active agents of historical change (as in the films of Eisenstein). For Benjamin the outstanding proponent of social documentary photography was August Sander. Sander's portraits of the different classes of Weimar society struck Benjamin as providing a "training manual" in a political situation characterized by rapid shifts in power, making "the ability to read facial types a matter of vital importance" (2 520). Sander's masterwork, *People of the Twentieth Century*, aimed to document the entire spectrum of society, subdivided into groups such as "The Farmer," "The Skilled Tradesman," "The

Woman," "Classes and Professions," "The Artists" and "The Persecuted" (including Jewish emigrés).

People of the Twentieth Century is organized around notions of social typology and the mentalities of different groups expressed through physiognomy. This project had antecedents in the popular genre established in France presenting physiognomies of urban types. Theories of physiognomy were widely influential during the Weimar period and can be seen as part of a response to the national identity crisis resulting from Germany's defeat in World War I. Physiognomy was often interpreted within the framework of racial ideology. The other tendency in photography of this period was to focus on physiognomy as part of the documentation of social class. Under the new National Socialist regime Sander's work was repressed and destroyed for failing to present the desired image of German racial superiority. Sander became associated with the "degenerate art" attacked by the Nazis.

People of the Twentieth Century does appear to have been influenced by the biopolitical imagination of the period which saw the population composed of various groups defined in terms of their vigor or decadence, such as Spengler's *Decline of the West*. Sander's intended arrangement of the pictures, however, was conceived in terms of a cyclical theory of civilization: the robustness of the farmer and the organic nature of his work and community contrasts with the physical decline of the middle-class professional and the fragmentation of urban society. Sander presents us with the worn faces of farmers with their families. Each individual is intrinsically interesting to study. In these photographs there is the potential to discover visual evidence of social history, geography, and the impact of the natural environment on human life. These "types" encourage the viewer to compare, to think about relationships and differences between young and old, men and women, rich and poor, town and country, human and animal. Human subjects are often shown standing in a natural environment but not acting in it: somehow displaced and yet also suggesting an organic relation to the world. Their gestures do not belong to them so much as individuals as much as a new kind of creaturely life captured by the camera, defying previous distinctions between human, animal and nature.

Sander's portraits are often characterized by a tension between the self-presentation of the individuals and the social environments in which they appear. As Lalvani explains the bourgeois constructed a self-image in the theatrical space of the photographer's studio, with props to convey the desired effect. Sander's photographs depart from the conventions of the early studio portrait, with its contrived settings and pretensions to social status. Ulrich Keller compares Sander's technique of posing his subjects to Bertolt Brecht's notion of the "demonstrative gesture" (30–31). The individual is shown as a social actor rather than a romantic or spiritual type. The viewer is encouraged to study and analyze the image in the spirit of critical inquiry rather than aesthetic appreciation or spiritual reverence. In his later commentaries on Brecht's epic theater, Benjamin emphasized the

importance of gesture to break the naturalist illusion. For Benjamin, gesture formed part of the alienation of the body by industrial technology. Gestures have become quotable, removing them from both the continuity of realist representation and from liberal humanist conceptions of the individual. The gesture functions as a caesura, linking it to the aesthetics of montage and shock. Benjamin believed that the gesture could thereby exceed the control of the bourgeois individual and connect directly with the physiognomy of the collective, or the "body politic" (Weigel 116–117).

Bare Life: Political Prisoners and Nazi Nudes

Sander's *People of the Twentieth Century* included photographs produced between 1892 and 1954. He first conceived of the project in the mid-1920s but reorganized and regrouped his pictures numerous times over the following thirty years. A selection of sixty of the portraits was published in a book *Face of Our Time* in 1929, receiving critical acclaim. The subsequent repression of Sander's work by the Nazi state prompted him to change some of his titles of portfolios to "National Socialist Women" and "National Socialist Soldiers." He also produced new portfolios such as "Refugees" and "The Persecuted." After World War II he added another portfolio: "Political Prisoners." These photographs were made by Sander's son Erich, a Socialist who was imprisoned by the Nazis from 1934 to 1944. Erich produced several portraits of fellow prisoners and had them smuggled out of prison. These photographs include an image of Erich seated at his desk in his cell wearing prison overalls. In 1944 he died in prison of an untreated appendicitis.

Erich's portraits of his fellow prisoners are different from almost all others in Sander's collection in one particular respect: they are naked.[6] A crucial feature of August Sander's project is the recording of different forms of dress as a primary indicator of gender, profession and social class. So it seems highly significant that Erich decided to produce images of his fellow prisoners without clothing. Some of his portraits show the subject in prison uniform but other portraits show only the face and the bare shoulders and chest of the prisoner. His father's work had retained traces of the archetypes of *Naturephilosophie* along with nineteenth century notions of "criminal types" and other forms of social degeneracy. Erich's portraits of political prisoners stripped the human subject of any of these preconceptions or Romantic ideas about natural life. What Erich, himself a victim of the Nazi state, recorded was the stark new fact of bare life in a totalitarian state.

Agamben has proposed that "the politicization of bare life ... constitutes the decisive event of modernity" (*Homo Sacer* 4). Bare life is embodied in the figure of *homo sacer* who can be killed but not sacrificed. This "obscure figure of archaic Roman law" (8) increasingly became the norm in the modern period. In a political state of emergency anyone can potentially be

arrested, imprisoned, held without trial, executed and their body disposed of: this has become the condition of entire populations. As a victim of the Third Reich, Erich Sander and his co-prisoners exemplified this condition of bare life. The fact that they look relatively healthy and well fed distinguishes them from the victims of the death camps. But their nakedness anticipates the images we now associate with the Holocaust: human individuals have been stripped of the clothing that communicates and defines their social role and status. Like K. in Kafka's *The Trial*, these political prisoners in Erich Sander's photographs are exposed "Before the Law": nothing stands between their nakedness and the state's capacity to destroy them.

The Nazi regime will always be associated with images of the naked, emaciated bodies, both living and dead, that were revealed to the world with the liberation of the death camps. We have also seen the images of the naked bodies in the death pits, killed by the Special Action groups in the East before the systematic use of the gas chambers for extermination. The visual taboo associated with nakedness, which continues in the mass media even today, was broken at the end of World War II for the purpose of publicizing the Nazi crimes. The Nazi genocide gave a new visibility to nakedness, associating it forever with mass death. Yet this state, which used nakedness as a weapon of degradation and destruction, was also associated with the celebration of the nude body in dance, gymnastics, painting and sculpture. We need to understand this importance of nudity for Nazism in the larger context of modernity and biopolitical media.

Nudity was a prominent feature of Nazi art, propaganda, and spectacle inherited from Weimar culture along with an innovative and sophisticated media culture that had developed rapidly during the Weimar years. Much of the avant-garde experimentation of the 1920s was linked to the political struggles of the period, with photography becoming a central tool of agitation and propaganda. Technological advances, such as the German Leica 35mm camera, made photography available to the public and gave rise to a new generation of enthusiastic amateurs. Their enthusiasm was fed by the mass circulation of illustrated magazines, which became the showcase of developments in the new medium. In the domestic realm Germans were encouraged to celebrate their membership in the master race by assembling family photo albums. In both public and private realms photography was used to define the nation as a biopolitical community. The party meticulously documented its public rallies, ceremonials and other events and the leadership, particularly Hitler, also had their private lives extensively recorded in photographs and home movies.

The use of photography as evidence of social deviance and racial difference was now extended to the entire society. Defining race and gender types became central to social policy, scientific research, education and propaganda. In particular the Nazis embraced the idea, first developed in nineteenth century anthropology, criminology, and psychology, that physiognomy could reveal the true nature of the individual. Whereas Sander

had extended physiognomic research to the entire spectrum of society, the Nazi system of recording and representing human identity tended toward rigid distinctions and hierarchies. The Nazis suppressed Sander's work and promoted Hans Günther's *Racial Elements of the German People*, which used photographic portraits to distinguish Aryan from "inferior" peoples. The age of the gentleman scientists had given way to a new corporate culture in which biological research was coupled with the emotional intensity pioneered by the new documentary movements and the polemical strategies of mass propaganda.

The Nazi state adapted photography as a tool for the advancement of the corporate body over biological and political enemies. Photography itself was proclaimed as a transparent medium of scientific truth at the same time as it was cynically used as a tool of mass manipulation and deception. The notion of photography as a weapon was aligned with the national and racial population. For the Nazis the photograph functioned as a protective shield for the racial collective—or what psychologists would call "character armor." As Benjamin explained:

> In great ceremonial processions, giant rallies and mass sporting events, and in war, all of which are now fed into the camera, the masses come face to face with themselves. This process, whose significance need not be emphasized, is closely bound up with the development of reproduction and recording technologies. In general, mass movements are more clearly apprehended by the camera than by the eye.
>
> (Benjamin 3 132)

Rather than allow the technological extension of human vision to make visible the natural and social environment in surprising new forms—as Blossfeldt and Sander had done—Nazi media enshrined the alienation of the individual subject in the technological image of the masses and the type.

These questions of media and mass narcissism usefully come into focus around the representation of nudity. In his study of nudity and physical movement in German culture of the early twentieth century, Karl Toepfer writes of a distinctly modern image of the body as an "autonomous force" (1). The body was removed from any social or historical context and its beauty and freedom of movement were celebrated in ways that were both sensuous and abstract. German nude photography from the 1920s and '30s might stand as the antithesis of Sander's project to document the physiognomies and gestures of gender, profession and class. Nudism and dance celebrated the dynamism of the body as an unconscious life force. The natural rhythms of the human body were contrasted with those of the machine, and yet the celebration of dynamism and abstract patterns of movement aligned the body with industrial technology. The conjunction of dance with machine movement during this period is famously captured in Fritz Lang's *Metropolis* (1927). The autonomy and beauty of the nude body that was

celebrated in Weimar culture was a powerful expression of vitalism. The body was transcendental and corporeal, mystical and material, and the celebration of nudity manifested itself in diverse forms of eroticism, sexuality and pornography.

In the Nazi state the cult of nudity was subordinated to images of the nation and race. Nudism formed part of capture of cultural vitalism by biopolitics. Rudolf Bode, who became director of the Nazi gymnastic program, was directly influenced by *Lebensphilosophie*. For Bode the aim of gymnastics was not to compete but to align human movement to organic rhythms in nature. This philosophy was assimilated into the Nazi ideology of *Blut und Boden* (blood and soil) (Lebovic 191–194). In Nazi spectacle bodily movement was synchronized, becoming a collective performance of national and racial sovereignty. Mass choreography became part of mediated events such as in the 1936 Olympic Games. Leni Riefenstahl's film *Olympia* (1938) included a short sequence of three nude female dancers in a natural setting but this was in contrast with the film's overall emphasis on mass spectacle, disciplined movement, and competitive athletics. The tension that runs through Riefenstahl's film—her tendency, derived from *Lebensphilosophie*, to aestheticize the autonomous body (the second part of the film is called *Festival of Beauty*) despite the context of competition between nations—is again symptomatic of the modernist vitalism that the Nazis attempted to contain and control.

Agamben notes that the cult of nudity in early twentieth-century Germany promoted the notion of *Lichtkleid* (clothes of light) that distinguished this idealized nakedness from the obscene bodies of pornography (*Nudities* 66). He proposes that this distinction has its origins in the theological significance of nudity. Adam and Eve only felt shame at their nakedness after committing the first sin in the Garden of Eden, leading to a change in the way that they perceived their bodies, which had lost their "garments" of divine grace. This idealized nakedness must be presupposed in order to be restored in the nude image:

> Just as the political mythologeme of *homo sacer* postulates as a presupposition a naked life that is impure, sacred, and thus killable (although this naked life was produced only by means of such a proposition), so the naked corporeality of human nature is only the opaque presupposition of the original and luminous supplement that is the clothing of grace. (*Nudities* 64)

Agamben proposes that just as bare life is the secret foundation of all sovereign power, so naked corporeality "implies a constitutive imperfection in creation" (65) that must be hidden from view. Nakedness remains a scandal that threatens to break through the idealized image of the nude. This helps to explain how the Nazis could celebrate the nude body in their official art, propaganda and public spectacle while using nakedness as a means of

humiliating and torturing their victims in the camps. Behind the ideal Aryan body was another form of nakedness: the bare life upon which biopower was exercised. The body that is not clothed in divine grace, or bathed in photogenic light, is marked by the naked corporeality of the animal.

Photography as Applied Biology

As Esposito and Lebovic explain, the idealized body of *Lebensphilosophie* and Nazism tended to position the Jew as the embodiment of death, decadence, and degeneration. In the Nazi state biopolitical media functioned as an apparatus of immunity in which the image of the Jew needed to be invoked in order to be expelled for the biological preservation of the *volk*. This also involved associating Jews with vermin, bacilli and (as we saw in Chapter One) the killing of animals. It was necessary to postulate the life-threatening nature of the Jew in order to reduce the Jew to bare life and to glorify the life of the Aryan superman.

The ideal body of the Aryan master race was based on concepts of physical beauty and strength. The strong would procreate and the weak would be eliminated from the gene pool. Arno Brecker, official sculptor of the regime, produced monumental nude figures, particularly of idealized male bodies. Paul Schultze-Naumberg, an artist who rose to a position of wide influence in the Nazi state, produced a book *Kunst and Rasse* (*Art and Race*) in 1928 in which paintings by Modigliani, Picasso, Braque and others were juxtaposed with photographs of people with mental and physical diseases and disabilities. Representations of the nude body in the masterpieces of Western art were presented as evidence of a biological drive to survive and reproduce. Schultze-Naumberg argued that the state needed to control art because whether it produced images of strength and beauty or images of degeneracy impacted on the biological health of the race (Michaud 132).

Hitler's deputy Rudolf Hess used the phrase "applied biology" (cited in Bachrach 1) to justify the "racial hygiene" programs that sought to eliminate Gypsies, homosexuals, the mentally ill and other "subhumans." Jews were described as "microbes" infecting the "national body" (2). Soon after Hitler's seizure of power in 1933, laws were introduced prohibiting the rights of Jews to forms of employment, professional and business activities, and marriage to Aryans, while other "undesirables," such as the diseased or mentally ill, were subject to compulsory forms of racial hygiene such as abortion, castration, sterilization and confinement.

Photography played a significant role in racial-biological research. The standard text on eugenics was *Foundations of Human Genetics and Racial Hygiene* (1921) by Edwin Baur, Eugen Fischer and Fritz Lenz. Hitler claimed to have read this work during the period in which he composed his own *Mein Kampf*. The book includes series of portrait photographs of different "racial types," encouraging comparison between Aryan, Slavic, Asian and African peoples. This visual language of racial typology served as the basis

of much Nazi propaganda, including the film *The Eternal Jew*. The Nordic race was seen as embodying the highest form of physical beauty. The Kaiser Wilhelm Institute for Anthropology, Human Heredity and Eugenics was established in 1927 and made extensive use of photographic archives in genetic studies of the population, including special research on twins. Its director, Eugen Fischer (a long-time friend of Martin Heidegger), openly supported the Nazi regime and benefited from its patronage (Weiss 28–34).

The uses of photography moved beyond the confines of scientific archives and publications to be used in publicity campaigns aimed to reeducate the general population in racial ideology. Negative stereotyping of those deemed mentally ill or deficient, the physically disabled and other "undesirable" minorities became more open and polemical. Away from public view, photography was also employed in the process of extermination. In the first killing centers, established under the secret euthanasia program, victims were photographed before they were gassed (Friedlander 165). In Nazi occupied Europe research on racial identity, particularly of Jews, was conducted on those non-citizens who were now imprisoned and without any right to resist or protest. Large archives were established that collected genealogical information, physical measurements and photographic documentation. Concentration camps became centers of racial research, most infamously conducted by Dr. Mengele at Auschwitz. There was a photography lab at Auschwitz. Arrival at the ramp at Auschwitz, along with the selection process and gassing was all documented in photograph albums (although not all of these have survived) (Struk 99–112).

The Nazi propaganda film *The Eternal Jew* depended heavily on the claim that physiognomy could reveal illness, criminality, and racial superiority or inferiority. Jews were portrayed as the "criminal type" to be found in dirty, overcrowded city streets and tenements. Facial features and expressions were recorded and presented as evidence of moral degeneracy. As in many other areas, the Nazis were not original in their ideas and beliefs. There was little in this notorious film that had not already been seen in France, Britain, and the United States since the late nineteenth century. What was new was the explicit linking of all negative connotations of moral and racial degeneracy with a single group: the Jews. All of the features that Foucault identified with modern biopolitics—a concern with the health and survival of entire populations, the defining of specific individuals and groups as degenerate, the need to control modern urban environments—were explicitly applied to the "Jewish problem." All of the techniques of visual documentation that contributed to this emerging biopolitical paradigm (discussed in Chapter One) were employed in *The Eternal Jew*.

The Camera, Creaturely Life and the Immune System

In 1940, the same year that the Nazis released *The Eternal Jew*, Benjamin formulated a number of new propositions about technological change and human perception in the essay "On Some Motifs in Baudelaire." Benjamin's

natural history of visual media arrived at very different conclusions from the Nazi use of media as applied biology. In this essay he developed an original synthesis of Bergson and Freud and advanced his own theory of modernity and shock. Benjamin proposed that Bergson's attempt to grasp the true nature of life was a response to the supposed "standardized, denatured life of the civilized masses" (4 314) in the age of industrialism and urbanism. Benjamin nevertheless praised Bergson's empiricism and his interest in biology. In *Creative Evolution* (1907) Bergson had proposed that "life in general is mobility itself" (141). In order to address the transitional, shifting states of being Bergson looked to the animal who instinctively inhabits a world of perpetual change. The nervous system in animal life mediates sensory experience and conscious awareness and volition. Bergson also distinguished between fixed states and non-fixed states of becoming by comparing them to photography and cinema. Photographs fixed life in an image while cinema captured movement, or animated life (Bergson 331–32). In this way the cinema functioned like the nervous system, transforming animated life into visual information and conscious understanding.

Benjamin adapted Bergson's notion of visual media capturing and transforming biological life along with Freud's account of shock and trauma in *Beyond the Pleasure Principle* (1920). Freud also drew on the biological understanding of the nervous system in his notion of the "protective shield" (18:27). According to Freud the function of consciousness was to protect the body from excessive stimuli. Just as Darwin had recognized *homo sapiens* as forming part of a long process of biological evolution, so Freud argued that individual consciousness was formed in relation to an unconscious that was non-individual and not limited to the human species. In Freud and Josef Breuer's research on hysteria they argued that hypnoid states can embody pathological fixations whose enduring power can be related to animal instinct (Lippit 104–106). Both Bergson and Freud developed vitalist accounts of the nervous system as based in animal impulses. Benjamin's commentary on Bergson and Freud allows us to see the relationship between cinema and animated life as a historical shift in which technology reprograms biological impulses and perceptual experience. It also allows us to see the animal not as embodying a vitalist principle but as part of an apparatus of power and mediated perception.

The new problem identified by Benjamin was that in a modern industrial society consciousness was working overtime to respond to the shocks of the urban environment. Into this historical situation came the camera: the technical apparatus that mediates shock by fixing it in an image isolated from the flow of experience. The camera extended the nervous system's protective shield against intrusive stimuli. The price it paid for this immunity was a "fixation" on shock. Unlike Bergson, who saw the cinema as overcoming the false isolation of moments in time, Benjamin proposed that the cinema serialized the impact of shock in a manner that he compares to the conveyor belt in processes of mass production (4 328). The cinema was a mass produced pathology.

According to Buck-Morss's reading of Benjamin, technology in industrial urban societies had alienated people from their instinctive responses to danger. This was the other side of the protective shield against intrusive stimuli. As she explains:

> Under conditions of modern technology, the aesthetic system undergoes a dialectical reversal. The human sensorium changes from a mode of being "in touch" with reality into a means of blocking out reality. Aesthetics—sensory perception—becomes anesthetics, or numbing of the senses' cognitive capacity that destroys the human organism's power to respond politically even when self-preservation is at stake. (*Dreamworld and Catastrophe* 104)

There is an element of idealism in Buck-Morss's account, insofar as she does not acknowledge that human sensory perception was always both limited biologically and encoded socially and culturally. As societies have changed from nomadic to agrarian to industrial, different sensory experiences have assumed different uses and been assigned different values. For Benjamin it was precisely the experience of shock and urban alienation that attuned the metropolitan subject to the forms of social experience distinctive to the industrial age. In this way the camera also potentially extended the survival of the human species in an increasingly technological world.

For Benjamin photography and film mediated the catastrophic force of change, but in doing so formed part of a new immunitary apparatus. This marked a significant break with the earlier Kantian aesthetics of catastrophe and the sublime. In his *Critique of Judgment*, argues Buck-Morss, Kant described the superior response to catastrophe as that of a general of an army, the man who remained calm in a crisis and took control of reality. Independence of mind was achieved by distancing oneself from the immediate sensory response of fear and the survival instinct. Kant's conception of the sublime required the elevation of reason at the expense of the suppression of the senses ("Aesthetics" 8–9). But later developments in the physiology of the nervous system showed that experience was not contained in an autonomous entity (such as "mind") but inherently open to the external environment in an unlimited network of perception, sensation and memory. For this reason sensory stimuli have the capacity to overwhelm intellectual comprehension. Unlike Kant, who sought to isolate the rational mind from excessive stimuli, Benjamin based his theory of modern experience on the neurological conception of shock. The impact of shock produced widespread neurasthenia: the shattering of the nervous system to the point of breakdown. The intense stimuli of the urban environment in the industrial era has made the experience of shock the "norm." The industrial worker has had to unlearn his/her natural sensory responses and to behave instead like an unfeeling machine.

Buck-Morss's commentary on Benjamin's account of modern aesthetics describes a biopolitics of immunity. The social body became the object of

surgical interventions, neurological numbing and therapeutic healing. In the late nineteenth century, explains Buck-Morss, the technics of anesthetics began to include "a vast arsenal of drugs and therapeutic practices, from opium, ether, and cocaine to hypnosis, hydrotherapy, and electric shock" ("Aesthetics" 18). The use of anesthetics in surgery made desensitization a central feature of medical science. The figure of the surgeon, calmly performing operations on the anesthetized body of the patient, became a model for other social "operators" such as the business entrepreneur or political leader directing masses of workers, voters and consumers. In the "Work of Art" essay Benjamin compared the surgeon to the camera. The surgeon penetrates the patient's body just as the cinematographer penetrates social reality (3 115–116).

Benjamin proposed that the mass media produced a collective pathological fixation in an attempt to neutralize the threat of psychically disturbing images:

> If one considers the dangerous tensions which technology and its consequences have engendered in the masses at large—tendencies which at critical stages take on a psychotic character—one also has to recognize that this same technologization has created the possibility of psychic immunization against mass psychoses.
>
> (Benjamin 3 118)

Benjamin's understanding of this historical situation is usefully compared with that of his contemporary Ernst Jünger, a right wing opponent of social democracy and an advocate of a technocratic state. Jünger believed that animal instinct could be the source of energies that were capable of responding to the catastrophic new reality of industrial age warfare. In war man recovers his animal self, providing him with the skills to survive the onslaught of technological mass destruction (Woods 43–44). In a discussion of photography, Jünger wrote of a "second" consciousness beyond the reach of pain. Comparing technological media to artificial limbs, Jünger wrote (two years before Benjamin) of the camera as an artificial eye that can penetrate spaces and matter previously inaccessible to human perception. The camera can capture "the moment in which a man is torn apart by an explosion" (Jünger 208). The camera is a new kind of weapon. Seeing becomes "an act of aggression" (208) exposing the weaknesses of one's enemies for all to see—both in warfare and in political propaganda.

In Jünger's version of the media as a protective shield removing the human subject from pain, the machinic extension of the senses is implicitly aligned with the recovery of animal instinct: both enable survival in the face of mass destruction. A new race had emerged from the traumatic experience of the trenches of World War I, hardened by the impact of shock. In Jünger's writings the Nietzschean superman merges with the machine (Aschheim 158–159). Jünger's vision is essentially a Social Darwinist appropriation of technology. By contrast Benjamin's account aligns media with a life that is

enmeshed in a specific historical world rather than an evolutionary teleology. For Benjamin the shield that protected human sensory response from intrusive stimuli was an adaptation to the modern urban environment. But this involved not so much a return to animal instinct as a new mutation of creaturely life. Media helped to protect the nervous system from traumatic disturbance, but this immunity was achieved at the price of desensitization.

Photography and the Final Solution

As the catastrophe of the Nazi genocide proceeded in the occupied territories, millions of humans were slaughtered. Their lives were considered of less value than those of animals. Different aspects of the process of extermination were recorded in photographs and on film. In this visual recording of violence and killing, unprecedented in quantity and scope, the killers apparently learned to master or repress any sympathy or pity for their victims. *The Eternal Jew* was screened for the killing squads and those working in the death camps. As the Third Reich expanded its territories in Eastern Europe its action groups massacred hundreds of thousands of civilians and prisoners of war. The Nazi death squads were initially encouraged to photograph their atrocities—as an exercise in group bonding—but later were subject to secrecy. During the war Jewish and Polish resistance groups published numerous photographs of atrocities, some produced by clandestine photographers and smuggled out of occupied Europe, in an attempt to persuade the Allied powers to directly intervene in the exterminations. The Polish government-in-exile compiled a large dossier of evidence of Nazi war crimes that they presented to the British government. They were met with incredulity and nonaction (Struk 5).

The Nazis obsessively recorded their atrocities in photographs, although these were not intended for publication. Sometimes these images were included in the personal photo albums of soldiers and their families. Eastern European Jews were viewed in terms of the stereotypes of "subhumans" disseminated by Nazi propaganda and were documented in similar ways to the native populations of colonized Africa and Asia. Janina Struk proposes that these photographs functioned as a psychological defense mechanism against the shock of the ethnic other who threatened the racial integrity of the Aryan conqueror. The poverty and destitution of the Eastern European Jews, exacerbated by their confinement in ghettos (as shown in *The Eternal Jew*), appeared to confirm their biological inferiority. Struk argues that the family photo album, by including images of the conquered territories and peoples, including hangings and mass executions, confirmed the larger corporate identities of the nation and the Aryan race (57–62). Thus these amateur images performed an important biopolitical function by integrating private life into the larger economy of life fit and unfit to live.

The S.S. also extensively documented the running of the concentration and death camps, including the arrival of the transports, the selection of

those fit to work, the process of mass murder in the gas chambers, and medical experiments conducted on prisoners. These images were sometimes compiled into albums and presented to the Nazi high command. Several of the major camps, including Buchenwald and Auschwitz, had their own photography departments. Most of the photographs were destroyed at the end of the war or have disappeared. Some survived due to heroic acts of resistance by prisoners working in the photo labs.

The wide circulation of atrocity images among the German public led to their prohibition in 1941 by the military high command and in 1942 by the S.S. The extermination of subhumans was seen as acceptable and necessary but to take pleasure in committing or viewing acts of violence was officially deemed unhealthy and perverse. It is tempting to speculate on the different possible psychological motivations for taking photographs of atrocity but there are no certainties about this area of human behavior. What is clear is that the photographs were produced and interpreted within the forms of discourse and violence instituted by Nazi race policy.

Francis Guerin has argued against the assumption that images of executions, massacres and atrocities recorded by soldiers on the Eastern front should automatically be seen as an acceptance of Nazi ideology. For one thing, the act of photographing these "special actions" was prohibited by the leadership of the army and the S.S. Also these photographs form a small part of a much larger number of images taken by soldiers documenting everyday life during the war. These, claims Guerin, can be compared to tourist images and form part of the larger role of photography in modernity. This is an interesting point, but Guerin does not consider it in the larger context of modernity and biopolitics. Racism is/was central to the gaze of both the tourist and the colonist. Surely it is the positioning of racist stereotypes and acts of violence as "everyday experiences" that supports Struk's argument that they played a specific role in German collective identity. In the terms of biological racism made official ideology by the Nazis, genocide was normalized.

Struk is one of the commentators who see these images produced by the Germans as reproducing the point of view of the perpetrator in those who view them after the fact. Guerin rejects this interpretation and argues that the images allow multiple perspectives and provide an important basis for bearing witness to the Holocaust. Because the amateur images do not always follow the codes and conventions of professional photography but include long shots, over exposure, out-of-focus shots, blurring and other "mistakes," these deviations from the norm, argues Guerin, can function as estrangement effects allowing the viewer to negotiate various forms of historical responsibility. Struk, however, reminds us that these images helped to establish another kind of "norm": the acceptance of genocide as a feature of modern war. It is true that the amateur image did not have the same authority as the photojournalist image at the time (although it could be argued that today the amateur image has assumed greater authority due

to its "authenticity"). Guerin proposes that the "mistakes" of the amateur potentially allow today's viewer to connect more directly with the victim rather than be persuaded by the ideological frames informing the photographer. These arguments are suggestive, but only if one's primary concern is with the responsibility of the contemporary viewer to bear witness to the past. The amateur nature of the photographs collected in German family albums during World War II were produced and framed by the Nazi biopolitical apparatus. The strongest historical perspective on the Nazi invasion and occupation of Eastern Europe is a comparison with the earlier colonization of Africa, Asia and the Americas. Just as the extermination of Native Americans was seen as a necessary part of frontier expansion, so was the Nazi murder of Jews and Slavs seen as an intrinsic part of gaining "living space" for its own populations.

Barbie Zelizer raises further issues about the photographs produced by the Nazis of their crimes. At first she appears to agree with Struk when she comments that the photographs that recorded the mass deportations and executions in occupied Europe "were themselves reprehensible for the mundane and cold-hearted attitude evinced toward death" (*About to Die* 136). She goes on to admit, however, that it remains unclear who exactly took the photographs and why. We can never know exactly what any individual photographer was thinking when s/he witnessed and captured with a camera the sufferings of these people. Ultimately this is true of all photographs: they are produced by a machine and the individual operator of the camera is only one factor in their social, cultural and political significance. For this reason neither the intentions of the photographer nor our own responses provide the most useful way to understanding these images. The photographs that document the Nazi atrocities formed part of the apparatus of genocide, even if we look at them today from a different perspective. The key fact of producing an image under such circumstances implied at least a temporary immunity from destruction.

There were instances where Jews were required to produce visual documentation of the deportations and were subsequently themselves liquidated (Elsaesser 163–164). It would have been impossible for the deportees and victims of mass murder to document their own fate with photographs or film. In one famous instance the *Sonderkommando* who worked in the gas chambers and crematoria at Auschwitz were able to document, with a camera smuggled into the camp, a group of Hungarian Jews being herded into the gas chambers and their naked bodies subsequently being burned in open pits. In this case we are confronted with those who inhabited what Primo Levi called the "gray zone": Jews who were forced to collaborate in the process of mass destruction in exchange for a temporary immunity from death.

Most photographs of the Final Solution surfaced after the war, sometimes in private collections or albums, although some had also been included in the Polish government-in-exile's documentation of Nazi war crimes. Most of the images were unofficial, secret or forbidden records of these crimes

but they now belong to the postwar culture commemorating the Holocaust. Photographs of crowds of Jews being rounded up, forced to undress, and gunned down in mass graves have come to stand for the millions of victims of genocide. One of the most famous Holocaust photographs shows a young boy, his arms raised in a gesture of surrender, with a German soldier holding a gun on him. This photograph was taken in the Warsaw Ghetto in 1943 and was included in an album compiled for General Jurgen Stroop and presented to Heinrich Himmler. It was discovered by Allied forces and used as evidence in the Nuremberg Trials and, later, the Eichmann trial. The unknown victim became known as the "Warsaw Ghetto boy" and the object of identification for many Jews who saw themselves and families as sharing or narrowly avoiding his fate. Over the years a number of different individuals have claimed to be the boy. The image has become "an emblem of universal suffering demarcating the divide between good and evil" (*About to Die* 141). The interpretation of this photograph is now framed by the cultural trauma of the Holocaust.

In these different arguments about how to interpret the photographs documenting the Final Solution we find at least three principal positions. The first concerns the ethical problem raised by Struk in which today's viewers of these images reproduce the gaze of the perpetrators and are unable to imagine the point of view of the victims. The second is the culturalist approach taken by Guerin which emphasizes that all images, even these, can generate multiple and contradictory meanings that participate in larger social and cultural discourses. The third, discussed by Zelizer, relates to the politics of identity and memory. These photographs now belong to a culture of commemoration of the Holocaust and provide spaces of identification for Jews but also for those who see the Holocaust as an historical trauma of universal significance for all humanity.

Thinking about these images as a form of biopolitical media allows us to see how they functioned in a system of power that exoticized the victims, normalized genocide, and immunized the viewer against the supposed threat of racial difference and against moral responsibility for killing enemy populations. These photographs were produced as part of everyday life and military operations in a society and state committed to genocidal policies. They do not only show the destruction of life but formed part of a biopolitical apparatus that sustained and protected some forms of life while destroying others. They reveal that the price of survival was a self-numbing extension of life through the inanimate apparatus of technological media.

Notes

1. The key works by Agamben are *Homo Sacer: Sovereign Power and Bare Life*, *State of Exception* and *Remnants of Auschwitz: The Witness and the Archive* and by Robert Esposito, *Bios: Biopolitics and Philosophy*, *Immunitas: The Protection and Negation of Life* and *Terms of the Political: Community, Immunity, Biopolitics*.

2. See for example Welch, *The Third Reich: Politics and Propaganda*; Michaud, *The Cult of Art in Nazi Germany*; Kallis, *Nazi Propaganda and the Second World War*; and Winkel and Welch (eds.), *Cinema and the Swastika: The International Expansion of Third Reich Cinema*.
3. See for example LaCapra, *History and Memory after Auschwitz*, Zelizer (ed.), *Visual Culture and the Holocaust*, Struk, *Photographing the Holocaust: Interpretation of the Evidence*, Joshua Hirsch, *After Image: Film, Trauma and the Holocaust* and Saxton, *Haunted Images: Film, Ethics, Testimony and the Holocaust*.
4. See Buck-Morss, *The Origin of Negative Dialectics: Theodor W. Adorno, Walter Benjamin and the Frankfurt Institute*; Hanssen, *Walter Benjamin's Other History: Of Stones, Animals, Human Beings, and Angels*; Santner, *On Creaturely Life: Rilke/Benjamin/Sebald*; and Weigel, *Walter Benjamin: Images, the Creaturely, and the Holy*.
5. See Buck-Morss, *The Origin of Negative Dialectics*.
6. One image by August Sander of the Dadaist Raoul Hausman shows him naked from the waist up and wearing white trousers. Other studies shows two boxers in shorts and gloves and a "Kinetics Researcher from Vienna" in a loin cloth, but for the most part the subjects are all clothed.

Works Cited

Adam, Hans Christian. *Karl Blossfeldt*. Köln: Taschen, 2001.
Agamben, Giorgio. *Homo Sacer: Sovereign Power and Bare Life*. Trans. Daniel Heller-Roazen. Stanford: Stanford UP, 1998.
———. *Nudities*. Trans. David Kashik and Stefan Pedatella. Stanford: Stanford UP, 2011.
———. *State of Exception*. Trans. Kevin Attell. Chicago and London: U Chicago P, 2005.
———. *Remnants of Auschwitz: The Witness and the Archive*. Trans. Daniel Heller-Roazen. New York: Zone, 2002.
Arendt, Hannah. *The Origins of Totalitarianism*. San Diego, New York, London: Harcourt Brace Jovanovich, 1973.
Aschheim, Steven E. *The Nietzsche Legacy in Germany 1890–1990*. Berkeley: U California P, 1992.
Bachrach, Susan. "Introduction." *Deadly Medicine: Creating the Master Race*. Ed. Sara J. Bloomfield. Washington, DC: United States Holocaust Memorial Museum, 2004. 1–13.
Benjamin, Walter. *Selected Writings Volume 2 1927–1934*, Trans. Rodney Livingston et al. Ed. Michael W. Jennings, Howard Eiland, and Gary Smith. Cambridge, MA, and London: Harvard UP, 1999.
———. *Selected Writings Volume 4 1938–1940*, Trans. Edmund Jephcott et al. Ed. Howard Eiland and Michael W. Jennings. Cambridge, MA, and London: Harvard UP, 2003.
———. *Selected Writings Volume 3 1935–1938*, Trans. Edmund Jephcott, Howard Eiland, et al. Ed. Howard Eiland and Michael W. Jennings. Cambridge, MA, and London: Harvard UP, 2002.
Bergson, Henri. *Creative Evolution*. Trans. Arthur Mitchell. New York: Random House, 1944.

Buck-Morss, Susan. "Aesthetics and Anesthetics: Walter Benjamin's Artwork Essay Reconsidered." *October* 62 (1992): 3–41.

———. *Dreamworld and Catastrophe: The Passing of Mass Utopia in East and West*. Cambridge, MA, and London: MIT Press, 2000.

———. *The Origin of Negative Dialectics: Theodor W. Adorno, Walter Benjamin and the Frankfurt Institute*. New York: Free Press, 1977.

Elsaesser, Thomas. *German Cinema—Terror and Trauma: Cultural Memory Since 1945*. New York and London: Routledge, 2014.

Esposito, Roberto. *Bios: Biopolitics and Philosophy*. Trans. Timothy Campbell. Minneapolis: U Minnesota P, 2008.

———. *Terms of the Political: Community, Immunity, Biopolitics*. Trans. Rhiannon Noel Welch. New York: Fordham UP, 2013.

———. *Immunitas: The Protection and Negation of Life*. Trans. Zakiya Hanafi. Cambridge: Polity, 2011.

Foucault, Michel. *"Society Must be Defended": Lectures at the Collège de France, 1975–76*. Ed. Mauro Bertani and Alessandro Fontana. Trans. David Macey. New York: Picador, 2003.

Friedlander, Henry. "From 'Euthanasia' to 'Final Solution.'" *Deadly Medicine: Creating the Master Race*. Ed. Sara J. Bloomfield. Washington, DC: United States Holocaust Memorial Museum, 2004. 155–183.

Freud, Sigmund. *The Standard Edition of the Complete Psychological Works of Sigmund Freud, Volumes 1–24*. Ed. James Strachey. London: Hogarth Press and the Institute of Psychoanalysis, 1953–74.

Guerin, Frances. *Through Amateur Eyes: Film and Photography in Nazi Germany*. Minneapolis: U Minnesota P, 2012.

Hanssen, Beatrice. *Walter Benjamin's Other History: Of Stones, Animals, Human Beings, and Angels*. Berkeley: U California P, 1998.

Hirsch, Joshua. *After Image: Film, Trauma and the Holocaust*. Philadelphia: Temple UP, 2004.

Jünger, Ernst. "Philosophy and the 'Second Consciousness.'" *Photography in the Modern Era: European Documents and Critical Writings, 1913–1940*. Ed. Christopher Phillips. New York: Metropolitan Museum of Art/Aperture, 1989.

Kallis, Aristotle. *Nazi Propaganda and the Third World War*. Hampshire, New York: Palgrave Macmillan, 2008.

LaCapra, Dominick. *History and Memory after Auschwitz*. Ithaca and London: Cornell UP, 1998.

Lalvani, Suren. *Photography, Vision, and the Production of Modern Bodies*. New York: State U New York P, 1996.

Lebovic, Nitzan. *The Philosophy of Life and Death: Ludwig Klages and the Rise of Nazi Biopolitics*. Basingstoke: Palgrave MacMillan, 1996.

Lippit, Akira Mizuta. *Electric Animal: Toward a Rhetoric of Wildlife*. Minneapolis: U Minnesota P, 2000.

Lukács, Georg. *The Destruction of Reason*. Trans. Peter Palmer. London: Merlin Press, 1980.

Michaud, Eric. *The Cult of Art in Nazi Germany*. Trans. Janet Lloyd. Stanford: Stanford UP, 2004.

Richards, Robert J. *The Romantic Conception of Life: Science and Philosophy in the Age of Goethe*. Chicago: U Chicago P, 2002.

Rose, Nikolas. *The Politics of Life Itself: Biomedicine, Power and Subjectivity in the Twenty-First Century*. Princeton and Oxford: Princeton UP, 2007.

Santner, Eric. *On Creaturely Life: Rilke/Benjamin/Sebald*. Chicago and London: U Chicago P, 2006.

Saxton, Libby. *Haunted Images: Film, Ethics, Testimony and the Holocaust*. London and New York: Wallflower Press, 2008.

Struk, Janina. *Photographing the Holocaust: Interpretation of the Evidence*. London, New York: I.B.Taurus, 2004.

Toepfer, Karl. *Empire of Ecstasy: Nudity and Movement in German Body Culture, 1910–1935*. Berkeley: U California P, 1997.

Weigel, Sigrid. *Walter Benjamin: Images, the Creaturely, and the Holy*. Trans. Chadwick Truscott Smith. Stanford: Stanford UP, 2013.

Weiss, Sheila Faith. "German Eugenics, 1890–1933." *Deadly Medicine: Creating the Master Race*. Ed. Sara J. Bloomfield. Washington, DC: United States Holocaust Memorial Museum, 2004. 15–39.

Welch, David. *The Third Reich: Politics and Propaganda*. London and New York: Routledge, 2002.

Winkle, Roel Vande and David Welch (eds). *Cinema and the Swastika: The International Expansion of Third Reich Cinema*. Hampshire, New York: Palgrave Macmillan, 2011.

Woods, Roger. *The Conservative Revolution in the Weimar Republic*. Hampshire and London: MacMillan, 1996.

Zelizer, Barbie (ed). *Visual Culture and the Holocaust*. New Brunswick: Rutgers Up, 2000.

———. *About to Die: How News Images Move the Public*. Oxford and New York: Oxford UP, 2010.

3 Colonial Trauma and the Holocaust

In 1945 photographs and film footage of the Nazi death camps made visible to the world the extreme consequences of Nazi biopolitics. Race theory, which had been widely espoused in both lay and scientific communities before the war, now became unacceptable in public discourse. The notion of crimes against humanity first used at the Nuremberg Trials initiated a new postwar humanism. Universal human rights required that no society could exclude people from citizenship on the basis of race. But as the shock of the images of the camps receded, a new discourse gradually began to emerge about the Nazi genocide as a historical trauma. The writings of Hannah Arendt—both *The Origins of Totalitarianism* (1951) and *Eichmann in Jerusalem* (1963)—played a formative role in this process. Arendt's pioneering analysis of totalitarianism and its historical relation to colonialism introduced a "traumatic" note into this history: she argued that the European encounter with the African produced a shock, setting off the genocidal violence whose ultimate victims were the Jews in Europe. This traumatic account of history, while it was intended to address the problem of race and totalitarian power, reproduced the biopolitical caesura that divided fully human European from less-than-human African.

This chapter argues that the idea that gradually emerges in the postwar period of the Holocaust as a historical trauma was symptomatic of a failure to understand the larger implications of Nazi biopolitics. For this reason it continued to reproduce biopolitical conceptions of the human and nonhuman that had their historical origins in European colonialism and racism. Chapter Two showed how the Nazi use of media as applied biology failed to recognize the ways that technology transformed natural life. Benjamin's concept of the creaturely showed that natural life was always embedded in technological change (and thereby discourses and institutions of power) and was marked by forces of catastrophic destruction. The idea of historical trauma acknowledges the profound effects of catastrophe but its relation to medico-scientific diagnoses of physical and psychical injury leads it to reproduce biopolitical conceptions of the human. Attending to the role of visual media in discourses about trauma reveals how this concept remains bound to the racial biotype.

Narratives about colonialism and the Holocaust as historical traumas have their origins in the visibility of racial difference. According to Arendt,

the "savage" appearance of the African was a profound shock for the civilized European. This shock reverberated in the later shock of the opening of the death camps to public view and transmitted by news photography and film. In both cases universalized notions of what it meant to be human were thrown into question. The trauma of the Nazi camps was also linked to colonialism in Alain Resnais's film *Night and Fog* (1955). Resnais commented in an interview years after the film's release that it had been an indirect statement about the French use of torture and concentration camps in the Algerian War. During this period Frantz Fanon also developed his account of colonial trauma in Algeria, stressing the importance of the stereotype and the experience of looking. Resnais's visual document of the Final Solution and Fanon's account of the visibility in colonial power both show that the idea of historical trauma originates in images of catastrophe, bare life and the functions and effects of biopolitical media.

This chapter approaches this under-researched relation between biopolitics, media and colonialism first through Agamben's reading of Arendt. Agamben acknowledges Arendt as a formative influence on his account of biopolitics but he chooses not to take up Arendt's path-breaking and complex argument about the historical relationship between colonialism and Nazism. Other scholars, particularly Michael Rothberg, have shown how Arendt's argument intersected with a range of anticolonial discourses in the 1950s. But Arendt reproduces certain biopolitical conceptions of race that do not sit well with her critique of Nazism. Rothberg has produced a subtle reading of Arendt that is attentive to her conception of the European encounter with the African as traumatic. Arendt's conception of colonial trauma was centered on the psychological experience of the European colonizer, who was imagined as an autonomous subject impacted by an external event. Rothberg suggests that the better way to understand this, however, is that the African posed a threat to the European's universalized notion of the human. Colonial trauma dramatizes an unconscious disturbance that assumes a particular conception of the Western subject. The trauma narrative in Arendt reinscribes Western sovereignty as part of her biopolitical vision of history. I propose that Rothberg's use of historical trauma as an interpretive frame also reinscribes this universalized model of the Western subject.

The following discussion seeks to rethink historical trauma as a narrative about collective identity by turning attention to the ways that visual media have constructed racial difference in the colonies and relating this to images of the Nazi camps. The chapter begins by considering the comparison of colonialism and Nazism in *Origins of Totalitarianism* and *Night and Fog*. It then explains how photographs of Algerian women produced by the French colonizers attempted to reduce the colonizers to bare life, making them available for both erotic fantasy and police surveillance. The unveiling of Arab women aimed to remove the protective shield surrounding traditional private life and construct instead a mediated immunity for the colonizer, who could enjoy voyeuristic pleasure from a position of distance

and control. As the sovereignty of the colonized society was destroyed, the life of the colonizer was enhanced by biopolitical media. Fanon argued that colonial trauma was a result of this destruction of the self-image of the colonized. The chapter concludes with a discussion of the documentary essay film *Images of the World and the Inscription of War* (1989) by Harun Farocki, which compares photographs of Algerian women with a photograph of a Jewish woman arriving at Auschwitz. Farocki's film suggests a different understanding of the relationship between the Holocaust and colonial trauma that reverses Arendt's narrative in *Origins of Totalitarianism*. Instead of a Eurocentric trauma based in racial hierarchies and universalized notions of the human, Farocki's film allows us to understand trauma as an effect of biopolitics: on one hand constituting certain groups as objects of knowledge and power while on the other maintaining a position of immunity by repeating and manipulating images of bare life.

Colonialism and Biopolitical Media

Biopolitics defines which members of a population are fit to live and which individuals and groups are not; it defines the threshold that separates human from non- or sub-human; it registers the power of the law and the state directly on the biological body, rendering it naked, unprotected and highly vulnerable; and it defines relations of power by which some groups use the technological apparatus to make others objects of knowledge and control. Biopolitical media transmit shocks but also immunize viewers from biological threats, including sickness, racial degeneration and death. We need to understand this dynamic of recording, viewing and protective insulation if we are to properly comprehend the claims that historical events are "traumatic."

The horrors of modern genocide were partly made possible by the visual classification of different groups as fit or unfit to live. The Nazi state was the first to use the media apparatus to record the systematic destruction of those it deemed unfit to live. The notion of historical trauma is premised on this making visible of violence by the modern media. Both the Holocaust and the colonial genocides that preceded it were justified by images and discourses about physical appearance as an indication of biological health and fitness to live. The image of the Jewish victim of Nazi violence, like the image of "subhumans" produced by Nazi propaganda, confronted the viewer with the danger of "degeneration" to something less than human. In both cases people were presented as objects of fear, disgust and horror. Although the historical trauma of the Holocaust is now understood in terms of bearing witness to, and feeling empathy for, the sufferings of the persecuted, the historical encoding of life by visual media tells a less reassuring story.

As earlier chapters have shown, photography and film have played an important role in incorporating biological life into the political apparatus of surveillance and control. These visual media have formed part of the

reconceptualization of individuals as members of a population rather than autonomous entities. In the nineteenth century the individual was increasingly understood in terms of pathological and racial types. Physiognomy and gesture were recorded as visual information, preserved in archives, analyzed and classified as a means of organizing large populations. The Holocaust is now remembered as the catastrophe that revealed the extreme possibilities of population control based on racial theory. But before the Nazi state and the postwar proliferation of weapons of mass destruction, the catastrophic implications of biopolitics were already visible in the European colonies.

In the late nineteenth century photography was used to document the different physiognomies of "superior" and "inferior" races. Photography quickly became an important instrument in defining the biological caesura that separated life fit to live from life available to be destroyed. The emphasis which Freud and Breuer gave to traumatic memories as the basis of hysteria was preceded by Charcot's visual documentation of bodies that were seen as beyond the control of individual subjects. Before the understanding of trauma in terms of psychological depth there was the shocking appearance of physical degeneration. The appearance of non-Western peoples, like the faces and bodies of criminals and the insane, was evidence of a threat to the health and survival of Western populations. Nazi propaganda made this explicit by comparing "degenerate" modern art with photographs of the physically and mentally ill and with "primitive" artifacts from Africa.

The emergence of photography and film as part of the modern biopolitical apparatus is contemporary with the period of European colonialism. The colonial division of Africa and the wars with Native American tribes during the 1880s and 90s had a direct influence on the formation of the first popular film genres and this influence continues today, particularly in action-adventure with its fantasies of Euro-American masculine supremacy. Along with dramatizing this colonial violence film was able to exhibit, in an anthropological or zoological sense, the visible difference of "native" populations (Shohat and Stam 100–106).

Influential theorists, including Foucault, Agamben and Esposito, have tended to make Nazism a central point of reference for understanding modern biopolitics. But as Simone Bignall and Marcelo Svirsky have pointed out, although Agamben explores the exclusionary structures of sovereign power he never explores their relation to Western colonialism and imperialism. He does not pursue Arendt's argument in *The Origins of Totalitarianism* that the precedents for the Nazi genocide are to be found in the European conquests in Africa, Asia and the Americas. By proposing that the camp is the paradigmatic space of modern biopolitics, Agamben avoids the question of colonial violence opened in Arendt's account of totalitarianism—despite the fact that the concentration camp originated in the colonial space. Agamben also fails to address the question of anticolonial struggles and the critique of European racism. Many of these omissions characterize not only Agamben's account of biopolitics but also Foucault's before him. Foucault was doubtless

influenced by the intellectual climate in France during the Algerian war, when Aimé Césaire, Jean-Paul Sartre and Frantz Fanon made explicit comparisons between Nazism and French colonialism. But in his lectures from the 1970s, in which he first developed his theory of biopower and racism, Foucault never directly addressed the question of colonialism. Whatever the political or cultural reasons for these omissions, the relation between media, biopower and colonial histories remains to be more fully explored.

The Nazi genocide has its roots in nineteenth century discourses about the inevitable extinction of "inferior" races. Foucault argued that "the modern state can scarcely function without becoming involved with racism at some point" (*"Society"* 254). Racism, in its various forms, defines "the break between what must live and what must die" (254):

> The fact that the other dies does not mean simply that I live in the sense that his death guarantees my safety; the death of the other, the death of the bad race, of the inferior race (or the degenerate, or the abnormal) is something that will make life in general healthier: healthier and purer. (*"Society"* 255)

Foucault proposed that once power had become concerned with the life and death of entire populations, genocide was an inevitable consequence. Any population—not only ethnic but also criminal, deviant, subversive, degenerate or abnormal—that threatened the health, well-being, fitness or vitality of the dominant group needed to be eliminated.

In the late nineteenth century racism became influenced by Social Darwinist notions of the survival of the fittest, which in turn became aligned with arguments in favor of *laissez-faire* capitalism. The application of Darwinist theory to modern society was given its justification by a "zoological reductionism" (Crook 8) in which classes of people were viewed as "breeds" or inferior species. Eugenics applied the theory of genetic evolution to improving the health of entire populations through selective breeding and the disposal of the weak and the sick. In Western Europe, where rapid industrialization had spawned proletarian slums with all of their associated health problems, such theories appealed to many in the professional classes. In fact there was something frightening (or "traumatic") about the visual classification of life fit and unfit to live. The European middle class confronted images of other humans and saw the potential for themselves or their loved ones to be reduced to disposable life. The photographic evidence of moral and racial degeneracy provoked shock and disgust but also demanded identification with the medico-scientific gaze. As Benjamin put it, the camera user was like a surgeon who must learn to remain emotionally unaffected while performing an operation.

The relation between shock and the stereotype was also a central part of the colonial experience. Homi Bhabha discusses two "primal scenes" described in Fanon's *Black Skin, White Masks* (1952): the first is the fear of the white

girl at the sight of the Negro; the second is the encounter of the colonized subject with the racist stereotypes in children's books (Bhabha 75–76). Both scenes constitute dark skin as the mark of visible difference. Film theorist E. Ann Kaplan has read these "primal scenes" as "traumas" and argued that for Fanon the experience of going to the cinema was a traumatic repetition of the childhood encounter with the racist stereotype. The image of the Negro on the screen ruptured, once again, the black viewer's unconscious identification with the dominant imaginary order of whiteness (Kaplan 150–151).

Fanon's account of colonial trauma explained the oppression of the colonized subject through the production of the biotype and the functioning of the anthropological machine. In *The Wretched of the Earth* (1961), Fanon described how the colonized subject was denied a human identity and was imagined by the colonizer as part of the natural landscape occupied through colonization. The native was part of a hostile environment which must be subordinated to colonial rule. The colonizer produced stereotypes of the colonized: a criminal, a thief, a murderer, a predator, a savage who is violent, impulsive, aggressive, irrational and of low mental capacity. The colonized subject was also pathologized by academic psychiatry. Finally, the primitivism of the colonized subject was seen as a result of biological and neurological underdevelopment. Fanon cites a Dr. Carothers of the World Health Organization who defined the African as a "lobotomized European" (302) and went on to explain in further detail the academic conception of colonial psychology:

> "the layout of the cerebral structures of the North African are responsible for the native's laziness, for his intellectual and social ineptitude and for his almost animal impulsivity. The criminal impulses of the North African are the transcription into the nature of his behavior of a given arrangement of the nervous system. It is a reaction which is neurologically understandable and written into the nature of things, of the thing which is biologically organized." (*Wretched* 303)

The passage which follows strongly resonates with Foucault's later account of disciplinary power:

> The lack of integration of the frontal lobes in the cerebral dynamic is the explanation of the African's laziness, of his crimes, his robberies, his rapes, and his lies. It was a sub-prefect who has now become a prefect who voiced the conclusion to me: "We must counter these natural creatures," he said, "who obey the laws of their nature blindly, with a strict, relentless ruling class. We must tame nature, not convince it." Discipline, training, mastery, and today pacifying are the words most frequently used by the colonialists in occupied territories. (*Wretched* 303)

For Fanon criminality was not a consequence of hereditary characterization or of neurological underdevelopment but of a relation of power in

which the colonist controlled the judicial and administrative system. The colonized were forced to struggle for survival in a situation where wealth and resources, including those of medical science, were owned and controlled by their masters. During the Algerian war European psychiatrists were known to have administered electric shock treatments to prisoners as a means of extracting information (*A Dying Colonialism* 138). The use of psychiatry by the colonizer was biopolitical, relating mental illness to racial inferiority and degeneration and employing shock treatment as a form of social control. Fanon attempted to reverse this in his analysis of colonial trauma as identification with the racial stereotypes produced by the dominant culture. Colonial trauma was a question of internalizing the gaze of European power. Fanon's account of colonial trauma allows us to grasp the role of media images, along with anthropological, biological, medical and psychiatric discourses, in producing the colonized subject. As we shall see, there were also close resonances between the European construction of the African biotype and the anti-Semitic conception of the Jew. For these reasons Fanon provides an important alternative to Arendt's Eurocentric account of colonial trauma in *Origins of Totalitarianism* and a useful corrective to Agamben's neglect of colonialism in his discussion of Arendt.

Agamben, Arendt and Colonialism

In the opening pages of *Homo Sacer*, Agamben constructs a new synthesis of Foucault's concept of biopolitics and Arendt's analysis of the modern politicization of life in *The Human Condition* (1958). He sees the work of these two theorists as both indicating a central problem—"the politicization of bare life" (4)—that neither thinker was able to fully address. Agamben notes that Arendt does not make any explicit connection between her discussion of biopolitics and her earlier analysis of totalitarianism, and that Foucault, while claiming biopolitics as the defining feature of modernity, never offered any direct commentary on totalitarian power or the concentration camps. Agamben also comments that a "biopolitical perspective is altogether lacking" (4) in Arendt's *Origins of Totalitarianism*: she recognized the production of bare life in the concentration camps, but she saw this as an experiment in total domination rather than an extension of already established forms of biopower.

Arendt did, according to Agamben, grasp the important link between the notion of human rights and the crisis of the modern nation-state: without national citizenship the human individual is effectively stripped of any political rights. The Declaration of the Rights of Man in 1789 granted political rights by the very fact of birth rather than to the subject, as had been the case under the system of royal sovereignty. Even Roman law had based citizenship on birth in a particular territory and from citizen parents, but the French Revolution transformed these rights of birth by making life the "origin and ground of sovereignty" (129). The separation between natural

and political life was abolished. When the nation-state entered into a period of crisis following World War I, human populations became open to the more direct forms of biopolitics practiced by totalitarian states. The extreme form of this equation of biology and political rights was the Nazi identification of racial purity with national citizenship.

Agamben's analysis of sovereignty neglects to address both the larger history of European imperialism and the importance of race theory in reshaping modern politics. For example, Elisa von Joeden-Forgey has explained how the German state turned to race-thinking as a means of legitimizing violent oppression in its colonies in Africa. Categorizing the colonized as "natives" (*Eingeborene*) was designed "to include colonial subjects within the boundaries of German state power (sovereignty) while excluding them from any institutions that would limit that power" (23). This legal category of "native" (resembling Agamben's conception of bare life) served to justify and legitimize massacres, atrocities, violent corporal punishment and, ultimately, genocide. Through racist ideology the category of native moved from a political and legal one to a biological one. After becoming established in the colonies, race-thinking was adopted in the European context by pan-German movements and combined with anti-Semitism, forming a basis for Nazism.

Agamben ignores the role of the colonies in providing a space where the radical implications of biopolitics were first applied and tested. Instead he finds the key to biopolitics in the application of medical and scientific knowledge to population control. In a pamphlet published in Germany in 1920 advocating euthanasia, Agamben finds "the first judicial articulation" of the "fundamental biopolitical structure of modernity—the decision on value (or non-value) of life as such" (*Homo Sacer* 137). Agamben sees in this pamphlet a proposal for a new judicial category of "life devoid of value" (139) that corresponds to the bare life of *homo sacer*. The Nazi state put this new judicial category into practice when in 1940–41 it undertook the extermination of those defined as incurably mentally ill. In *The Origins of Totalitarianism*, however, Arendt had shown how the biological principal of selecting life fit to live was already operating in the colonies. She argued that evolutionary theory effectively subsumed natural life into the historical process allows the extinction of "primitive" races to be understood as natural selection in its historical form. Totalitarian governments in Europe then applied the same rationalization to the destruction of specific ethnic groups and social classes.

Arendt's pioneering analysis was contradicted, however, by another strand in her argument: a narrative of degeneration. Unfortunately Arendt's historical analysis of totalitarianism suffers from its own racist assumptions; for example when she comments that America and Australia were "without a culture and a history of their own" (186) and that the nations of Africa were "without the future of a purpose and the past of an accomplishment." She describes Africans "as incomprehensible as the inmates of

a madhouse" (190). The natives "had not created a human world, a human reality" (192) but remained subject to nature as an overwhelming force. In fact Arendt's assumptions about Africans were virtually identical with those of the colonial psychologists criticized by Fanon.

In the colonies, argued Arendt, the European regressed to the level of the natives, imitating their practices of enslavement and genocide rather than establishing political rights on the model of the Western nation state. According to Arendt the wars between African tribes had already set a precedent for European extermination, and the history of these people remains "unreal" and "incomprehensible" (193). This designation of African culture and society as incomprehensible is the basis of Arendt's account of the historical trauma of colonization. Later the notion of incomprehensibility became widely associated with the Holocaust. In both cases the construction of a "traumatic" encounter reproduced the biological assumptions about the human species that underpinned the practice of genocide. Western nations did not "learn" genocide from African nations, degenerating to their level of primitive violence and bringing it home to Europe. Rather the construction of the "native" as nonhuman was part of a European conception of racial hierarchy and species evolution.

Arendt's account of the encounter between European and African was based on widespread ideas from the nineteenth century about nervous degeneration. The interpretation of neurological disorder as hereditary was subsequently joined with the theory of evolution, emphasizing the advanced development of the nervous system as what distinguished humans from animals. The complex nervous condition of "civilized man" also meant greater vulnerability to pathological breakdown. The degeneration hypothesis also played its role in racial theory. Western civilization was contrasted with "primitive" and "savage" peoples whose cerebral apparatus was at a lower level of evolutionary development. There was always the danger, moreover, that the civilized might degenerate to the savage state (Oppenheim 270–282).[1]

Arendt grasped an important historical link between European colonialism and Nazism but she inflected it with anxieties about race and social exclusion. Michael Rothberg has argued that *The Origins of Totalitarianism* "demands a double reading" (37), one that both acknowledges and learns from Arendt's original historical insights but also recognizes her racist and Eurocentric assumptions about colonialism. Rothberg argues that Arendt's account of European imperialism is a narrative of trauma: the profound shock suffered by the colonizers when confronted with the African native who appeared outside their conception of the human. But Rothberg does not discuss the ways that the psychoanalytic conception of trauma is itself premised on a universalized Western subject. Rothberg argues that the "physical and epistemic violence of colonialism" is "traumatic" insofar as it produces the biopolitical distinction between the human and inhuman. Later in this chapter I will discuss how the very notion of trauma appears

bound to a narrative of regression that proves to be problematic in Arendt's text. Thus, Rothberg proposes, we must acknowledge the possibility that

> the "shock" experienced by Europeans in Africa emerged from the very universalism and humanism of Enlightenment thought, which leads the colonies to expect an encounter with sameness. It is from within the expectation of homogeneous universality that difference becomes traumatic.
>
> (Rothberg 62)

This account of trauma does not include the point of view of the colonized, as described by Fanon. There is a still more unsettling possibility, not considered by Rothberg, that trauma is used by the colonizer as a narrative frame *in order to* justify the production of difference, including racial hierarchies and the distinction between the human and inhuman. To describe the historical experience of colonialism or Nazism as "traumatic" is always open to different interpretations, depending on whose historical experience is at stake—victim, survivor, witness or perpetrator. But the biopolitical caesura that separates the human from the nonhuman defines relations of power that have very real and specific consequences.

Night and Fog

Arendt's narrative of colonial trauma and degeneration, having acknowledged the historical relation between colonialism and Nazism, reinscribes the Western human subject as biologically superior to colonized peoples. This double movement of acknowledgment and retraction characterizes attempts by both intellectuals and statesmen during this period to account for this historical relationship. Raphael Lemkin, a Polish-Jewish lawyer, coined the term "genocide" in 1944. The recognition of this crime is usually associated with the Holocaust but, as A. Dirk Moses has shown, Lemkin himself associated it first with colonization and empire. The Nazi genocide in Eastern Europe followed the precedent of the European conquest of the Americas: the occupying power needed to wipe out the much larger indigenous population in order to establish demographic dominance (Moses 8–10). Lemkin saw the Nazi genocide as not limited to the extermination of the Jews but as part of a larger plan to colonize Eastern Europe after Germany's failure to win significant territories in Africa or Asia. In the case of Herman Göring the relationship was direct: he was the son of Heinrich Göring, who had been a colonial governor in Southwest Africa. In 1904 up to 50 percent of the Nama and up to 80 percent of the Herero who rebelled against German rule in Namibia were wiped out in retaliation (Olusoga and Erichsen 10–11).[2] Hermann Göring oversaw the brutal expansion of the Third Reich into the conquered territories of Eastern Europe and when later questioned at the Nuremberg Trials justified the genocidal policies of

the Nazis by comparing them to the colonization of the Americas and the advance of the British Empire. Göring's self-defense was completely cynical, but it was true that not only the Germans were guilty of genocide.

Alain Resnais's film *Night and Fog* was completed in 1955. Years later Resnais claimed that he intended the film to suggest a comparison between Nazism and French colonialism and racism. His film has more recently been interpreted within the frame of the Holocaust as a historical trauma. *Night and Fog* tells a specific story: the planning and construction of the camps; the round-up and transportation of the victims; the shock of arrival at the camp; the prisoners being forcefully undressed, shaved, tattooed, given a number and a uniform. Most of this is shown on screen by using archival images produced by the Nazis, who made sure to document the entire process of extermination. Other footage from the Allied liberation of the camps shows mounds of emaciated naked bodies, piles of corpses burned or prepared for burning, and finally the emaciated bodies being thrown and bulldozed into mass graves. This visual documentation of the degradation and destruction of human beings remains some of the most extreme available to public view.

Night and Fog is widely acknowledged as the first important documentary about the Holocaust, yet the film only once mentions the Jews (although many individuals and groups are clearly shown wearing the Star of David). Nor does the film acknowledge the complicity of the French Vichy government in the deportation of 80,000 Jews as part of the Final Solution. The one image that directly showed the French involvement in the genocide was a still of a French *gendarme* guarding a group of deportees and this was blocked out by the French censors (Rice 23–27). To complicate matters further, Resnais later claimed in an interview that *Night and Fog* was "about" the French-Algerian war which began in 1954. By 1955 reports had begun to circulate of torture being used by the French army to repress the Algerian struggle for independence. Again, however, the film never makes any explicit comparison between French and Nazi terror. The absence of any clear reference to the Jewish victims, the French involvement in the Nazi crimes and the comparison with the colonial repression in Algeria leaves *Night and Fog* with universalized claims about responsibility attached to specific images of genocide.

In the postwar period various political interests aligned to repress the memory of the Holocaust: America was building an alliance with West Germany against the threat of Soviet communism; several nations, including France, wanted to dissociate themselves from their wartime collaborations with the Nazis; Great Britain and America wanted to evade responsibility for failing to intervene in the extermination process. The German government demanded that *Night and Fog* be removed from the French entries in the Cannes Film Festival of 1956 and the French complied.

On the other hand, as Rothberg has shown, the critique of Nazism as an extension of colonial violence was common in anticolonial discourses in the postwar period. French war crimes in Algeria were seen by leading intellectuals such as Sartre as consistent with the Vichy involvement with the

Nazis. It was this political context that framed the production and reception of *Night and Fog*. The film emphasizes the industrial process of mass killing, as Mathew Croombs puts it, from "the round-up of Jews like cattle in the Vel' d'Hiv', to the socioeconomic classification of prisoners productivity, to the transmogrification of these same prisoners' bodies into commodities like soap and fertilizer" (11). As Debarati Sanyal notes, the film continually reiterates the role of the camp in the military-industrial economy. The complete exhaustion of the inmates' bodily resources is extended even beyond death with the recycling of hair, bone and body fat (155). The dehumanization of the Jews was aligned by Sartre and Fanon with the economic domination of Algeria in which people, like land and livestock, were treated as a resource available for limitless exploitation and punitive control. For Sartre the Algerian, like the Jew, had been reduced to the status of subhuman. Both torture and concentration camps formed part of the French political repression of Algeria throughout the 1950s.

For today's viewers the connections between *Night and Fog* and the Algerian War may be more difficult to make: the crowds of victims rounded up and stripped naked before being killed, the mounds of naked corpses in the death camps—these images make the bare life of the Jews highly visible, indeed they have become iconic for public memory in the West. The incarceration and torture of Algerians was not visible to those outside the immediate context of Algeria itself. The violence of French colonialism was and remains *veiled*, despite the enduring power of Sartre's denunciations, Fanon's anticolonial rhetoric or Gallo Pontecorvo's film *The Battle of Algiers* (1966), which dramatized the French use of torture.

In recent decades *Night and Fog* has sometimes lost this association with the Algerian War and instead has been widely discussed in the context of the Holocaust and trauma studies. Joshua Hirsch calls *Night and Fog* "the most important, if not the sole, originator of posttraumatic cinema" (28).[3] Hirsch proposes that the film's failure to directly refer to the extermination of the Jews was typical of leftist anticolonial politics. More importantly for Hirsch the film contributed to an emerging discourse of historical trauma. He argues that the footage showing the liberation of the Nazi camps, widely exhibited at the end of the war, "so overwhelmed the historical consciousness of the spectating public that the images failed to register" (55). According to Hirsch *Night and Fog* self-consciously addressed this historical trauma and the problem of remembering and acknowledging the past. The film attempted "to have spectators open themselves up to the traumatizing potential of the images without having to resort to the defenses of numbing, denial, or premature mastery" (Hirsch 61). Libby Saxton also agrees that the film presents images of historical trauma and "confounds our desire to know and understand while implicating us bodily, affectively and ethically" (Saxton 90).

Night and Fog can be seen, along with *The Origins of Totalitarianism*, as one of the founding texts establishing the Holocaust as a historical trauma.

By focusing on the processes and machinery of extermination the film reveals the biopolitical operation whereby the state reduced human individuals to the condition of animals available to be slaughtered, their bodies harvested as a source of biopower. This emphasis on the calculated, preplanned and carefully organized aspect of mass destruction does not sit easily with the interpretation of the Holocaust as incomprehensible or unrepresentable. One problem is that almost all of the images were produced either by the Nazi perpetrators or the Allied liberators. The "trauma" of witnessing the Holocaust is supposed to establish empathy with the victims and survivors but it also situates the viewer in an apparatus of visibility and power. The narration by camp survivor Jean Cayrol is at odds with this visual language of domination and annihilation. On one hand we are asked, by Cayrol's verbal text in the film, to acknowledge the impossibility of showing the reality of the camps. We are then asked, by subsequent commentators, to participate in the traumatic memory of the camps by "opening" ourselves to our "implication" in the events. These invitations to witness the trauma of the Holocaust assume a humanist empathy with the victims.

The "incomprehensible" sufferings of Holocaust victims also resonate, however, with longer histories of colonial violence in which the perspective of the perpetrator is somehow justified by the nonhuman otherness of the colonized. As we saw in Arendt's text, trauma narratives may be seen as registering the profound shock of encountering extreme difference, but in doing so they also reinscribe the biopolitical caesura that separates the fully human from the sub- or nonhuman. The original subject of trauma, the hysteric, was associated in the nineteenth century (like the Jew) with biological degeneracy. Although Freudian psychoanalysis and, more recently, trauma theory attempts to recover repressed histories and ask us to acknowledge past events that we may wish to forget, these interpretive and therapeutic paradigms are historically enmeshed with biopolitical conceptions of degeneracy and race. Our ability to identify with the sufferings in the camps is limited by the historical construction of the human within the structures and institutions of Eurocentrism and anthropocentrism. *Night and Fog*, whether interpreted as an allegory of colonial power or as a film transmitting the trauma of the Holocaust, carries the legacy of biopolitical media in the production of bare life.

Colonial Trauma

To move beyond the humanist assumptions of historical trauma narratives we need to consider the role of visual media in producing biotypes and constructing immune systems that induce and absorb shock. Accounts of colonial trauma by Sartre, Césaire, and Mannoni were, as Rothberg has shown, contemporary with and responded to the revelations of the Nazi death camps. Like Arendt's *Origins of Totalitarianism*, some of these accounts reproduced Eurocentric conceptions of the colonies as a space of

psychic regression. Fanon presented perhaps the strongest challenge to these accounts of colonial trauma and his work includes a direct engagement with the biopolitics of colonial institutions and discourses.

Freud's conceptualization of the unconscious drew on anthropological research that was embedded in European colonial power. The unconscious was the "dark continent" and the rituals and taboos of "primitive" societies corresponded to the forgotten childhood of European civilization. Like infants, colonized peoples were regarded as primarily irrational. Freudian psychoanalysis assumed the white European male as the norm of mental health, implicitly positioning the colonized subject as mentally ill or abnormal. Freud borrowed from colonial archeology in his formulation of the unconscious and the origins of repression. He metaphorizes woman as the "dark continent," thereby aligning female sexuality with "primitive" Africa (Khanna 49), revealing his self-conception as a heroic male figure akin to nineteenth century European explorers and archaeologists, uncovering the lost and hidden parts of the world. The Freudian unconscious defines an individual subject who has emerged from infantile consciousness and has repressed those irrational impulses that give him/her a psychic history and interiority. The colonizing group similarly constituted its cultural superiority by assigning the colonized to a psychologically undeveloped state.

Ranjana Khanna argues that just as the Freudian conception of the individual psyche emerged in the context of European nationalism and colonialism, so in the postwar period Sartre's existential philosophy registered the historical impact of the Holocaust and anticolonial struggles. Unlike Freud, with his images of the unconscious as archaeological excavation or colonial frontier, Sartre emphasized conscious agency and pragmatic intervention in psychoanalysis. Sartre rejected the theory of the unconscious and formulated instead a conscious subject who nevertheless often failed to fully understand or recognize his social and historical situation. The subject did not act out of unconscious motivation but achieved authentic existence through historical agency based on conscious choice. Sartre also rejected French Surrealism because of its embrace of the Freudian unconscious. For Sartre the theory of the unconscious prevented the subject of psychoanalysis from achieving full self-consciousness. For the same reason, he argued, the Surrealists' desire to immerse themselves in the cultural unconscious prohibited effective political agency. Sartre, however, supported the Negritude movement as a more proper surrealist poetics that was grounded in political struggle. One of the leaders of the Negritude movement, Aimé Césaire, wrote of the "colonial trauma" (126) based in the history of domination from which the black must liberate himself. The notion of colonial trauma suggests a collective unconscious formed through the experience of colonization. Sartre interpreted this as a struggle for historical agency: through the remembering of colonial trauma the colonized answered back to the colonizer and forced him to recognize a history of oppression. Sartre's emphasis on free agency, however, was difficult to reconcile with the implications of collective traumatization.

Like Arendt's *Origins of Totalitarianism*, Césaire's *Discourse on Colonialism* (1955) made an explicit link between the Nazi crimes and the genocide perpetrated by European powers in the colonies of Asia, Africa and the Americas. Césaire argued that colonization brutalized the colonizer. In the colonies the European master regressed to a state of violent hatred toward the colonized subject. By accepting this structure of violent domination European civilization was "infected" by this regression toward savagery. As Rothberg points out, the trope of regression reproduced the idea that European cultures were more advanced than non-European cultures, which Césaire shared with Arendt.[4]

Through the experience of clinical practice Fanon developed a critique of the colonial mental institution, anticipating Foucault's later analysis of psychiatric power. In the late 1940s he worked as a psychiatrist in a hospital in Algeria. His patients included both French soldiers, who worked as torturers, and their victims. Fanon's psychology of black oppression has its origins in ethnopsychiatry, beginning with attempts by European psychologists to understand the "African mind." This involved situating the peoples of Africa in a historical teleology leading from the primitive origins of human society to the advanced civilizations of Europe. Richard C. Keller explains how mid-nineteenth-century Europeans imagined North Africa as a "space of savage violence and lurid sexuality, but also a space of insanity" (1). Later, during the decolonization struggles of the 1950s and 60s, North African writers argued that this insanity was the result of the traumas of colonization. In the interim period colonial asylums were established as "a key component of France's imperial project in North Africa" (3). Concepts of mental health were integrated with goals for productivity and labor power. The colony served as a laboratory in which to conduct psychiatric research on the North African who was "born criminal" or "born insane." In a "biocracy" (55) social evolution would be directed by the life sciences. After the massive trauma suffered by soldiers in World War I psychiatry was promoted as increasingly central to national health, prosperity and "biological regeneration" (65).

Fanon's critical engagement with ethnopsychiatry gave him important insights into what Foucault would later call biopolitics. During the Algerian war medicine and psychiatry were used in attempts to retain control over the colonized population. The French army used psychological warfare and torture, including electro-shock to combat revolutionary terrorism, which they saw as evidence of Arab madness. Professor Porot of the University of Algiers concluded in 1918 that the North African Muslim was neurologically underdeveloped and prone to compulsive violence. In the 1950s a Dr. Carothers of the World Health Organization extended Porot's argument to include all Africans, whose supposed lack of cultural development was due to genetic inheritance (McCullogh *Black Soul* 17–19). Carothers proposed that the African had little capacity for intellectual reflection, was ruled by his emotions, and was prone to violence. In this way anticolonial rebellion was explained by genetic deficiency rather than by political oppression and economic exploitation.

The turning point in ethnopsychiatry came with Octave Mannoni's *Prospero and Caliban* (originally published in 1950 as *Psychology of Colonization*), which was the first study to consider the psychological effects of colonial domination. Mannoni advanced beyond the biological account of the native when he acknowledged the ambivalence of the colonizer whom both looked down on the native as culturally inferior but also envied for his supposed freedom from the restraints of civilization. The narrative of degeneration was again reiterated in Mannoni's diagnosis: in the colonies the settler progressively lost contact with civilization and regressed to the cultural level of the native. According to Mannoni's analysis the natives too had regressed psychologically to a state of infantile dependence on the colonizer. But for Mannoni colonialism was ultimately progressive because it fostered a difficult process of psychological maturation for native peoples.

In *Black Skin, White Masks* (1952), Fanon extended and directly criticized the analysis of colonial psychology begun by Mannoni. In Fanon's analysis the black child was traumatized by the stereotypes imposed by the dominant European culture that negated black cultural identity and social experience.[5] The black wanted to escape from his social origins and sought acceptance by and integration into the white world. But this was impossible because of the visibility of difference based in skin color. Fanon began *Black Skin, White Masks* with a proposition: "the black is not a man" (10). Fanon proposed that only psychoanalysis can explain the complex relation between the white man, who believed in his innate superiority, and the black man, who sought recognition and equality. The psychic structure of the individual derived from his social situation, involving racial inequality and prejudice. The black man defined his identity by internalizing the gaze of the whites, thereby internalizing visible difference—the color of his skin. The trauma for the colonized was not necessarily the direct experience or witnessing of violence but the repeated symbolic violence that undermined the formation of a positive self-image. The basis of Negrophobia was sexual and biological: "The Negroes are animals. They go about naked" (165).

Bare Life: Algeria Unveiled

The psychological conception of trauma has its roots in anxieties about sexuality and degeneracy among the urban poor and colonized peoples. In the nineteenth century the medico-scientific management of life at the level of populations and species made both race and sexuality a focus of surveillance, intervention and regulation. The health of the race demanded the control of sexual behavior and reproduction. Domestic hygiene and personal morality played important roles in maintaining racial superiority and colonial dominance. Policing normality defended society against biological enemies (Stoler 33–35). The control of sexuality as biopower shifted away from the traditional regulation of sexual life by marriage and religion. In the colonies, sexual relations between men of the colonizing society and "native"

women were often accepted in forms outside marriage that would have been seen as illicit in the home country. Arguments against "racial mixing" saw sexual relations with the colonized as a symptom of moral degeneration. At the same time the visual representation and symbolic possession of "native" women also formed part of the colonial economy. In Algeria anxieties about the sexuality of Arab women were played out specifically with respect to the wearing and removal of the veil. The veil was associated with traditional Arab society and its removal with the secularization and modernization of Muslim women.

In *The Colonial Harem*, Malek Alloula presents a collection of postcards of Algerian women produced by the French in the early twentieth century. In these images the faces and breasts of Arab women were exposed for the voyeuristic pleasure of the colonist. To be able to look at native women was a feature of the possession of colonial territories. Concealed by the veil, the Algerian woman was unavailable for the colonist's scopic pleasure. The invisibility of the woman behind the veil was a reminder of the private space of the Algerian home that was also outside the colonists' visual domain. The veil signified a reserve, a space that remained beyond surveillance and control. The unveiling of the Algerian woman signified the intrusion into, and taking possession of, this space. In *A Dying Colonialism* (1959) Fanon explains that it is the veil worn by Arab women that most obviously signifies the difference between Arab and Western societies. The universalizing of the Arab woman was the first decisive step in the colonists' attempt to dismantle Arab culture. The veil was seen as a form of medieval barbarism from which the Arab woman must be liberated. But this unveiling was also eroticized. Fanon compared this to the "aura of rape" that, as Sartre had claimed, surrounded the Jewish woman. Conquest and colonization brings with it the rape of captured and subject women. The unveiling of the Arab woman carried this history of forceful possession and sadistic pleasure. During the French-Algerian war this unveiling took on a new urgency under the state of emergency.

The year following the first publication of Alloula's *Colonial Harem* in 1981 saw the appearance of another collection of photographs, Marc Garanger's *Femmes Algériennes 1960*. Garanger worked for the French army as an official photographer during the war and produced a series of identity cards showing unveiled Algerian women. Only six of these photographs were published at the time. In Garanger's photographs the women were unveiled not for the purpose of the viewer's erotic gratification but to make their faces available to be recognized by the police. Yet in these photographs the facial expressions of the Algerian women, particularly the determined ways that they hold their mouths (almost always closed) and the directness and defiance with which they look at the camera, appear to challenge the authority of the photographer and his right to record their faces and bodies. The women are presented for the colonial gaze that had long fixated on the exoticism and eroticism of Arab women. Indeed the other thing that strikes the Western viewer of these photographs is the evidence

of a distinct culture evident in the clothing, cosmetics and jewelry: neck-laces, bracelets, rings, brooches, layers of fabrics and headscarves decorated with ornamental needlework, face powder and heavy eye makeup adorn the women. These photographs convey something of an entire society and way of life, possessed with dignity, pride and a hostility to the occupying power. The production of these identity photographs required the destruction of the traditional distinction between private and public life in Arab society. These women who had previously only revealed their faces to their families now become an object of knowledge and power. They are posed against rough stone walls and exposed to the open light of day. But apart from recording the individual features of each person what do they tell us? The different faces do not conform to any racial stereotype and the private lives of these women remain withheld from view.

If *Night and Fog* was "about" the French use of torture and concentration camps in Algeria it never stated this explicitly, either verbally or visually. Harun Farocki's documentary film *Images of the World and the Inscription of War* makes this connection more explicit by juxtaposing Garanger's photographs of Algerian women with photographs of prisoners arriving at Auschwitz. More directly than Resnais, Farocki suggests that the trauma of the camps is related to the trauma of colonization. By basing this comparison of the Holocaust and the Algerian war on concrete images of surveillance, Farocki shows the common basis of these events in biopolitics. This chapter will conclude with a more detailed discussion of Farocki's film, but first we should consider how theories of the gaze and the look, developed earlier by Sartre and Fanon, influenced Farocki's montage of historical documents.

The Look, the Gaze and Biopower

The role of the look and the gaze in relations of power is a theme that runs through the various writings of Sartre, Fanon and Foucault. For Sartre the look (*le regard*) turned the individual subject into an object for the Other. The subject achieved freedom and transcendence by reducing the Other to an object; for example, the anti-Semite who denied the humanity of the Jew. Fanon was influenced by Sartre's account of the look and anti-Semitism when formulating his own critique of colonial racism. Like the Jewish woman in Sartre's account, Fanon saw the Arab woman as the object of sexual desire and sadistic impulses for the European male. Foucault extended the con-cept of the gaze to include larger forms of institutional power, such as the medico-scientific gaze that defined the patient as an object of knowledge and power. The individual was seen and understood in terms of codes of repre-sentation and visibility and in terms of discourses that define and interpret human appearance. The gaze of the panopticon equalized all individuals as objects of surveillance. The subject internalized the panoptical gaze and transformed him/herself into an object of self-surveillance. The panopticon showed that the gaze was not only a feature of intersubjective relations but

could be manifest in depersonalized architecture and technology, including the camera. As we have seen, Foucault never developed an analysis of modern visual media or of colonial power, although questions of vision were a persistent concern in his writings.

Sartre elaborated his conception of the look in *Being and Nothingness* (1943). To be aware of being seen is to apprehend one's self as an object for the Other, whose look is experienced by the subject as anxiety, shame, anguish and fear. Generalizing on this fundamental human condition, Sartre commented that he was situated as "a European in relation to Asiatics, or to Negroes" (279). The question of the look returned Sartre to the problem of European colonialism and racism. He developed a more detailed analysis of this problem in his long 1946 essay "Anti-Semite and Jew." Sartre argued that anti-Semitism constituted a form of sovereign power. The sovereignty of the community of anti-Semites was established through the violent exclusion of the Jew. This violence was sanctioned by the laws of national citizenship and at the same time stood outside or above the law because anti-Semitism defined a community more pure and of a higher social order than that of legal citizenship (*Anti-Semite* 31–32). Society was purified of evil through the expulsion or extermination of the Jew. The hatred of the Jew also contained "a profound sexual attraction" (46) expressed through sadism.

Sartre's analyses of the look and of racism anticipated many of the themes later developed by Foucault and Agamben, including a critique of liberal democracy for failing to address the implications of biopolitics. Sartre argued that the universal humanism espoused as part of liberal democracy could not understand the nature or power of anti-Semitism. Democracy did not want to acknowledge cultural particularity and difference:

> there may not be so much difference between the anti-Semite and the democrat. The former wishes to destroy him as a man and leave nothing in him but the Jew, the pariah, the untouchable; the latter wishes to destroy him as a Jew and leave nothing in him but the man, the abstract and universal subject of the rights of man and the rights of the citizen. (*Anti-Semite* 57).

For Sartre, being Jewish was not defined by racial attributes, cultural practices or religious beliefs, but by the historical and political situations that defined the Jew: "The Jew is one whom other men consider a Jew" (69). By emphasizing the construction of the Jew in the anti-Semitic stereotype, however, Sartre also failed to acknowledge the importance of tradition and historical experience for Jewish collective identity.

Fanon's account of colonial psychology owed much to Sartre. Like Sartre, Fanon rejected any pregiven Freudian formulations, such as the Oedipus complex, as offering universal accounts of human behavior. The colonized subject chose to identify with the stereotypes imposed by the dominant

colonizing culture in a misguided attempt to achieve an autonomous, authentic identity. But because the colonial situation demanded that this choice would fail to realize itself, a traumatic disturbance emerged in the experience of the colonized. The trauma was not unconscious but the product of a political situation of violence and inequality. Fanon's colonial psychology was directly indebted to Sartre's account of the look, through which the subject is alienated as an object for the Other. The colonial stereotype divided the world into images of blacks and whites and the colonial subject differentiated him- or herself by conforming to this image system. Setting out to become white, the colonized subject instead experienced the trauma of being seen as black. It was only by consciously choosing blackness and negating the white stereotype that the colonized could transform their historical situation.

Farocki's *Images of the World*

Fanon's account of colonial trauma presents an important alternative to Arendt's narrative in *The Origins of Totalitarianism* connecting the European experience of colonialism to the Nazi genocide. Arendt understood bare life primarily in terms of a shock for European conceptions of the human. Fanon's analysis of the colonial stereotype and the look reminds us that bare life is always produced by a system of power. The idea of a "traumatic" encounter with racial difference or the dehumanized victims of Nazism reproduces the biological caesura upon which humanism depends. Fanon asks us to imagine the impact of this caesura on those who are excluded from full human subjectivity. *Night and Fog* dramatized this problem by presenting visual documents of the Nazi process of extermination juxtaposed against a verbal text composed by a survivor of the camps. The images were almost all produced by the perpetrators and the voiceover asked us to consider the impossibility of showing the experience of the victims. This tension between image and voice in *Night and Fog* has been typical of subsequent discourses about and representations of the Holocaust as a historical trauma: we are invited to identify with the sufferings of the victims while also being reminded of the impossibility of understanding their experience. The photographic documentation puts us in the position of the perpetrators, with whom identification is taboo. The attempt to identify with the victims on the basis of universal human values, however, is doomed because they were defined by their exclusion from full human status.

Night and Fog never explicitly made the comparison with French colonialism that Resnais claimed that he implied by the film. Perhaps the film could not make this comparison explicit because to show that colonialism and Nazism both used a biopolitics of visual classification would have undermined the humanist claims of its "traumatic" account of the genocide. The narrative of the Holocaust as historical trauma demands that we denounce racial persecution and violence as a crime against humanity but

it does not require us to consider how the human and nonhuman are constituted through systems of visual representation. To consider this would be to see the Nazi genocide not as a trauma for humanity but a trauma for all of those who have been excluded from the European conception of the human. By comparing photographs of Algerian women with a photograph of a Jewish woman at Auschwitz, Farocki requires the viewer to confront this question in ways that *Night and Fog* had been unable to do.

Thomas Elsaesser describes Farocki as "first and foremost an archivist" ("Harun Farocki" 27). But unlike television documentaries, which simply edit together archival images as self-evident facts supporting a narrative, Farocki's films confront the audience with the choices and interpretations that underlie any audiovisual text. His essay film, *Images of the World and the Inscription of War* (1989) is an extended meditation on vision and visuality and on image-producing technologies and image archives. Farocki presents a range of examples of the ways that drawing, photography, video and digital technologies record and encode the visible world. He considers the differences between the perception of the eye—both human and animal—and the camera. He shows how the encoding of the visual world by photography paves the way for the image as digital information. His examples include: architectural reconstruction, aerial photography, flight simulations, automated factory assembly lines, life drawing of nude models, makeup applied to the face of a female model, drawings and photographs from the Nazi death camps, identity cards of Algerian women, and composite images of the human face. Farocki juxtaposes archival images with his own footage in an intellectual montage informed by pioneering directors such as Eisenstein and Godard and by critical theorists such as Benjamin, Arendt, Fanon, Foucault and others.

In Farocki's films the interrogation of the frame is often posed as a meditation on preservation and destruction. In *Images of the World and the Inscription of War*, Farocki pauses over a photograph of a woman who has just arrived on the ramp at Auschwitz:

> a woman has arrived at Auschwitz; and the camera captures her in the act of looking back as she walks by. On her left, an S.S. Man holds an old man, also recently arrived at Auschwitz, by the lapels of his jacket with his right hand: a gesture of sorting. In the center of the image the woman: the photographers always point their cameras at the beautiful women. Or, after they have set up their camera somewhere, they take a picture when a woman they consider beautiful passes by. Here on the "platform" at Auschwitz, they photograph a woman the way they would cast a glance at her in the street. The woman knows how to take in this photographic gaze with the expression on her face, and how to look ever so slightly past the viewer. In just this way, on a boulevard she would look past a gentleman casting a glance at her, into a store window.

She shows that she does not respond to the gaze but is still aware of being looked at. With this gaze she transports herself into a different place, a place with boulevards, gentlemen, shop windows, far from here. The camp, run by the S.S., is meant to destroy her and the photographer who captures her beauty for posterity is part of the same S.S. How the two elements interact—destruction and preservation!

(Farocki 199)

Today this image has become yet another example of a "Holocaust victim." But Farocki asks us to consider how she glances at the camera, how this glance might have once been directed at a photographer on a city street, and how she wishes her beauty could return her to the boulevard and her glance remove her from the ramp. The new frame that Farocki constructs for the picture is provocative because we know that the woman can never tell her story and that the power to produce the image lay entirely with the Nazi apparatus of extermination. Farocki attempts to restore a subjective experience to one who has been reduced to an object to be captured, detained, transported, looked at and "selected" for life or death. The woman on the ramp is familiar with the look of the male who constitutes her as an object of admiration and desire. Her subjectivity in everyday urban life (if indeed she is from the city—we don't know anything about her personal history) is partly defined by the multitude of looks she receives from men on the street. When she is photographed on the street she composes herself as an elegant woman of fashion. But when the photographer, who is also an S.S. Man, looks at her through the camera she is constituted as an object of the biopolitical gaze: she is defined by her race and her membership in a population that has been consigned for annihilation.

The photograph of the woman on the ramp at Auschwitz is taken from the album of photographs showing the arrival of Hungarian transports in 1944. The album was discovered by a Jewish woman, Lili Jacob, at Dora-Nordhausen concentration camp at the end of the war. Auschwitz had a specialist photography department, including two darkrooms and a room for producing identity photographs. As the camp became more crowded only political prisoners were photographed. The photographs on the ramp were probably taken by SS Sargent Bernhardt Walter. At least three such albums were produced, including photographs showing people entering the gas chambers. The albums were reportedly sent to Berlin, but the others have never been recovered (Struk 99–111).

This sequence of *Images of the World* could be described as progressing from a Sartrean conception of the look to a Foucauldian conception of the gaze. In this historical situation the dialectic of looking that defines sexual desire was overtaken by the panoptical gaze of the Nazi apparatus of extermination. The snapshot of the woman passing in the street became the record of a transport being "processed" on arrival at the camp. Similarly, the sexual desire that defined the look directed by the male colonist at the veiled

Algerian woman was overtaken by the war waged by the French state. The postcard of the Moorish woman as sex object was overtaken by the identity card that recorded and monitored the distinctive features of members of the Algerian population in a state of emergency.

Farocki (himself an Algerian) follows Fanon, who had drawn on Sartre's analysis of anti-Semitism, in his own critique of colonial racism. Like Fanon, Farocki suggests a comparison between the Arab woman and the Jewish woman. In doing so he makes a connection between the Algerian war and the Holocaust that *Night and Fog* had suggested but failed to make explicit or concrete. The unveiling of the Arab woman for the identity card constitutes her, like the woman photographed on the ramp at Auschwitz, as a biopolitical image. In his film Farocki shows himself looking at Marc Garanger's book of photographs, *Femmes Algeriennes 1960*. He places his hand over the face of one woman and then removes it to simulate the effect of veiling and unveiling. During this sequence the voice commentary states:

> How to face a camera? The horror of being photographed for the first time. The year 1960 in Algeria: women are photographed for the first time. They are to be issued with identity cards. Faces which up till then had worn the veil.

Kaja Silverman comments that this sequence challenges

> the popular Western assumption that removing the veil from the face of the Algerian woman would in all situations represent a "liberation." The voice-over suggests that, in addition to rendering its wearer publicly invisible, the veil provides a kind of shield. It provides protection not so much from the gaze—which is itself both "inapprehensible" and neutral, and is, in some guise, necessarily already a part of these women's lives—as from that experience of it which is mediated by the colonial deployment of the camera, a deployment that can only be characterized as a violation and subjugation.
>
> (Silverman 148)

The veil is a protective shield that confines visibility of the woman's face to the private domain of home and family life. The veil belongs to traditional sovereign power that must be stripped away in order to make the face of the colonized woman available for biopolitical surveillance. The sequence that discusses the photographs of Algerian women is intercut with another sequence in which a woman's face appears on a blue video screen and has parts of other faces—glasses, hair, mouth—superimposed on her features. The police identikit picture, like the photographs of the Algerian women, is designed to apprehend possible criminals.

Farocki's film shows how the protective shield of the Arab woman is stripped away in order to construct another protective shield for the

colonizer: the mediated immunity provided by photographic surveillance and pornography. Garanger's photographs and those in the Lili Jacob album reproduce the gaze of power and position the viewer as socially and emotionally removed from those who are shown. We cannot "open" ourselves to the trauma of their experience without questioning the discourses of racism and universal humanism by which they are defined. The construction of the Holocaust as a trauma acknowledges the historical importance of this catastrophe but tends to obstruct our understanding of its relation to biopolitics. The new legal category of crimes against humanity and the idea of historical trauma both reinscribed Eurocentric and anthropocentric notions of the human. One of the central forms of dehumanization by Nazism and colonial power was the use of media images as evidence of the human or less-than-human status of different groups. Comparing images, as Farocki does, of the Jewish victims of the Nazis to images of colonized people in North Africa allows us to see how media was used to justify the oppression and destruction of those shown. The images were used to insulate the viewer in a mediated zone of invisibility, separateness and control. Those who claim full human status are thus actually creatures of a technologically induced immunity.

Notes

1. Arendt's repugnance for this supposed devolution in the colonies could also be related to anxieties associated with anti-Semitism. As Sander Gilman explains, in the late nineteenth century hysteria and neurasthenia were associated with the Jews. Charcot attributed this to inbreeding (154–155). Neurasthenia was also associated with urbanism and cosmopolitanism. The labeling of the child, woman, homosexual or Jew as degenerate was a projection of anxiety that had its roots in colonial domination. The degenerate races deserved to be ruled over but they also threatened to rise up or to contaminate their rulers. This logic also underpinned the racialization of class and the fear of the urban mob (214).
2. David Olusoga and Caspar W. Erichsen propose that the death camp was invented by the German colonials in Namibia as part of the campaigns to exterminate the Herero and Nama peoples.
3. According to Hirsch's definition, posttraumatic cinema departs from linear historical narrative and realist representation to include montage shock-effects and reflexivity about the limits of representation.
4. Rothberg also argues, however, that Césaire's use of this trope is "ironic" (75) and multidirectional because Césaire reveals regression as a racist fantasy but also proposes that Nazism embodies a regression within Europe. Césaire's text is highly polemical and it may be that Rothberg goes too far in emphasizing the underlying consistencies where there may actually be more fundamental contradictions.
5. Jock McCulloch has pointed out that Fanon's emphasis on the traumatic impact of representations can only apply to specific classes of colonial society (McCulloch 70).

Works Cited

Agamben, Giorgio. *Homo Sacer: Sovereign Power and Bare Life.* Trans. Daniel Heller-Roazen. Stanford: Stanford UP, 1998.

Alloula, Malek. *The Colonial Harem.* Trans. Myrna Godzich and Wlad Godzich. Minneapolis: U Minnesota P, 1986.

Arendt, Hannah. *Eichmann in Jerusalem: A Report on the Banality of Evil.* New York: Viking Press, 1963.

———. *The Origins of Totalitarianism.* San Diego, New York, London: Harcourt Brace Jovanovich, 1973.

———. *The Human Condition.* Chicago and London: U Chicago P, 1958.

Benjamin, Walter. *Selected Writings Volume 4 1938–1940,* Trans. Edmund Jephcott et al. Ed. Howard Eiland and Michael W. Jennings. Cambridge, MA, and London: Harvard UP, 2003.

Bignall, Simone, and Marcelo Svirsky. "Introduction: Agamben and Colonialism." *Agamben and Colonialism.* Ed. Marcelo Svirsky and Simone Bignall. Edinburgh: Edinburgh UP, 2012. 1–14.

Césaire, Aime. *Discourse on Colonialism.* Trans. Joan Pinkham. New York and London: Monthly Review Press, 1972.

Conrad, Joseph. *Heart of Darkness.* London: Penguin, 2007.

Crook, Paul. *Darwinism, War and History: The Debate over the Biology of War from the 'Origin of the Species' to the First World War.* Cambridge: Cambridge UP, 1994.

Croombs, Mathew. "French Algeria and the Police: Horror as political affect in Three Short Documentaries by Alan Resnais." *Screen* 55.1 (2014): 29–47.

Elsaesser, Thomas. "Harun Farocki: Filmmaker, Artist, Media Theorist." *Harun Farocki: Working on the Sightlines.* Ed. Thomas Elsaesser. Amsterdam: Amsterdam UP, 2004. 11–40.

Fanon, Frantz. *Black Skin, White Masks.* Trans. Charles Lam Markmann. New York: Grove, 1967.

———. *A Dying Colonialism.* Trans. Haakon Chevalier. New York: Grove, 1967.

———. *The Wretched of the Earth.* Trans. Constance Farrington. New York: Grove, 1963.

Farocki, Harun. "Reality Would Have to Begin." *Harun Farocki: Working on the Sightlines.* Ed. Thomas Elsaesser. Amsterdam: Amsterdam UP, 2004. 193–202.

Foucault, Michel. *"Society Must be Defended": Lectures at the Collège de France, 1975–76.* Ed. Mauro Bertani and Alessandro Fontana. Trans. David Macey. New York: Picador, 2003.

Garanger, Marc. *Femmes Algeriennes 1960.* Paris: Contrejour, 1982.

Hirsch, Joshua. *After Image: Film, Trauma and the Holocaust.* Philadelphia: Temple UP, 2004.

Joeden-Forgey, Elisa von. "Race Power, Freedom, and the Democracy of Terror in German Rationalist Thought." *Hannah Arendt and the Uses of History: Imperialism, Nation, Race, and Genocide.* Eds. Richard H. King and Dan Stone. New York and Oxford: Berghahn, 2007. 21–37.

Kaplan, E. Ann. "Fanon, Trauma and Cinema." *Frantz Fanon: Critical Perspectives.* Ed. Anthony C. Alessandrini. London and New York: Routledge, 1999. 146–157.

Keller, Richard C. *Colonial Madness: Psychiatry in French North Africa.* Chicago and London: U Chicago P, 2007.

Khanna, Ranjana. *Dark Continents: Psychoanalysis and Colonialism*. Durham, NC, and London: Duke UP, 2003.

McCulloch, Jock. *Black Soul, White Artifact: Fanon's Clinical Psychology and Social Theory*. Cambridge: Cambridge UP, 1983.

———. *Colonial Psychiatry and the African Mind*. Cambridge: Cambridge UP, 1995.

Moses, A. Dirk. "Empire, Colony, Genocide: Key Words and the Philosophy of History." *Empire, Colony, Genocide: Conquest, Occupation, and Subaltern Resistance in World History*. Ed. A Dirk Moses. New York and Oxford: Berghahn, 2008. 3–54.

———. "Hannah Arendt, Imperialism, and the Holocaust." *German Colonialism: Race, the Holocaust, and Postwar Germany*. Ed. Volker Langbehn and Mohammid Salama. New York: Columbia UP, 2011. 72–92.

Olusoga, David, and Caspar W. Erichsen. *The Kaiser's Holocaust: Germany's Forgotten Genocide and the Colonial Roots of Nazism*. London: Faber and Faber, 2010.

Oppenheim, Janet. *"Shattered Nerves": Doctors, Patients, and Depression in Victorian England*. New York and Oxford: Oxford UP, 1991.

Rice, Louisa. "The Voice of Silence: Alain Resnais' *Night and Fog* and Collective Memory in Post-Holocaust France, 1944–1974." *Film and History: An Interdisciplinary Journal of Film and Television Studies* 32.1 (2002): 22–29.

Rothberg, Michael. *Multidirectional Memory: Remembering the Holocaust in the Age of Decolonization*. Stanford: Stanford UP, 2009.

Sanyal, Debarati. "Auschwitz as allegory in Night and Fog." Griselda Pollock and Max Silverman, *Concentrationary Cinema: Aesthetics as Political Resistance in Alan Resnais's Night and Fog (1955)*. New York: Berghan, 2011. 152–182.

Sartre, Jean-Paul. *Anti-Semite and Jew*. Trans. George J. Becker. New York: Schocken, 1948.

———. *Colonialism and NeoColonialism*. Trans. Azzedine Haddour, Steve Brewer, and Terry McWilliams. London and New York: Routledge, 2001.

———. "Preface." Frantz Fanon, *The Wretched of the Earth*. Trans. Constance Farrington. New York: Grove, 1963.

———. *Being and Nothingness: An Essay on Phenomenological Ontology*. Trans. Hazel E. Barnes. London: Methuen, 1957.

Saxton, Libby. *Haunted Images: Film, Ethics, Testimony and the Holocaust*. London and New York: Wallflower Press, 2008.

Shohat, Ella, and Robert Stam. *Unthinking Eurocentrism: Multiculturalism and the Media*. London and New York: Routledge, 1994.

Silverman, Kaja. *The Threshold of the Visible World*. New York and London: Routledge, 1996.

Stoler, Ann Laura. *Race and the Education of Desire: Foucault's History of Sexuality and the Colonial Order of Things*. Durham, NC: Duke UP, 1995.

Struk, Janina. *Photographing the Holocaust: Interpretation of the Evidence*. London, New York: I.B.Taurus, 2004.

Wyman, David S. *The Abandonment of the Jews: America and the Holocaust, 1937–1945*. New York: Pantheon, 1984.

4 The Biopolitical Imagination

> I mean, the trauma suffered by everyone in the middle of the twentieth cen-
> tury when it became clear that, from now on to the end of human history,
> every person would spend his individual life under the threat not only of
> individual death, which is certain, but of something almost insupportable
> psychologically—collective incineration and extinction which could come at
> any time, virtually without warning.
>
> Sontag, "The Imagination of Disaster" (1965)

In the immediate postwar period the political left associated the Nazi Final
Solution with the bombing of Hiroshima and Nagasaki as together man-
ifesting the terrifying new reality of mass death perpetrated by industrial
technologies. In subsequent decades this association between the Nazi
and American killing of civilian populations gradually receded behind the
narrative that emerged about the Holocaust as a historical trauma. The
postwar response by Western nations to the Nazi genocide was to pro-
mote universal human rights and to associate racism with crimes against
humanity. The gradual construction of Holocaust as a trauma for humanity,
however, was unable to acknowledge the continuities between Nazism and
the genocides perpetrated by European nations in their colonies. Instead
of acknowledging responsibility for biological warfare perpetrated against
civilian populations, Western powers made weapons of mass destruction a
symbol of a new absolute power: the "nuclear sublime." The potential for
global destruction was used as a means of social control. The open use of
torture and concentration camps by the French in Algeria was accompanied
in America by secret research on mind control and a public campaign pro-
moting fear of the bomb. Shock and trauma began to function as calculated
effects in the biopolitical apparatus of security. The documentation of the
Nazi camps in photographs and film, along with the image of the mush-
room cloud above Hiroshima and subsequent simulation of nuclear bomb
blasts, together formed the catastrophic horizon of postwar life. Images that
showed the annihilation of civilian populations, whether censored as evi-
dence of inconvenient truths or simulated in order to authorize state power,
played their role in a new immune system that aimed to induce, monitor and
control levels of anxiety and paranoia in the general population.

This chapter explains how postwar intellectuals such as Robert J. Lifton and Susan Sontag negotiated this new biopolitics of catastrophe. Lifton was the first psychotherapist to do research with the survivors of the atom bomb attack on Hiroshima. He also worked with Holocaust survivors and Vietnam veterans, leading to the recognition by the American Psychiatric Association of Post-Traumatic Stress Disorder as a diagnostic category. Lifton's path breaking work of recording, analyzing and classifying survivors of trauma—including his documentary film about Hiroshima survivors, *To Die, To Live* (1975)—was a protest against American military power. His less often discussed research on brainwashing in Communist China, however, reveals an unacknowledged link between covert experiments in mind control and the more publicly approved discourse about the Holocaust and Vietnam War as cultural traumas. Psychological torture and psychotherapy formed two sides of the attempt to understand the effects of extreme distress on individuals and populations.

Although she does not cite him directly, Lifton's research resonates in Sontag's accounts of apocalyptic science fiction cinema in her 1965 essay "The Imagination of Disaster" and her later account, in *On Photography* (1977), of her first encounter with images of Belsen and Dachau concentration camp. Lifton's psychological research on survivors led him into the broader domain of cultural criticism when he extended the experience of trauma, survival and "psychic numbing" to the entire American population. Sontag made the link between the extreme events of Hiroshima and the Holocaust and the cinematic production of apocalyptic fantasy. Sontag's media criticism provides an influential and symptomatic case study showing how discourses about catastrophe, immunity and bare life developed in the postwar period with respect to visual media.

Images of Catastrophe

The Allied liberation of the death camps in 1945 was recorded in photographs and film footage that was widely published and exhibited in the immediate postwar period. After this initial exposure a silence began to surround these images, which were subsequently withdrawn from public circulation. In the 1960s, stimulated by the Eichmann trial, television documentaries and dramatizations and movies gradually began to emerge, establishing the Holocaust as an ongoing source of fascination in Western media. This dynamic of concealing and revealing the spectacle of bare life— the naked and emaciated survivors, the mounds of dead and mass graves— functioned as part a new postwar immune system. Images of the camps were used to place responsibility for the mass killing of civilians on the shoulders of the defeated enemy. The Allies used the revelations of the camps as a moral justification for the war and a propaganda opportunity. These images quickly lost their value for the victors, however, as they prompted more difficult questions than those in power wished to answer, such as "How could

this have happened?" and "Who is responsible?" (the final words of *Night and Fog*). The postwar alliance with West Germany against Soviet Russia required that these questions be put aside. After refusing to intervene in the process of extermination, Britain and America needed to retain their immunity from responsibility for the genocide.

Ideas about racial hierarchies were widely espoused in the nineteenth and early twentieth centuries but the revelations of the Nazi exterminations discredited racism as a public discourse. After World War II a new consensus about racial equality was achieved and enshrined in the declarations of the United Nations and the Nuremberg Trials. Crimes Against Humanity and Human Rights were now seen as applying to all people, irrespective of race, color or creed. This universal humanism, however, disguised the continuation of biopolitics in the Cold War period. The secrecy that had surrounded the Nazi Final Solution and Japanese experiments in biological warfare was extended by the American state to conceal the effects of the atom bomb. The partial revelation of what governments were perpetrating without their citizens' knowledge or consent created a new space in which the threat of catastrophe overshadowed democratic participation. Strict government censorship of news was imposed on coverage of the effects, including radiation sickness, of the bombs dropped on Hiroshima and Nagasaki. This included censorship within Japan of the testimony of survivors through the remainder of the 1940s.

Herbert Sussan, a filmmaker who served in the U.S. Strategic Bombing Survey unit, shot color footage showing the suffering of the civilian populations in Hiroshima and Nagasaki, which was confiscated and kept secret until the 1980s. Further filming was prohibited. U.S. authorities censored open discussion of the bomb, fearing it would incite public unrest. According to the official narrative it was the Japanese military who were guilty of war atrocities, not the U.S. Army. In August 1945 a Japanese film unit headed by Akira Iwasaki was commissioned by the government to make a film record of the effects of the bombing of Hiroshima and Nagasaki. Iwasaki had a background in the left wing documentary movement of the 1930s and had been jailed by the military regime during the war. At first the unit was prohibited from filming by the occupying forces but then the U.S. Army decided it wanted the film and took control of its production. It was to be a "scientific" record and the effects on human beings were downplayed. A three hour film was produced but was seized, shipped to Washington and classified as secret. It was not made available to the public until 25 years later (Barnouw 121–122).

The rigorous censorship of Hiroshima footage can be contrasted with the widespread publication of images of the Nazi camps. As Barbie Zelizer explains, there was no precedent in war photography for the scenes revealed by the camps (*Remembering* 16). Censorship during World War I left audiences unaccustomed to seeing images of violence, suffering and death. As World War II progressed propaganda ministries began to see the powerful effect of these images. The depiction of violence became more widely

used and accepted, but the depiction of war atrocities remained taboo. Both media professionals and the public still approached atrocity stories with disbelief. The unprecedented scale of atrocity and death in the Nazi camps defied verbal description and the public remained inclined toward skepticism. Even those who directly witnessed the camps claimed that they could not believe their own eyes. This created an opportunity for the photograph to more directly transmit the events to the public.

Film footage of the camps also presented unprecedented images of mass death. Leshu Torchin stresses that the documentary films of the Nazi camps shown at the Nuremberg Trials played an important role in defining crimes against humanity (61). Valerie Hartouni comments that "the very organization of the courtroom at Nuremberg was configured in its reconstruction for the trial to accommodate (and we could even say feature) a movie screen in precisely the space at the front of the room normally reserved for the judge's bench" (106).[1] After this initial exposure of atrocity, however, photographic documentation of the war tended to marginalize images of the camps. It was not until the early 1980s that films of the liberation of the camps were again made available to the public (Struk 151). The silence surrounding the Nazi atrocities was part of a new Cold War politics of strengthening capitalist democracy in West Germany and constructing the U.S.S.R. as the totalitarian enemy. The still insecure position of Jews in postwar American society also contributed to the aversion for recalling the European genocide. It was only the political left who insisted on making the Nazi past an issue.

The Biopolitical Imagination

Images of the camps and the bomb raised questions about modern war and state power that were not adequately answered by the discourse of crimes against humanity. They required the production of new narratives about collective survival and immunity from destruction: a new biopolitical imagination. In *The Sociological Imagination* (1959), C. Wright Mills proposed that most individuals in modern societies failed to understand the larger historical forces that shaped their lives. Modern industrial capitalism, colonization and anticolonial struggles, political revolution and totalitarian states, have all had a massive impact on the lives of millions of people. The pace of social change defied comprehension for many. What was needed, proposed Mills, was not more information—which by itself can overwhelm and confuse—but what he called the "sociological imagination" (5). The sociological imagination would allow the individual to understand his or her experience with respect to larger social and historical forces and transformations such as war, unemployment, the divorce rate, the urban environment, etc. Mills argued that science and technology did not provide answers to these complex problems of modern social life and instead—primarily through the developments of weapons of mass destruction—have been the cause of even greater anxiety.

This sociological imagination, however, was not adequate to comprehend the deeper impact of science and technology on politics and culture. Hannah Arendt commented in her prologue to *The Human Condition* (1958) on the launch into space in 1957 of the first manmade satellite. Arendt proposed that this new technical accomplishment finally achieved something that many had fantasized about for decades: the escape from earthbound existence (1–2). For Arendt, science did not provide answers to social and political problems because it was engaged in a more ambitious project to transcend the limits of natural or animal life. Elsewhere Arendt wrote that the atom bomb constituted another instance of the techno-scientific drive for transcendence. The bomb was "an image of omnipotence" (cited in Caruth 88). Both the space satellite and the bomb took human endeavor beyond the limits that had previously defined not only social existence but biological life itself.

Arendt's images of techno-scientific transcendence showed the limits of the sociological imagination, which presupposed an inability to separate the private world of the individual from his or her social and political existence. This convergence of public and private life was itself the product of a more fundamental biopolitical transformation. In *The Human Condition* Arendt returned to the classical Greek distinction between the *bios politikos* and the domestic realm (*oika*) in which the *polis* was a realm of free choice whereas the home was ruled by the necessities of human survival. Arendt argued that the emergence of the social realm, which no longer respected the ancient division between private and public life, was a phenomenon that characterized the modern nation-state. The nation began to be imagined as a family called "society" (28–29). The autonomy of the family was overtaken by socialization, behavior became regulated by codes of normality, and the political freedom of the individuals was replaced by statistical uniformity and economic calculation. The life of the free citizen in the *polis* was once distinguished from the mere animal-like survival in the domestic realm, but today the citizen is a job-holder—or "wage slave"—and status is premised on economic survival.

The classical ideal of political life had collapsed in modern mass societies and new images of techno-scientific transcendence now took its place. The image of the bomb, for example, could not be understood in terms of Mills's sociological imagination because it transcended all social relations and governed life itself. The bomb formed part of a new biopolitical imagination, or what Susan Sontag would call "The Imagination of Disaster." Postwar entertainment and propaganda presented countless scenarios of immanent catastrophe and the deployment of science and technology to destroy civilian populations. The public had seen the mounds of naked corpses in the Nazi camps but the Americans censored images of the mass destruction of civilian lives in Japan. In place of this evidence they promoted the iconic image of the mushroom cloud: a "sublime" image of destructive power beyond the limits of individual experience and perception. Gene Ray argues that America's failure

to confront the implications of Hiroshima created the "need for an enemy who would be a credible target for unbounded violence" (100). This was one of the foundations for the Cold War fixation on the specter of International Communism. The use of weapons of mass destruction on non-European peoples had its historical precedent in the genocidal conquests of Africa and the Americas. This was the "secret history" that everyone knew but which was never openly acknowledged. The bomb, as a technology of terror, gave rise to a new culture of secrecy and security that further undermined the universalist principles of liberal democracy.

Instead of historical understanding of why the bomb was dropped and what its consequences were, the events were incorporated into "a technological image-making power that determines the future as an explosion annihilating both past and future history" (Caruth 89). The entire population was now forced to live under the constant threat of annihilation. The attempt to control public memory through images of catastrophe was a feature of postwar life in both America and Japan. As Japan struggled to recover economically after the war the bomb became "a symbol of America's material might and scientific prowess" (Dower 120). Hiroshima became a place of commemoration and a so-called city of peace but this also "helped disseminate the view that the world's peaceful order was attained and will be maintained not by diplomatic efforts or negotiations, but by sustaining a menacing military force and technological supremacy" (Yoneyama 20).

In 1949 the Soviets exploded the first atomic bomb and the Cold War began in earnest. Lewis MacAdams presents a vivid description of this cultural moment:

> A 1949 *New York Times* article addressed the citizens of America's major cities: "If war is declared, you, your home, and your place of business will disappear in the next second." The next year, *Life* magazine's biggest rival, *Colliers*, published "Hiroshima U.S.A," a detailed description of what a devastating nuclear attack on the United States would be like. Accompanying the story was a lurid illustration of a cratered, incinerated Manhattan a few minutes after the A-bombs rained.
> (MacAdams 79)

Today such an image of a "cratered, incinerated Manhattan" inevitably evokes the 9/11 attacks. MacAdams goes on to describe Operation Alert, a simulated Russian nuclear attack on the United States orchestrated by the American government on the morning of June 15, 1955. Like President Bush on September 11, 2001, "President Eisenhower and his top aides were being helicoptered from the White House lawn to a top-secret underground command center in Maryland" (186). The June 15 exercise was not the only Operation Alert that helped to foster mass paranoia. The 1950s also saw the production of numerous Hollywood films featuring communist conspiracies and weapons of mass destruction, including *Invasion U.S.A.*

(Columbia 1952) in which a "live" television broadcast shows America over-run by Communists after an A-bomb attack. The promotional poster for the film included an image of "New York city in ruins" (Barson and Heller 78).

Joseph Masco comments that in Cold War America "it became a civic obligation to imagine ... the physical destruction of the nation state" (39). The public spectacle of civil defense simulation, evacuations, and drills was "not defense in the classical sense of avoiding violence or destruction but rather a psychological reprogramming of the US public" (39). This anticipation of catastrophe constituted an idea of community under constant threat and justifying militarism, anticommunism and an obsession with national security:

> An immediate project of the nuclear state was thus to calibrate the image of atomic warfare for the American public through the mass circulation of images of the bomb and the censorship of all others. In this way, officials sought to mobilize the power of mass media to transform nuclear attack from an unthinkable apocalypse into an opportunity for psychological self-management, civic responsibility, and ultimately, governance.
>
> (Masco 43)

This model of "emotional inoculation" (43) aimed to introduce manageable doses of fear "formidable enough to mobilize citizens but not so terrifying as to invalidate the concept of defense" (43). Everyone must feel that they are a potential target, thus making "mass death an intimate psychological experience" (45). Foucault commented that the bomb created a paradoxical relation between the sovereign power to kill and the biopower that preserves and enhances life: the bomb embodies a kind of absolute sovereign power that overtakes life itself (*"Society"* 253–254). What Foucault is describing resonates with what Derrida would call, after 9/11, an autoimmune disorder. The system of national security designed to protect and preserve life has created the conditions for self-destruction. Biopower, engaged to control human populations, has potentially exceeded human agency.

Documenting Hiroshima

Biopolitical immunity requires the coordination of mass destruction with the regulation of mediated shock through censorship and spectacle. The bombing of Hiroshima and Nagasaki was subject to very different regimes of visibility than those operating after the liberation of the camps. To understand the biopolitical function of this rigorous censorship we need to examine the continuities that underlie media representation, mass destruction and medical research. The U.S. government justified the bombing of Japanese cities during World War II as a form of psychological warfare. The goal of demoralizing the enemy extended the targets of the bombing beyond the industrial and economic infrastructure to include civilian populations. The precedent for

this was the English bombing of German cities. In America, magazines presented the public with "lurid illustrations of terrified Japanese being pounded from the air" (Dower 169). Nevertheless, public relations officers for the U.S. Air Force were instructed not to inform the public about attacks on towns and cities. In a strange exception to this silence, in May 1945 the *New York Times* reported that perhaps up to two million Japanese had been killed by American bombs. The threat of annihilation was made explicit in leaflets dropped on Japan featuring images of women and children fleeing through collapsing buildings and towering flames (Dower 172–189).

Almost immediately after the war the U.S. government established the Atomic Bomb Casualty Commission. From 1946 to 1975, in a building on Hijiyama Hill on the outskirts of Hiroshima, the ABCC conducted scientific research and study on the effects of radiation on atomic bomb survivors (Hibakusha), particularly focusing on pregnant women and unborn children. This scientific research set out to measure technological power in the service of military dominance. The alleviation of physical and psychological suffering was irrelevant to this goal. The ABCC clinic was financed by the U.S. Atomic Energy Commission. During the nearly thirty years of its research the clinic did not provide medical treatment for a single survivor. The effects of atomic radiation were kept secret from the American public. This censorship was crucial to the covert nature of postwar biopolitics. Sheldon Harris explains how the postwar Japanese National Institute of Health (JNIH) recruited members of Unit 731, who conducted biological warfare experiments on the Chinese during World War II:

> The joint staff of the JNIH and the ABCC hounded the Hibakusha with threats of severe punishment by the Occupation forces for those who refused to cooperate. Hibakusha were taken to ABCC buildings, stripped of their clothing, photographed, X-rayed, and forced to yield blood samples to the examining physicians. It was as if Unit 731 war criminals were back in business at Ping Fan. These doctors treated the Hibakusha as if they were experimental material. Bereaved families of Hibakusha who died were pressured into permitting the ABCC-JNIH staff to autopsy their bodies, sending their organs, their burnt skin, and other body parts to laboratories in the United States for further studies.
> (Harris 324)

Like the film footage documenting the aftermath of the bombing, the bodies of the survivors were treated as material to be stored, analyzed and kept secret from the public. Meanwhile the mass destruction of civilian populations continued to be an important area of research and development.

In their book *Hiroshima in America*, Robert Lifton and Greg Mitchell explain the official narrative presented by the American government as a justification for the use of the atom bomb on Hiroshima. First it was a response to Japan's attack on Pearl Harbor; second it was a race with the Axis powers

to develop the bomb, with the argument that enemy would not have hesitated to use it. It was only later that the story took hold that the bomb had saved many American lives. The first official statements did not acknowledge the extent of civilian casualties. The first challenges to the official narrative came soon after the event, claiming that the bombs violated international law. In subsequent months public discourse began to include more reflection on the wider implications of the bomb's destructive power. John Hersey's long feature article "Hiroshima," published in a special issue of *The New Yorker* in 1946, attracted a mass readership in America and for the first time provoked expressions of shame from the public. The official response, an article by Henry Stimson in *Harpers* in 1947, authorized and supported by President Truman, justified the use of the bomb to secure an unconditional surrender from Japan and to save hundreds of thousands of American lives. The terms of modern warfare were now clearly biopolitical: certain populations must be destroyed in order to protect and enhance the lives of those most fit to live. Lifton and Mitchell argue that as important as this justification was, the message to the Soviet enemy was to show America's resolve to produce and, if necessary, use atomic weapons. The bomb was not only a weapon of mass destruction but also a psychological weapon, conveying a sense of omnipotence with the threat of absolute, global destruction and producing an aesthetic-political-psychological effect: the "nuclear sublime" (305).

From the end of World War II up until the early 1960s a number of feature films were produced in America that dramatized the possible effects of nuclear catastrophe. These abruptly stopped after 1965 (the year of Susan Sontag's essay "The Imagination of Disaster" discussed later in this chapter). This was the period of the arms race. After the Cuban missile crisis in 1962 and the subsequent Limited Test Ban Treaty in 1963, nuclear themes declined in popular culture (Perrine 10–11). The American government classified the footage of the bombing of Hiroshima and Nagasaki as secret and it remained in the National Archives in Washington until parts of it were first made available to the public in 1968. Professor Erik Barnouw from the Center for Mass Communications at Columbia University edited the two hours and forty minutes of footage he was given into a sixteen-minute documentary called *Hiroshima-Nagasaki-August, 1945* released in 1970. The first television documentary to examine the moral and military implications of atomic weapons was Fred Freed's *The Decision to Drop the Bomb* in 1965. Further such documentaries appeared in the late 1960s and early '70s. *Hiroshima-Nagasaki*, produced by National Education Television and incorporating Barnouw's short film was shown only once by the Public Broadcasting Service in 1970 and was subsequently withdrawn from availability, including for educational purposes. Other notable examples include Betty Jean Lifton's documentary film *A Thousand Cranes* (1962) about child victims of the bomb. Robert J. Lifton made *To Die, To Live*, a documentary recording the testimony of survivors of Hiroshima, for the BBC in 1975

(Shaheen xv–xvi). This relatively small body of work making documentary evidence of the bomb available to the American public stands in clear contrast to the extensive cultural production that has made the Holocaust such a prominent feature of popular culture.

The Physiognomy of Catastrophe

It was not until 1962 that Lifton undertook his research on the psychological effects of the bombing of Hiroshima. Today's preoccupation with collective trauma has its roots in his path breaking work. Lifton's work with Hiroshima survivors was followed by intensive psychotherapy with Holocaust survivors and Vietnam veterans resulting in the formulation of Post-Traumatic Stress Disorder. The notion of collective trauma was a critical response to the biopolitics that produced the death camps and the atomic bomb. It was also an extension of the surveillance, recording and analysis of the health and survival of human populations. The survivors, having been reduced to a condition of bare life by the technologies of mass destruction, were now being induced to produce testimony for the purposes of psychological research. Their specific historical experience served as a basis for formulations about collective identity and a universalized imagination of catastrophe. In his conclusion to *Death in Life: Survivors of Hiroshima* (1967), Lifton wrote: "We are all survivors of Hiroshima and, in our imaginations, of future nuclear holocaust" (479). Naomi Mandel comments that when trauma is aligned with "Holocaust" it reiterates the cultural assumption that what happened in Europe reverberates globally (52) . The bombing of Hiroshima was now something that happened to "us" rather than something we did to "them."

Lifton's research on survivors of the Hiroshima bombing revealed that emotional numbing and "psychic closing-off" were defense mechanisms that enabled psychological survival. Lifton and Mitchell later extended these psychological mechanisms to include those who created and used weapons of mass destruction. They then generalized further to include all Americans, for whom "numbing serves the additional purpose of warding off potential feelings of guilt" (338). Lifton and Mitchell compared numbing to selective inattention and avoidance of whatever provokes feelings of anxiety. This numbing then extends to other forms of human catastrophe witnessed through mass media: "if we can speak of an age of numbing, especially for Americans, it begins with Hiroshima" (340). They also comment:

> After Hiroshima, it has been difficult to separate individual death from a vast, collective "death event." We still struggle with a foreground of impending personal death but do so against an intrusive background, of vague but menacing impersonal annihilation.
>
> (Lifton and Mitchell 351)

Lifton's drive to universalize the experience of the bomb is related to his conception of psychohistory as a response to radical social change and extreme experience in which humans "suffer, survive, adapt, and evolve new modes of feeling and thought" (*History* 4). His 1964 essay "The Hiroshima Bomb" (originally written during the 1962 Cuban Missile Crisis) discusses his research with Japanese survivors. The "most striking psychological feature" of the experience was "a sudden and absolute shift from normal existence to an overwhelming encounter with death" (122). This sudden and radical change, for which no one could be psychologically prepared, demanded a "psychic closing-off" (127) as a defense mechanism against shock. Despite this closing-off, powerful feelings of guilt and shame were experienced by survivors. The development of radiation sickness extended the sense of an overwhelming encounter with death over long periods of time and even across generations to include sickness and abnormality in the subsequent offspring of survivors.

Survivors and their children became tainted by the bomb and discriminated against—a new kind of social outcast:

> The dominant emotion here is the sense of having been made into "guinea pigs," not only because of being studied by research groups (particularly American research groups) interested in determining the effects of delayed radiation, but more fundamentally because of having been victimized by the first "experiment" (a word many of them use in referring to the event) with nuclear weapons.
>
> (Lifton and Mitchell 147)

Unfortunately the recording of survivor testimony reproduced aspects of this human experiment, insofar as the survivors bodies were presented as physical evidence, and their words as psychological evidence, of their extreme experience.

A documentary film based on Lifton's work with Hiroshima survivors, *To Die, To Live* (1975), was written and directed by a concentration camp survivor, Robert Vas. Like *Night and Fog*, which included a voiceover written by a camp survivor, *To Die, To Live* juxtaposed color footage from the time of the film's production with black and white footage produced at the time of the catastrophe and its immediate aftermath. Serene color images of the sun rising over the sea, children going to school, and fishermen in boats show life in present day Hiroshima but also evoke a time before the bomb was dropped. In *Night and Fog* (discussed in Chapter Three) there was an unresolved tension between the claims made in the voiceover, regarding the impossibility of showing or describing the experience of the camps, and the explicit documentary images presented in the film. Similarly, in *To Die, To Live* there was an unresolved tension between the filmmaker's attempt to communicate the experience of the bomb through survivor testimony and the rather crude imposition of psychological categories in the form of verbal captions appearing on screen.

Captions such as "Death guilt," "Invisible contamination" and "A-bomb disease" suggest a disturbing correspondence between Lifton's psychological research and the effects of biological warfare. Through their physical appearance and verbal testimony the survivors become case studies of general psychological conditions and pathologies. Color footage of their faces and bodies, scarred by burns, are juxtaposed with black and white archival footage of the aftermath of the bomb showing the ruined city, corpses lying in the streets, piles of skulls, and survivors being treated by doctors. Another series of images of the daily life of Hiroshima in the mid-1970s shows people shopping and amusing themselves in arcades, working in offices and factories and dancing in night clubs. It is as if the daily life of postwar society constantly threatens to overwhelm the memory of the survivors, whose presence, along with the black and white footage, suggests a ghostly haunting of contemporary life. Their faces and words must carry the burden of proof for the catastrophe.

Although in the case of *Night and Fog* the verbal commentary was composed by a survivor and in *To Die, to Live* the visual text was filmed and edited by a survivor, the underlying tension between word and image in both films points to a deeper problem that neither film is able to resolve. The attempt to represent the catastrophe and to communicate the experience of the survivors is at odds with the apparatus of recording, archiving and analyzing human life on film. Neither film was able to directly address the ways that visual media function as part of the biopolitical apparatus. The designation of civilian populations for systematic extermination or death by weapons of mass destruction is the result of a longer historical process in which human life has become an object of scientific knowledge and technological domination. Filming victims and survivors of state violence can bear witness to social and political injustice but it can also reproduce inequalities in forms of visibility and visual experience. (Only Farocki's *Images of the World*, of the films discussed in this book, directly raises these problems in a self-conscious way in the film text.)

To Die, To Live is pioneering example of testimony film, anticipating Lanzmann's later *Shoah* (which attempted to resolve the problems raised by archival footage by eliminating it from the film altogether). The justification for testimony has become the transmission of traumatic experience to subsequent generations. The terrifying destruction of Hiroshima and its people made visible a new space of war and destruction from which no one is immune. Yet the collecting and preservation of testimony appears to play its role in the new media immune system. The survivors provide evidence of bare life and embody the threat of our own potential destruction. For the survivors the experience of the bomb became "an interminable encounter" (151) with death leading to a "profound loss of confidence in human social ties" (153). The experience of "immersion in death" and the "fear and anticipation of annihilation" (161) resulted in what Lifton called "psychic closing-off":

> Psychic closing-off is thus related to the defense mechanisms of denial and isolation, as well as the behavioral state of apathy. But it deserves

to be distinguished from these in its sudden, global quality, in its throwing out a protective symbolic screen which enables the organism to resist the impact of death—that is, to survive psychologically in the midst of death and dying.

(Lifton "Hiroshima" 162)

Lifton also addressed the Jewish survivors of the Nazi genocide as sharing much with survivors of Hiroshima and their common relation to *"massive technological murder"* (195) and compared the account of the "sleepwalkers" after the bombing of Hiroshima to the *Muselmänner* or "walking corpse" (201) in the Nazi camps.

Psychic closing-off enabled survival. For Lifton the experiences of Hiroshima and Holocaust survivors were symptomatic of a more general psychohistorical transformation. Hiroshima was a historical trauma not only for the Japanese but for all humanity. The image of the collective "death event" served as a universal symbol that replaced the biological "experiment" on a specific population. This universalizing took the place of analyzing the extension of biopolitics to the general population. The drive to universalize Hiroshima and, later, the Holocaust as images of catastrophe and collective trauma emerged more strongly after the decline of Cold War propaganda promoting fear of the bomb. Postwar universal humanism also failed to acknowledge the ongoing physical and psychological experimentation on populations undertaken by the state. For this reason Lifton's universalizing claims about Hiroshima sit uneasily with his earlier research on mind control.

Mind Control

Lifton used his research on Hiroshima and Holocaust survivors to generalize about a larger cultural response to catastrophe. In *Home from the War* (1973), the book on his work with Vietnam veterans, Lifton claimed that the American population experienced psychic numbing induced by media coverage of the war (157–159). Weapons of mass destruction and systematic genocide had made civilian populations the direct targets of war. The use of media to induce shock and emotional withdrawal was supported by psychological research. Cold War propaganda implicated civilian populations in war through mass media accompanied by secret experiments in mind control. Psychic closing-off may have been a collective reflex responding to the horrors of modern war but psychologists were also researching ways to close the mind through the use of drugs, electroshock, and sensory deprivation.

Lifton's research on brainwashing in Communist China was contemporary with experiments in mind control funded by the CIA. His interest was in ideological reprogramming through dehumanizing abuse and controlled psychological regression. The destruction of individual autonomy made possible a collective identification with the absolute power of the state. The

logic of this psychological transformation was similar to the one he later identified with the atom bomb: the threat of total annihilation overwhelmed any sense of individual agency and imbued the weapon with an aura of sublime power. Lifton suggested that the threat of collective annihilation could have powerful psychological effects on large populations. His psychological studies of survivors showed how the suffering of one group can be incorporated into the immune system of another.

Lifton's first book, *Thought Reform and the Psychology of Totalism* (1961), was based on research conducted in Hong Kong in 1954–55. The term brainwashing was first used to describe Chinese indoctrination techniques but was soon applied in other contexts (including American advertising). Chinese thought reform operated through the solicitation of confession and the renunciation of past beliefs followed by a program of reeducation in the Communist world view. The goal, as defined by Mao Tse Tung, was to release individuals from the ideological evils of capitalist society. "Imperialists" and "reactionaries" were submitted to a process of "struggle" (accusation and interrogation) where they were pressured into confessing to real or nonexistent crimes against the state, such as espionage. After confessing came a more lenient treatment with reeducation to learn the "people's standpoint" and be instructed in Marxist theory.

The goal of brainwashing was to internalize feelings of guilt and self-doubt and to transfer identification to "the people." The subject was systematically reduced to "the position of an infant or a sub-human animal, helplessly being manipulated by larger and stronger 'adults' or 'trainers'" (67). The controlled or enforced experience of psychological regression from autonomous individual to helpless child led to the acceptance of guilt and submission to the collective point of view. Estranged from one's earlier self, the subject was threatened with complete annihilation. This period of dehumanizing terror was followed by one of leniency in which he was given the opportunity to "reform": "His sense of nakedness and vulnerability nourishes the growth of the 'new man'" (79). The reborn "new man" then participated in the collective strength of the mass movement.

Thought reform had a psychological momentum based in what Lifton called "*ideological totalism*" (419), involving moral puritanism, the demand to confess one's guilt, control of communication, surrounding power with a mystical aura, the absolute authority of scientific doctrine, reducing language to the "thought-terminating cliché" (429), and liquidation of those who fail to reform. Despite the Soviet endorsement of Pavlov's theory of conditioned reflex and its supposed influence on propaganda techniques, Lifton argued that psychiatry and psychology had little influence on Chinese indoctrination techniques. The emphasis on obtaining confession in Chinese thought reform owed more to the Soviet purge trials of the 1930s and the stress on internalizing guilt as part of ideological reeducation also showed the Soviet influence. Lifton's research with survivors provided the missing psychological analysis to explain the effectiveness of the Chinese approach.

The American Central Intelligence Agency was also impressed by the Soviet success in extracting public confessions from enemies of the state. In the early 1950s Edward Hunter, a journalist who was also an undercover agent for the CIA, produced a series of articles and books on the subject of brainwashing by the Chinese Communist Party. Irving L. Janis, a prominent psychologist at Yale University, advised the CIA to investigate mind control, including the use of drugs and electroshock. In the subsequent decades the CIA would fund research in two distinct directions:

> Research into psychological warfare methods explored mass persuasion through the U.S. Information Agency and the academic field of mass communications—surfacing, in time, as the legitimate areas of diplomacy and scholarly study. By contrast, as it probed the impact of drugs, electric shock, and sensory deprivation on individual consciousness, interrogation research moved ever deeper inside the clandestine complex of military intelligence and medical laboratories.
>
> (McCoy 25)

Overt propaganda was supplemented by covert psychological research and both had precedents in the activities of totalitarian states.

Experiments in mind control using mescaline were conducted on prisoners in Dachau concentration camp. After World War II America's Office of Strategic Services (OSS) recruited Nazi scientists, including Walter Neff from the team at Dachau, who had performed psychological experiments on Jewish prisoners. The OSS later became the CIA in 1947 and went on to test drugs such as marijuana and LSD as part of interrogation of suspected spies. In 1953 the CIA established MKULTRA, a program pursuing experiments with hypnosis and hallucinogenic drugs culminating in an interrogation manual in 1963, the *Kubark Counterintelligence Interrogation* handbook.

The use of electroshock was also pioneered under fascism and was first tested through the abuse and slaughter of animals. Electroshock treatment was first used in psychiatric therapy by Professor Ugo Cerletti in Rome in 1938. In the early 1930s he conducted experiments inducing epileptic fits in dogs: inserting one electrode in the mouth and the other in the rectum, often with fatal results for the animal. Responding to the high mortality rate in these experiments, Cerletti shifted both electrodes to the cranium. Before applying this method to humans in order to treat schizophrenia, Cerletti had observed the use of electroshock to stun pigs before their throats were cut in the Rome municipal slaughterhouse (Shorter and Healy 34–36). After being pioneered in fascist Italy, electroshock played its role in the eugenics and euthanasia programs of the Third Reich. The systematic killing of mental patients, code-named Operation T-4, included shock therapy as its first option. Electroshock machines were widely used in German public hospitals in the early 1940s (Andre 37–39). The practice of ECT continued in Italy throughout the war years, and became popular internationally in the 1940s and '50s.

Throughout the 1950s other forms of mind control were also being tested in Canada. At McGill University in Montreal, Dr. Donald Hebb began pioneering work on sensory deprivation, which included hallucinations, intense stress, panic and personality disintegration. Hebb went on to become president of the American Psychological Association. In 1954 the CIA became aware of Hebb's research and within a year had demonstrated its potential as an interrogation technique. One of Hebb's colleagues at McGill, Dr. D. Ewen Cameron (who would also become president of the APA), used prolonged drug-induced sleep combined with intensive electroshock therapy in an attempt to "wipe the mind totally clean" (Marks 133). The CIA began to fund Cameron, encouraging him to attempt reprogramming the blank minds of his patients. Cameron experimented with subliminal tape loops which he called "psychic driving" (136), later moving on to sensory deprivation and LSD. As opposed to the highly successful Chinese method of "thought reform," the American experiment in shock treatment and psychotropic drugs only produced "vegetables" with "no operational use" (145).

In *The Shock Doctrine*, Naomi Klein notes that one of the most significant effects of intensive electroshock treatment is the destruction of memory. Cameron was attempting to reduce the mind to a blank slate, thereby leaving it open to intervention and control. Klein compares the effects of sensory deprivation used in the *Kubark* interrogation techniques to the shock of the 9/11 attacks: "profound disorientation, extreme fear and anxiety, and collective regression" (42). This vulnerability creates opportunities for those in power to declare a state of emergency and to intensify surveillance, override political rights and engage in radical economic restructuring.

Lifton proclaimed the universal significance of Hiroshima ("we are all survivors") but his earlier research on brainwashing suggested potentially more disturbing psychohistorical insights. Psychic closing-off was not just necessary for survival but also made possible the radical reprogramming or erasure of independent memory and thought. Lifton's research on psychic closing-off and emotional numbing intersected with a larger postwar apparatus of research on the biological and psychological control of populations. If "we" were all survivors of Hiroshima then "we" were also the subjects of a mass biological and psychological experiment.

Cold War Psychohistories

Lifton's psychological research on Hiroshima and Holocaust survivors also had parallels in the writings of cultural critics who began to explore the idea of collective trauma. As they did so they (perhaps inevitably) returned to the question of race. Human populations had become the object of biological and psychological experiments, reducing them to the condition of bare life. In order to universalize this historical experience intellectuals reinscribed Eurocentric and anthropocentric conceptions of the human. The notion of

this experience as a trauma carried with it the historical baggage of the European encounter with the African. In 1957 Norman Mailer published his essay "The White Negro," which began:

> Probably, we will never be able to determine the psychic havoc of the concentration camps and the atom bomb upon the unconscious mind of almost everyone alive in these years. For the first time in civilized history, perhaps for the first time in all of history, we have been forced to live with the suppressed knowledge that the smallest facets of our personality or the most minor projection of our ideas, or indeed the absence of ideas and the absence of personality could mean equally well that we might still be doomed to die in some vast statistical operation in which our teeth would be counted, and our hair would be saved, but our death itself would be unknown, unhonored, and unremarked, a death which could not follow with dignity as a possible consequence to serious actions we had chosen, but rather a death by *deus ex machina* in a gas chamber or a radioactive city ...
>
> (Mailer 282)

Mailer went on to propose that in a capitalist culture based on the mastery of nature and manipulation of society the sovereign individual had been revealed to be ultimately powerless and his or her life without meaning. The same drive to dominate and control had created the conditions allowing for the mass destruction of the human individual and a general fear and paranoia that had silenced dissent and radical protest, replacing it with a society of mass conformity.

According to Mailer, the Negro, who had experienced a long history of violent oppression, had much to teach white society about how to survive and to fashion a subcultural identity in Cold War America. Into this bleak landscape (or, more usually, cityscape) invoked by Mailer wandered the figure of the hipster who, faced by the alternatives of annihilation by the state or "slow death by conformity," chose "to set out on that unchartered journey into the rebellious imperatives of the self" (283). Developing a conception of the psychopath first made by psychoanalyst Robert M. Linder, Mailer proposed that one is either "a frontiersman in the Wild West of American night life" or "trapped in the totalitarian tissues of American society" (284). In the closing sections of the essay Mailer envisioned a time "of violence, new hysteria, confusion and rebellion" that will "be likely to replace the time of conformity" (300).

The spectacle of the Nazi death camps and the atom bomb subjected postwar populations to a new biopolitical threat. Mailer's attempt to use this experience to formulate a new heroism only revived the old fantasy of the African "savage," even if in a new positive guise as the hipster. A few years before Mailer, Arendt had described the European colonists confronting Africans who "were as incomprehensible as the inmates of a madhouse"

(*Origins* 190). Stranded on the colonial frontier, the European lost contact with the basis of his civilized identity and was contaminated by the madness of the African, prompting a turn to genocidal violence. Now Mailer was claiming that because the African had a long history of experiencing such violence he showed the way to survive in a new age of universalized catastrophe. Arendt implicitly blamed the African for the degeneration of the European. Mailer saw the African as a survivor. Both intellectuals invoked the African as a way of addressing the specter of bare life in the death camps and both translated biopolitical violence into a universalized trauma.

Writing about the postwar generation of American intellectuals, Leslie Fiedler commented on their paradoxical relation to violence. The American mass media was saturated with images and narratives of violence and catastrophe but the direct experience of violence had all but disappeared from the experience of the newly affluent majority. Yet, Fiedler went on, America possessed a singularly violent history, including the extermination of Native Americans, the enslavement of African Americans, the Civil War, the gang wars of the 1920s, the class struggles of the '30s, and the participation in the two World Wars. The Cold War, however, bought with it new forms of terror, including the legacy of guilt for the atomic bombing of Japan and the horrific revelations of the Nazi death camps. The new generation was threatened by the possibility of a kind of absolute violence from without. Yet, Fiedler writes:

> Their dreams are possessed by images that their society cannot fulfill. In a world rent by violence, and plagued by disaster, America remains strangely immune at home.
>
> (Fiedler 178)

Fiedler published his essay "Negro and Jew: Encounter in America" in 1956, a year before Mailer's "White Negro." In Fiedler's account the Jew is a "late-comer" (231) to America whereas the Negro is "the root of our guilt and fear and pain" (232). The African slave represented a fundamental, traumatic feature of American identity and was at the heart of the Civil War, the bloodiest conflict in American history. The Negro represented "the primitive and instinctive" (237), the "projection of the white man's own 'dark' sensuality which he can neither suppress nor justify" (238) (a fantasy that is replayed in Mailer's "White Negro"). The Jew, by contrast, has fared well in the new world and enjoyed a social mobility and cultural impact that was prohibited in Europe. Reading Fiedler's essay today, one is struck by the absence of any discussion of the Holocaust: the single reference that Fiedler makes to concentration camps pertains to the incarceration of Japanese Americans during World War II. The story of the Jews in America was a "good" story for Fiedler, without any accusations regarding the failure of the Allies to strike against the Nazi machinery of extermination.

Mailer and Fiedler were drawing from the sense of trauma and terror surrounding the atom bomb and the Cold War and filtering it back through the politics of race. The widely accepted racial hierarchies of the prewar period were discredited and universal humanism now prevailed. Initially this universal humanism favored a politics of assimilation and global modernization along with a psychology of therapeutic normalization. By the 1960s, however, new voices that emerged that challenged this universalism in the name of particular ethnicities and cultures and traditions. Third World anticolonial struggles, the Black Civil Rights Movement and the emergence of the Holocaust into public memory all drew attention to the failure of Western universalism to include specific groups. Mailer and Fiedler were articulating an Americanized version of what Sartre and Fanon had shown connected anti-Semitism and colonial racism (discussed in Chapter Three). Mailer attempted to redirect the racial violence of America's history into an image of self- transcendence. Fiedler saw the Jew and the Negro as figures of unconscious fantasy for white Europeans. Both fell short of Sartre's or Fanon's attempts to understand the role of racism in the apparatus of Eurocentric vision and visibility.

Susan Sontag was another Jewish American intellectual who developed influential accounts of the Cold War imagination. Sontag is rumored to have assisted her then husband Philip Rieff to research and write his book *Freud, the Mind of a Moralist* (1959), which considered Freud's conception of the transmission of cultural memory. Whether this is true or not, Sontag certainly developed many of its themes in her own cultural criticism. Beyond the conscious transmission of culture through literature and history, Freud adopted a biological understanding of hereditary memory in which primitive impulses survived unconsciously beneath rational thought. Primal acts of violence, upon which societies are founded, persisted in collective memory as unconscious traces *because* they were denied or forgotten. For Freud history was shaped by the return of traumatic events that were transmitted through a collective unconscious. This species memory was compared by Freud to the memory of an individual, in which emotional conflicts leave behind permanent traces that resurface after a period of latency.

These themes emerged clearly in Sontag's 1965 essay "The Imagination of Disaster," in which she discussed B grade science fiction films of the 1950s and '60s. The typical scenario of these films included alien invasions, mass destruction, the cooperation of scientists and the military, and the launch of a special weapon to defeat the alien threat. In such films, Sontag wrote, "one can participate in the fantasy of living through one's own death and more, the death of cities, the destruction of humanity itself" (212). Although these films were characterized by technological spectacle and moral simplification, for Sontag they provided images that expressed unconscious anxieties about depersonalization and death. These anxieties, although essentially human, were also specifically historical. Sontag explained the basis of these anxieties:

I mean, the trauma suffered by everyone in the middle of the twentieth century when it became clear that, from now on to the end of human

history, every person would spend his individual life under the threat not only of individual death, which is certain, but of something almost insupportable psychologically—collective incineration and extinction which could come at any time, virtually without warning. ("Imagination" 224)

These lines were written at a time when American television was broadcasting and print media were publishing images of death and destruction caused by technological warfare in Vietnam. The fact that the victims of the American atom bomb were Japanese and that the victims of American napalm were Vietnamese did not stop Sontag from seeing in these science fiction fantasies a deep fear that destruction by advanced military technology was potentially to be experienced by everyone. Sontag had grown up in the Cold War period when fear of nuclear attack formed a pervasive part of American culture. The concern of Sontag's essay on science fiction cinema is that the films present a wholly "inadequate response" (224) to the real threat of mass destruction. Her concerns in her later essay on photography remain essentially the same. The images of the Nazi camps or of the killing of women and children in Vietnam are real but are drawn into a mediated unreality. More recent commentators have elevated Sontag's account of her own first encounter with photographs of the Nazi death camps to an iconic example of the transmission of historical trauma.

Sontag and the Holocaust

In her 1977 book *On Photography*, Susan Sontag described the impact of first seeing, in 1945, photographs of the Nazi death camps recently liberated by Allied forces. Here is the passage in full:

> One's first encounter with the photographic inventory of ultimate horror is a kind of revelation, the prototypically modern revelation: a negative epiphany. For me, it was photographs of Bergen-Belsen and Dachau which I came across by chance in a bookstore in Santa Monica in July 1945. Nothing I have seen—in photographs or in real life—ever cut me as sharply, deeply, instantaneously. Indeed, it seems plausible to me to divide my life into two parts, before I saw those photographs (I was twelve) and after, though it was several years before I understood fully what they were about. What good was served by seeing them? They were only photographs—of an event I had scarcely heard of and could do nothing to affect, of suffering I could hardly imagine and could do nothing to relieve. When I looked at those photographs something broke. Some limit had been reached, and not only that of horror: I felt irrevocably grieved, wounded, but a part of my feeling started to tighten; something went dead, something is still crying. (*On Photography* 19–20)

Sontag's brief comments on images of the concentration camps were made during a period when America had withdrawn from Vietnam and attention

was shifting, in the wake of the 1967 Arab-Israeli war, to the Middle East. The growing American interest in the Holocaust formed part of an ideological shift out of the Cold War. Did the new level of interest in the Holocaust allow Sontag to voice a traumatic memory—her first viewing, as a young girl, of images of Belsen and Dachau—that she had been unable to voice before? Or was she responding to a post-Vietnam ideological shift that helped foster new interest in the Holocaust by retrospectively constructing a buried trauma? And is it possible to decide between these two readings, the first oriented toward the influential trauma theory developed by Cathy Caruth, the second extending the more critical discussions of the so-called Americanization of the Holocaust?

The trajectory I have explored in this chapter suggests a third way to understand this passage: in terms of the biopolitical imagination. Although she did not cite him, Sontag's phrase "the photographic inventory of ultimate horror" recalled Lifton's account of the atom bomb experience in Hiroshima. It seems likely that Sontag would have read Lifton's *Death in Life*, which won a National Book Award in 1969. In Lifton's account the ultimate horror lies in "a specific image of the dead or dying with which the survivor strongly identifies himself" (*Death* 48). Lifton explained that images of the ultimate horror retained in the memory of survivors evoke feelings of both pity and guilt. In the section that immediately precedes her comments on the images of Belsen and Dachau, Sontag discussed media coverage of the Vietnam War. Like Sontag, Lifton saw this coverage as ultimately producing an effect of psychic numbing in the American public.

Zelizer cites this passage from *On Photography* as an example of how photographs of the Holocaust have been used to redefine collective memory. Sontag's account designated the moment of a transaction between an individual experience of looking and the social construction of memory. Her personal testimony has become part of the widespread discussion of Holocaust representation over the past thirty years. Sontag's experience as a twelve-year-old girl has been incorporated into a widely influential discursive formation around Holocaust memory that now includes films, museums and memorials, audiovisual archives, scholarly research, critical debates and popular narratives. All of which accommodate, as Zelizer puts it, "broader issues of identity formation, power and authority, and political affiliation" (*Remembering* 3). And just as photography, film, television, video and the Internet allow us to store, retrieve, reproduce and view images with unprecedented ease, quotations such as Sontag's testimony can be reproduced in new contexts that need not address in any detail the original historical situations from which they emerged. And like the photograph or film image, the power of Sontag's testimony depends on claiming an immediate and indelible link with the past. Traumatic memory, like a photograph or film image, carries an authority that is often claimed to transcend spatio-temporal context.

Marianne Hirsch continues this concern with memory in her widely discussed essay "Surviving Images: Holocaust Photographs as the Work of

Postmemory," which she begins by citing the passage from Sontag in full. Hirsch's essay is concerned with the transmission of Holocaust memory across generations. Whereas Zelizer analyzed the historical and cultural authority gained by documentary photographs as part of broader ideological agendas, Hirsch is concerned with the ways that the impact of the image is lessened or transformed over time. Have the photographs, she asks, become "Cliches, empty signifiers that distance and protect us from the event?" (Hirsch 218). Or, she goes on, "does the repetition in itself re-traumatize, making distant viewers into surrogate victims …?" (218). Hirsch argues that the repetition of these images over time does not desensitize but reproduces the original shock as a means of "working through a traumatic past" (218). This second generation memory Hirsch calls "postmemory" (220), which "defines the familial inheritance and transmission of cultural trauma" (220). Postmemory is

> an intersubjective transgenerational space of remembrance … defined through an identification with the victim or witness of trauma.
>
> (Hirsch 221)

Hirsch's concern is with the transmission of Holocaust memory, which she finds is bound to the repetition of certain images. Traumatic experience is recalled through compulsive repetition, and Hirsch argues that the repetition of images participates in this traumatization and thereby transmits it from the first generation of survivors to the second. Postmemory is the inheritance and transmission of "monumental traumatic events that resists understanding and integration" (221).

Hirsch's argument implicitly reverses Zelizer's. Whereas Zelizer wants to understand the transformation of meaning across time and in the different discursive contexts in which images are produced and reproduced, Hirsch claims that it is only in the contexts removed from the original events that the truth of traumatic experience can be witnessed and worked through. This confers an enormous authority on representations of historical events, an authority grounded in the testimonial status and evidential force of both the photograph and of traumatic memory.

Janina Struk also cites Sontag's anecdote about first seeing the images of Belsen but notes that Sontag herself in the same passage goes on to question whether anything of value can come from seeing the images (Struk 132). In fact the statement that immediately follows the passage cited by Hirsch would seem to refute Hirsch's argument:

> To suffer is one thing; another thing is living with the photographed images of suffering, which does not necessarily strengthen conscience and the ability to be compassionate. It can also corrupt them. Once one has seen such images, one has started down the road of seeing more—and more. Images transfix. Images anesthetize.
>
> (Sontag 20)

In support of this point Struk cites other commentators from the period of the liberation of the camps who stressed how the images themselves further dehumanized and degraded the survivors. Joshua Hirsch also cites the same passage from Sontag as "Perhaps the clearest statement on the relaying of trauma to the public through photographic imagery" (15). Interestingly, Hirsch reads Sontag as a member of the public responding to the publication of the photographs of the camps, rather than as a public intellectual writing thirty years after the event, who has herself played a significant role in defining subsequent responses to representations of the Holocaust.

The cultural and intellectual production around the Holocaust has absorbed the shock of the first appearance of the death camps into a narrative about collective identity. The shock has become a feature of the transgenerational transmission of cultural memory. But if we place Sontag's account of first seeing images of the camps in the larger context of her discussion of postwar trauma, we recover a different story. Sontag was part of a new generation impacted by media images of mass death and a Cold War propaganda campaign of fear. Like Lifton and others she was struggling with the ways that media anesthetize public response and create effects of immunity rather than political engagement. Her description of first seeing images of the camps has contributed to the construction of the Holocaust as a unique event attracting collective identification. But her account of images of catastrophe, along with those of other postwar intellectuals like Lifton, Mailer and Fiedler, reveals an ongoing attempt to imagine the changing relation between media and survival in the age of modern biopolitics.

Note

1. This association between images of the death camps and the moral authority of the court is reflected in the inclusion of documentary footage at a key moment in the Hollywood film *Judgment at Nuremberg* (1961).

Works Cited

Andre, Lisa. *Doctors of Deception: What They Don't Want You To Know About Shock Treatment*. New Brunswick, NJ: Rutgers UP, 2009.

Arendt, Hannah. *The Human Condition*. Chicago and London: U Chicago P, 1958.

———. *On Violence*. London: Penguin, 1970.

Barnouw, Eric. "The case of the A-Bomb footage." *Transmission: Toward a Post-Television Culture*. Ed. Peter d'Agonisto and David Tafler. 2nd ed. Thousand Oaks, CA: Sage, 1995. 121–133.

Barson, Michael, and Steven Heller, *The Commie Menace in Propaganda and Popular Culture*. San Francisco: Chronicle Books, 2001.

Caruth, Cathy. "Lying and History." *Thinking in Dark Times: Hannah Arendt on Ethics and Politics*. Ed. Roger Berkowitz, Jeffrey Katz, and Thomas Keenan. New York: Fordham UP, 2010. 79–92.

Dower, John W. "The Bombed: Hiroshima and Nagasaki in Japanese Memory." *Hiroshima: History and Memory*. Ed. Michael J. Hogan. Cambridge: Cambridge UP, 1996. 116–142.

———. *Cultures of War: Pearl Harbor/Hiroshima/9-11/Iraq*. New York and London: Norton/New Press, 2010.

Fiedler, Leslie A. *No! in Thunder: Essays on Myth and Literature*. London: Eyre and Spottiswoode, 1963.

Foucault, Michel. *"Society Must be Defended": Lectures at the Collège de France, 1975–76*. Ed. Mauro Bertani and Alessandro Fontana. Trans. David Macey. New York: Picador, 2003.

Hall, James, and Jack.C. Shaheen. *"To Die, To Live." Nuclear War Films*. Ed. Jack C. Shaheen. Carbondale and Edwardsville: Southern Illinois UP, 1978.

Harris, Sheldon H. *Factories of Death: Japanese Biological Warfare, 1932–1945, and the American Cover-Up*. New York and London: Routledge, 2002.

Hartouni, Valerie. *Visualizing Atrocity: Arendt, Evil, and the Optics of Thoughtlessness*. New York and London: New York UP, 2012.

Hirsch, Joshua. *After Image: Film, Trauma and the Holocaust*. Philadelphia: Temple UP, 2004.

Hirsch, Marianne. "Surviving Images: Holocaust Photographs and the Work of Postmemory." *Visual Culture and the Holocaust*. Ed. Barbie Zelizer. New Brunswick, NJ: Rutgers UP, 2001. 214–246.

Lifton, Robert Jay. *Death in Life: Survivors of Hiroshima*. New York: Random House, 1967.

———. *Home from the War: Vietnam Veterans: Neither Victims nor Executioners*. New York: Simon and Schuster, 1973.

———. *History and Human Survival: Essays on the Young and Old, Survivors and the Dead, Peace and War, and on Contemporary Psychohistory*. New York: Random House,1970.

———. *Thought Reform and the Psychology of Totalism: A Study of "Brainwashing" in China*. New York: Norton, 1961.

Lifton, Robert Jay, and Greg Mitchell. *Hiroshima in America: A Half Century of Denial*. New York: Avon, 1995.

MacAdam, Lewis. *The Birth of the Cool: Beat, Bebop, and the American Avant-Garde*. New York: Free Press, 2001.

Mailer, Norman. *Advertisements for Myself*. London: Andre Deutsch, 1961.

Marks, John. *The Search for the "Manchurian Candidate": The CIA and Mind Control*. New York: New York Times Books, 1979.

Masco, Joseph. "Engineering Ruins and Affect." *Cultures of Fear: A Critical Reader*. Eds. Uli Linke and Danielle Taana Smith. London and New York: Pluto Press, 2009. 38–53.

McCory, Alfred W. *A Question of Torture: CIA Interrogation, from the Cold War to the War on Terror*. New York: Metropolitan Books, 2006.

Mills, C. Wright. *The Sociological Imagination*. Oxford and New York: Oxford UP, 2000.

Perrine, Toni A. *Film and the Nuclear Age: Representing Cultural Anxiety*. New York and London: Garland, 1998.

Rieff, Philip. *Freud: The Mind of the Moralist*. London: Victor Gollanz, 1965.

———. *The Triumph of the Therapeutic: Uses of Faith after Freud*. London: Penguin, 1973.

Shorter, Edward, and David Healy. *Shock Therapy: A History of Electroconvulsive Treatment in Mental Illness*. New Brunswick, NJ: Rutgers UP, 2007.

Sontag, Susan. *Against Interpretation and Other Essays*. New York: Farrar, Straus and Giroux, 1966.

———. *On Photography*. London: Penguin, 2008.

Struk, Janina. *Photographing the Holocaust: Interpretation of the Evidence*. London and New York: I.B.Taurus, 2004.

Torchin, Leshu. *Creating the Witness: Documenting Genocide on Film, Video, and the Internet*. Minneapolis, London: U Minnesota P, 2012.

Zelizer, Barbie. *Remembering to Forget: Holocaust Memory through the Camera's Eye*. Chicago and London: U Chicago P, 1998.

5 The Immunity of Empire

Images of war and catastrophe in mainstream media are usually framed by discourses about humanitarian crises, states or extreme groups hostile to Western societies, and the need for aid and military intervention by Western powers. Viewers are addressed as concerned citizens who are dismayed and possibly distressed by the sight of human suffering and who desire this suffering to be alleviated by governments and international organizations. This book has considered a range of perspectives that question this liberal humanist construction of media and catastrophe and has proposed understanding media as a biopolitical apparatus that produces human subjects defined by the constant threat of destruction. Catastrophe is no longer the exception but the norm, demanding that individuals and communities inhabit mediated environments that secure their immunity from harm.

This chapter discusses some of the specific biopolitical functions of media in the post 9/11 world. The spectacular destruction of the World Trade Center and the mass death of American civilians prompted a further intensification of the military-security-media apparatus in order to reestablish biopolitical immunity. Media technologies and information networks were used to record, archive and analyze data about populations and to disseminate images of threatening persons and hostile actions. News and entertainment media generated stereotyped images of a new political threat: the Islamic terrorist (replacing the now defunct enemy of international Communism). Biometric data were collected on internationally mobile populations and used to police borders and to detain anyone deemed a threat to national security. Military interventions in Afghanistan and Iraq were presented as retribution for the attacks and preemptive action against future threats. The catastrophic penetration of America's national security system was proclaimed as a traumatic experience for the general population and a justification for intensified surveillance, policing, incarceration and military aggression.

As entire populations are threatened with destruction by high tech weaponry or detainment in camps and prisons, media images of mass death and bare life function as part of the immune system of populations whose lives are deemed worth living. Whether the response to these media images is shock, dismay, indifference or gratification, the viewer is supposed to remain immune from actual destruction. Images of death or suffering enhance the lives of those who view them by intensifying feelings of anxiety, numbing

emotional response or allowing voyeuristic pleasure. All of these responses insulate viewers from any direct threat to their lives. As other populations are destroyed or incarcerated the image assumes attributes of a more potent life and virulent presence. As previous chapters have shown, attempts to monitor, classify and thereby control human life as biological information have always been accompanied by vitalist conceptions of the image. Digital media have produced a population explosion of images that are internationally mobile and connected through social and information networks. The politics of seeking control over this image population intersects with the biopolitics of controlling human life. As W.J.T. Mitchell has shown, this image vitalism has intensified in digital culture. As it is reproduced, repeated and circulated through media devices and networks the digital image takes on a life that in turn must be captured, tamed, confined or disposed of. This vitalism of the image carries with it biopolitical conceptions of race and species. As society attempts to maintain immunity from catastrophe the media image assumes a new potency: image vitalism is a projection of the biopolitical imagination.

The Lives of Images

Speeches by Barack Obama that address the legacy of the 9/11 attacks provide clear examples of how discourses about catastrophe and trauma are framed by the biopolitics of sovereign power and immunity. In the speech he gave after the 2011 assassination of Osama bin Laden, Obama began by evoking images of the 9/11 attacks that were "seared into our national memory." Remembering the "nearly 3000 citizens taken from us," Obama went on to claim that after the attacks "the American people came together" and "we were united as one American family."[1] With the killing of bin Laden the trauma of 9/11 was avenged and the sovereignty of the American community restored. In his dedication speech at the opening of the 9/11 Memorial Museum in 2014 Obama again invoked the catastrophe, this time with a story of heroism after the South Tower of the World Trade Center was hit. On the 78th floor the "man in the red bandana," a young man who tended the wounded and led others to safety, was killed when the tower collapsed. Wells Crowther, a twenty-four-year-old white male who worked in finance, embodied "the true spirit of 9/11: love, compassion, sacrifice." Crowther sacrificed his life so that others could live, proving that "nothing can ever break us. Nothing can change who we are as Americans."[2]

According to Obama the events of 9/11, which had penetrated America's security system and destroyed the long held immunity of American civilians from direct attack, had the beneficial effect of bringing the nation together and making it stronger. The general population shared a sense of common purpose. Obama's speeches about 9/11 are completely conventional in terms of a political leader affirming national identity in the face of adversity and catastrophe. They also follow the logic of what Esposito has called the immunitary paradigm. The community is bound together by releasing itself from

obligations to those outside the community and by insulating itself from external threats. But immunization is only achieved by incorporating the external threat into the body politic. By making "the man in the red bandana" a representative of the American community Obama assimilated the civilian victim of terrorist attack into the narrative about who Americans are. Wells Crowther may have responded heroically in the midst of catastrophe, but many of those killed in the attacks disappeared without a trace. The destruction of civilian populations in modern war and terrorism is difficult to reconcile with liberal democratic ideas of citizenship and individual agency. Only enemy populations are supposed to be killed, only the American population is supposed to be immune.

Alongside the public celebrations in America of bin Laden's death, a minor controversy arose about the absence of any pictures of his dead body. Obama claimed that the release of such pictures was undesirable as they could be used for anti-American propaganda. Bin Laden's body disappeared, joining the bodies of those who perpetrated the 9/11 attacks, the many unrecovered bodies of those who died in the planes and buildings on 9/11, the bodies of suicide bombers and their victims, the countless civilians killed by American bombs, etc. All of these disappeared bodies inhabit a new kind of limbo produced by contemporary war. For many who identify with the attack on American power, suicide bombers and leaders like bin Laden are martyrs. In Obama's speeches there are populations whose lives count, such as the citizens killed in the 9/11 attacks, and those who are enemies of America or who are never mentioned, such as the citizens of Afghanistan and Iraq. The body of bin Laden has been disposed of, but the unrecovered body of Wells Crowther has been enshrined as a representative of life that is worth living. The Arab male enemy can be killed but not sacrificed because he must not be allowed to become a martyr.

In *Multitude* (2004), Hardt and Negri discuss the new global form of war that is emerging with the decline in the sovereignty of nation-states. Modern warfare used to be based on conflicts between sovereign nations and were not related to conflicts internal to society. War was the exception: nations went to war when normal diplomatic relations broke down. Now America wages war on a global scale and lays claim to a fundamentally different kind of power than that of the European nation-state. American power is above international law. By claiming moral responsibility for the entire planet, America has made itself immune from the obligations that limit the power of other states. War has become the norm:

> War has become a *regime of biopower*, that is, a form of rule aimed not only at controlling the population but producing and reproducing all aspects of social life. This war brings death but also, paradoxically, must produce life. This does not mean that war has been domesticated or its violence attenuated, but rather that daily life and the normal functioning of power has been permeated with the threat and violence of warfare. (*Multitude* 13)

Despite Barack Obama's official ending of the war on terror, this war continues, has no limits and cannot ever be concluded. Its aim is not to overthrow the old order and install a new one. Its purpose is to govern and regulate all aspects of social life in terms of existing hierarchies of power and to sustain America's immunity from destruction.

In the Cold War period intellectuals such as Lifton and Sontag made claims for the American population as traumatized survivors of Hiroshima and the Holocaust. The indirect or simulated experience of catastrophe via media exposed the general population to the threat of collective annihilation. In the post–Cold War period the image itself has been assigned the capacity to traumatize populations: it is not only the sight of the dead but the life of the image that poses a threat. The suffering bodies shown in images of catastrophe have now been eclipsed by their afterlives as images that circulate as part of a media autoimmune system. To understand these mediated discourses and effects in biopolitical terms requires that we see their place in a longer history of the therapeutic and technological management of life. As previous chapters have shown, the colonial encounter with the non-European, the revelations of the Nazi death camps, the testimony of survivors of atomic warfare, all presented the Western liberal subject with a "traumatic" image of bare life. But the catastrophic events with which these images were associated served partly to distract attention from the everyday incorporation of private existence into technologically monitored and controlled forms. To summarize: the traumatic image is how bare life is imagined from the perspective of immunity.

The intensification of the threat of catastrophe and its deeper integration into everyday life has prompted a return of vitalistic conceptions of the image. The life *of* the image is enhanced as actual death and destruction is experienced only *as* an image. For example, W.J.T. Mitchell has proposed that "images are like living organisms" (11) and that the animistic conception of images continues to be a feature of secular and technologically advanced societies, even if this is not consciously acknowledged. He goes on:

> If the living image has always been the subject of a double consciousness, of simultaneous belief and disavowal, what conditions are making the disavowal more difficult to maintain today? (*What Do Pictures Want?* 11)

Mitchell finds a possible answer to this question in two images: the cloned sheep "Dolly" and the destruction of the World Trade Center. The cloned sheep and the twin towers appear as "idols" of biotechnology and global capitalism that are "worshipped" in Western societies. Mitchell opposes the "liberal and flexible" (20) belief in these idols found in America to the intolerant and inflexible beliefs of the Islamic iconoclasts responsible for the 9/11 attacks. Western secular societies fetishize life (and money) in technologically mediated forms, whereas fundamentalists attack these "false" images as challenging the sovereignty of God-given life.

A different answer to Mitchell's question, however, is that biotechnology and the media image of catastrophe share a common history in modern biopolitics. The mass destruction of animals and humans is a feature of societies in which the production and maintenance of life has become the central project of political power. We can therefor understand the idea that images have a life of their own as a symptom of biopolitical media: that is, of the ways that visual media function as a life-support system, an insulating shield that safeguards life by introjecting and expelling alien or contaminating life forms. The image is an extension of the self and society imagined as living organisms. For this reason the image is more alive to us than the suffering and deceased bodies that it shows. If images seem more alive than ever it is because the need to insulate ourselves from the threat of destruction appears ever more urgent.

For this reason I propose a modification of what Mitchell has called the "biopicture" or "biodigital picture" (Mitchell 70). According to Mitchell the biopicture emerged with nineteenth century capitalism and embodies Social Darwinist ideologies. Today the often violent content of the biopicture is "designed to overwhelm the viewer's defenses" (97). The problem is that it is also designed to maintain and strengthen the viewer's defenses. The conception of biopolitical media that I have developed in this book differs from Mitchell's insofar as I question the "traumatic" impact of the image and see the claim that human communities experience a collective psychological disturbance as itself biopolitical. The pathology of trauma applied to modern populations is an extension of the medicalizing gaze as an instrument of power. Biopolitical media do not transmit traumatic experience but bare life: their purpose is to constitute, sustain and monitor the human subject as an object of knowledge and power.

The bombing of Hiroshima and Nagasaki and the subsequent arms race with the Soviet Union lead to a propaganda campaign in America cultivating fear of a nuclear attack. The 9/11 attacks served a similar purpose for the American government's new campaign of fear (although this time it had been American civilians who were the victims). The bomb had been seen as a collective trauma primarily by intellectuals on the left who saw the underlying similarities between totalitarian terror and American postwar hegemony. 9/11 was constructed as a trauma by the government and corporate media as a means of restructuring the military-security-entertainment complex. The terrorist embodies the contemporary threat of the bad life form that threatens the survival and security of life worth living.

The danger with the conception of images as overwhelming the viewer's defenses is that it implies an otherness, an exterior, catastrophic force that impacts on a vulnerable population. But what if this population already lives with an everyday familiarity with images of violence and catastrophe? The obvious rejoinder is that images of the 9/11 attacks or of Americans being executed by ISIS are qualitatively different from other media images because they show real suffering and destruction of members of the national community.

Such an argument, however, assumes a unified collective experience of political community. In any society there will always be a range of perspectives on and responses to even the most catastrophic events. The very idea of a traumatized population potentially extends political violence against democratic participation by denying this irreducible plurality. The Western populations that are the target of terrorist attacks are also deeply embedded in the technological mediation of experience. Violence and catastrophe are regular features of media use and parrying the shocks they provoke has long been a function of the nervous systems of those who inhabit mediated worlds. We can see cultural trauma, then, as a discourse through which the mediated subject monitors his/her own resilience, coping mechanisms, and levels of distress.

The Immune System

The question of security is at the heart of Foucault's account of biopolitics. Liberal governments, he argued, are engaged in the regulation and management of risk. The welfare state aimed to protect its citizens from the insecurities of unemployment, homelessness, injury, illness, natural disaster and other threats. It also permitted, regulated and limited social and economic freedoms. A third element, alongside liberal governments' aim to provide security and regulate freedom, is fear. The necessity of risk creates uncertainty and potential instability. Neoliberal governments demand that individuals manage higher levels of risk, thereby also creating higher levels of fear—of unemployment, poverty, and terrorism. Fear stimulates the individual to constantly monitor his/her physical and psychological health and well-being. In neoliberal societies those who are poor or sick are seen as a threat to those who have more effectively managed risk (Lemke "Risks" 64–70).

Liberalism speaks the language of universal human rights but its legitimacy has been undermined by biological conceptions of life. As Michael Dillon and Julian Reid explain, there are always potential contradictions between natural political rights, which are supposed to be universal and unchanging, and the biological properties of species, which are constantly evolving and adapting to new environments. Universal principles have their origins in theological world orders. Rights are guaranteed by sovereign power; and sovereignty, whether of monarch or subject, is always God-given. But in modern societies the natural sciences have overtaken religion as the measure of truth. Political rule concerns itself with the health and survival of populations, whereas membership in a political community is determined, in the first instance, by birth.

The modern state, argued Foucault, is premised on a state of war and for this reason needs conceptions of race to define enemy populations. The liberal state is no exception:

> Committed to promoting and securing the life of the biohuman ...
> liberal rule must be prepared to wage war not so much for the human,

but on the human. It does so by seeking, among other things, to glo-
balize the domesticating power of civil society mechanisms in a war
against all other modes of cultural forms, invoking horror at other
cultural, as well as tyrannical, political practices …

(Dillon and Reid 20)

This "horror" of alien cultural and political forms had an earlier expres-
sion in the colonial trauma that Arendt invoked with reference to Conrad's
Heart of Darkness (as discussed in Chapter Three). The European who has
equated his/her supposed biological and cultural superiority with universal
human values, expressed horror at encountering the African "savage." The
biological and cultural diversity of the human species poses a threat to the
universalizing claims of the Western liberal subject. What Dillon and Reid
call the "liberal way of war" is waged in the name of the biohuman and
decides what forms of life deserve to live and which must be destroyed.

Biology has become the basis of political rationality, replacing the tra-
ditional dependence of sovereign power on theology. The need to achieve
collective security is no longer only territorial but a question of preserving
and maintaining life. Biopolitics has also transformed the ways we under-
stand visual media. Biology provided the category of race as a means of
defining social membership and political rights. Early photography and film
were used to analyze racial characteristics and produce racial stereotypes as
a protective shield against difference. In the contemporary era of globalized
information networks the media itself is spoken of as if it were a form of life.
Digital information circulates through the body politic carrying the threat of
viral contamination or genetic mutation. Media no longer merely confront
the viewer with the mass trauma of war, genocide or natural disaster, but
are understood as themselves agents of potentially catastrophic destruction;
they are no longer thought to show the suffering of others, but to transmit
it, potentially traumatizing populations.

As we have seen in earlier chapters, modern populations have been under-
stood by cultural critics as somehow suffering the delayed effects of collec-
tive guilt and anxiety, and/or displaying inadequate responses to violent and
catastrophic effects that reveal forms of psychological numbing. Or they
are seen as politically disenfranchised by the overwhelming psychological
impact of media images. In any case, cultural experts turn large populations
into case studies. Images of total war and genocide perpetrated on civilian
populations now form a central part of the psychobiology of citizenship,
reproducing a conception of the individual as both politically dispensable
and available to be monitored in terms of psychological effects. Those who
are defined as vulnerable to trauma constitute a biopolitical "problem" and
are no longer conceived as political subjects in the sense of having the capac-
ity to actively change the conditions in which they live.

This pathological conception of the population has developed gradu-
ally over the past century. Evaluating the propaganda campaigns of World

War I in the 1920s, Harold Lasswell noted the importance of traditional prejudices against, and alliances between, nations. Given these historical conditions, propaganda aimed to orchestrate hatred against enemies, preserve the friendship of allies, and to demoralize the enemy (Lasswell 195). Lasswell's conception of propaganda was primarily about mobilizing emotional loyalties and hostilities and included no conception of collective psychological disturbance. As we saw in Chapter Four, since World War II the construction of the public as a victim or survivor has become a defining feature of American identity.

Empirical research on collective trauma constitutes a new stage of what in previous decades had been more speculative arguments about the effects of mediated violence and catastrophe. For example Robert Jay Lifton, after undertaking extensive psychotherapeutic work with Vietnam veterans, commented that the television coverage of the war had "contributed to massive additional numbing on the part of society, in relationship to the already existing numbed violence of those pursuing the war" (*Home* 157). Lifton noted the spectacular nature of the media coverage "removed from appropriate emotional impact both by the television medium and by the regularization of the performance" (157). The war extended over a period of years and much of the controversy around Vietnam was in response to the images that emerged of Americans as not only victims but perpetrators of atrocity. Lifton's concern with the effects of spectacle and repetition in media coverage had to do with the problem of moral and political disengagement on the part of both the military and the public. Since 9/11 the concept of collective trauma has been applied to the general population of America, who are no longer conceived as "numbed" or indifferent to violence but as potentially vulnerable to disturbing images. The *Report of Findings from the National Vietnam Veterans Readjustment Study* found that over half of war veterans experienced "clinically significant stress-reaction symptoms" (Vickroy 17, Tal 272). Since 9/11 similar figures have been used with reference to viewers of media representations.

Lifton noticed—as did Susan Sontag—that the extensive photojournalist and television coverage of suffering and atrocity in Vietnam seemed to have produced a saturation effect that inhibited further moral outrage. Although the media coverage of the Vietnam conflict was unprecedented in its exposing of the horrors of war to the general public it appeared, after an initial shock effect, to construct a protective shield against emotional involvement. In the subsequent Falklands and Gulf wars the state regained its power to control media coverage and to present military operations as carefully planned and executed. The 9/11 attacks reintroduced the effect of shock into the dynamics of censorship and spectacle.

In his post 9/11 essay "Americans as Survivors," Lifton argued that because America (with the exception of Pearl Harbor) was not invaded or bombed in either of the world wars, their national narrative tended to portray Americans as victors rather than victims. According to Lifton this

changed with the defeat in Vietnam, the 9/11 attacks and the war in Iraq. Now Americans can see themselves as survivors, that is, as people who have been exposed to the threat of death or witnessed the deaths of others and remained alive. Survivors "struggle with images of death and dying" (428). Immediate survivors have been directly exposed to death. Lifton places all Americans in the category of distant survivors who experience "a sense of individual and collective fear and vulnerability and feelings of injured national pride and humiliation" (428).

Over a decade after the 9/11 attacks, research on the psychological effects of the catastrophe have extended well beyond those who directly witnessed the events. Early research on residents of Manhattan was quickly extended to include those who had witnessed the attacks through audiovisual media, broadening the definition of PTSD to potentially include the entire American population. Those effects, however, were shown to have abated over time, with a considerable falling away after one year, except among so-called vulnerable groups which included people of low income or immigrant status, women, and those with a history of mental illness or depression. Research on PTSD sufferers also commented on "inappropriate" feelings of shame or guilt and lack of social networks leading to greater psychological vulnerability.[3] Vulnerability becomes a measure of those elements in the population most likely to be reduced to the condition of "bare life," but the larger population is always potentially included in this category. Despite—or perhaps because of—these far reaching claims about the general population, the latest edition of the *Diagnostic and Statistical manual of Mental Disorders* says that media viewing in itself cannot be considered a cause of PTSD, although it may compound existing mental stress. (After all, claims for compensation from corporate media for damage to mental health would appear potentially limitless.)

The symbolic transference of the suffering experienced by survivors of war or genocide onto populations who witness the sufferings of others through visual media presents a clear example of the dangers of "harvesting" trauma as biopower for the purpose of constructing and maintaining an immunizing shield. Media images of war perform a function in this discourse of security by maintaining a sense of threat to the body politic, thereby reaffirming which forms of life need to be preserved and implying which lives need to be destroyed. In this way the immunizing function of this discourse of security reproduces conceptions of racial hierarchy and species survival. The psychological study of vulnerable populations is accompanied by the technological surveillance of elements in the population deemed a threat. Both gather information for the purposes of sustaining biopolitical security.

Biometrics

The new medium of photography was used in the nineteenth century by Bertillon, Galton and others to record physiognomic details and to compile an archive of social and racial types. This photographic documentation

was aligned with the policing of the "dangerous classes" in the rapidly expanding populations of the metropolis (as discussed in Chapter One). Today digital media form part of biometric systems that record biological information about individuals and populations for the purpose of assessing the risk that they pose to collective security. Facial recognition, fingerprinting, iris scanning, DNA analysis and other techniques are used to identify individuals and to interpret their risk level according to a "complex assemblage of codes, protocols, agreements, alliances, conventions, training programs and so on" (Dillon "Security" 191). Facial recognition systems are driven by computer programs that classify human individuals in ways that exceed the understanding and control of those whom they assess and those who operate them. The digital codes that scan and recognize facial characteristics are stored as numerical information.

After 9/11 the U.S. government initiated new identification programs to document people entering and leaving the country. The National Security Entry-Exit Registration System (NSEERS) and the U.S. Visitor and Immigrant Status Indicator Technology Program (US-VISIT) have captured and archived the biographical data, facial images and fingerprints of millions of people (Finn 107–109). Research has shown that these systems have a significant race bias and more easily recognize nonwhite faces. Resident aliens from twenty-five countries—most from the Middle East but also North Korea, Indonesia, Pakistan and North Africa—were identified by NSEERS as requiring surveillance and monitoring. The threat posed by these aliens is racialized as their skin color and facial features become visual information that is recorded and recognized by biometric systems. The individuals who are identified as a threat to national security may suffer restrictions placed on their freedom of movement or legal rights. In this way entire populations are potentially criminalized.

As Dillon explains, biopolitical war is conducted by liberal governments through the discourses and practices of security. Biometric systems aim to preserve, regulate and promote species life by assessing risks in human populations. Those risks are racialized, bearing out Foucault's proposition that modern states cannot function without war and that race provides the biological caesura through which enemy threats are identified. Discourses that describe media images as agents of physiological and psychological distress reproduce this liberal conception of security: images are all potential foreign terrorists. The image is threatening when it shows or is associated with the racialized other, the sub- or nonhuman, or with bare life.

The new biopolitical threat of terrorism has replaced the more easily recognizable and territorial enemy of the Soviet Union. The viral presence of the terrorist cell in the home territory requires that the enemy be racialized in order to be made visible (Gates 98–99). Facial recognition and other biometric systems of identification not only service the biopolitical management of welfare, immigration, labor and consumer behavior but also play an important role in technological warfare. Identifying the enemy at a distance

enables killing distant targets. As with facial recognition systems, military surveillance and weaponry now exceed the perceptual range of both the targets and the operators: the suspected terrorist on the streets of Baghdad may not even realize s/he is the object of helicopter surveillance and may be killed without being aware of any hostile military presence. Drone technologies further extend this power over life and death beyond human agency.

Hardt and Negri comment on how the immunity of American power is extended through technology to remove even soldiers from the risk of death:

> Increasingly, U.S. leaders seem to believe that the vast superiority of its firepower, the sophistication of its technology, and the precision of its weapons allow the U.S. military to attack its enemies from a safe distance in a precise and definitive way, surgically removing them like so many cancerous tumors from the global social body, with minimal side effects. War thus becomes *virtual* from the technological point of view and *bodyless* from the military point of view; the bodies of U.S. soldiers are kept free of risk, the enemy combatants are killed efficiently and invisibly. (*Multitude* 44–45)

This passage recalls Benjamin's metaphor comparing the surgeon and the cameraman (4 263). The convergence of the camera and the missile allows the soldier to destroy targets in the style of a video gamer. Nicholas Mirzoeff proposes that the rapid transformation of visual media technologies in the 1990s was partly driven by military research and generated what he calls a "weaponized image" (70). Visual media were "embedded" in American military operations in Afghanistan and Iraq, positioning viewers as participants in, rather than witnesses to, destruction of military opponents and civilian populations. The image was designed to promote identification with America's geopolitical agenda and to do "psychic harm" (75) to the enemy.

The Image as Weapon

This relation between high tech weaponry and communications media has a long history. The Internet has its origins in the development of a decentralized computer network communicating between American nuclear weapons stations. But before that, according to Friedrich Kittler, television was "largely a civilian byproduct of military electronics" (208). The BBC television service, introduced in 1936, was discontinued with the outset of World War II and its high frequency tubes employed by radar stations to detect enemy planes. When Walter Bruch, a pioneer of the German television system, constructed a camera inside a bomb during World War II, he initiated "the first self-guided weapons systems, which have since made people, the subject of all modern philosophies, simply superfluous" (218). Norbert Wiener's weapons research during World War II pioneered the new science of information systems that possessed qualities of biological life, responding and adapting to changes

in the environment. The concept of the network in the emerging science of cybernetics was modeled on the nervous system, or the organic organization of responses to, and interactions with, information. Genetic and molecular biology understood life in terms of information exchange. Cybernetics devised complex models for encoding and decoding that resembled organic life. The biological and non-biological combined to form a complex system in which life was conceived as information and information technologies were modeled on natural life.

N. Katherine Hayles has explained how the Macy Conferences in Cybernetics held from 1943 to 1954 led to the formulation of a theory of communication that included animals, humans and machines. This involved bringing together theories of neurons and computers as information processing systems. Although Wiener, as one of the leaders of this research, saw cybernetics as compatible with the liberal humanist subject, the theory of information systems tended to undermine notions of the self as an autonomous entity (7). Liberal humanism continues to speak in terms of universal truths and values but human life is understood in biological terms as genetic information and populations are recorded, monitored and organized through systems, networks and archives of digital information. The merging of the biological sciences with computer technologies has produced new posthuman conceptions of life. With the convergence of genetic and digital information technologies the media image has come to embody the threat of hostile life forms. The life of the image—its mobility, its resilience, its capacity to reproduce, multiply and thereby engender new populations—has overtaken even the concern with the psychic impact of media.

The ever-increasing speed of media transmission means that images and stories appear with a suddenness and apparent randomness that belies any clear sense of historical causality. Andrew Hoskins and Ben O'Laughlin call this new situation "diffused war" (2). In the post-broadcast era of digital media and information networks participants and witnesses are connected in unpredictable and uncertain scenarios. The increasing interconnectedness of economies, environments and human populations makes the impact of actions and events, along with representations of those actions and events, difficult to control even by governments or large corporations. This connectivity is apparently reflected in the hypertextual construction of the digital text: no image or story is encountered in isolation but is always only one mouse click away from an infinite series of other images and stories which de- and recontextualize its meanings. Media images now appear not only as presentations by corporate publishing or broadcasting but as part of a limitless archive potentially available to anyone, anywhere at any time.

The proliferation of images can be compared to a population explosion presenting new challenges for biopolitical management and control. Images are constantly multiplying, promiscuously connecting and combing with other images, lending themselves to multiple users. Images are increasingly

deterritorialized: like stateless people they constitute a new kind of bare life; like a suicide bomber the image is both a weapon and a living body with the potential to injure, contaminate or destroy other living bodies. The greater the complexity of the codes and networks of digital information the more the element of chance becomes a key factor. In biological terms this means that bodies need to become more responsive to change and able to adapt to changes in their environment. A more open field of possible circulation and connectivity means higher levels of risk and the necessity for new forms of immunization.

At the beginning of the twenty-first century, argues W.J.T. Mitchell, digital media and the Internet produced "a global plague of images" (Mitchell 2). We are also witnessing a "war of images" that

> has been fought by means of images deployed to shock and traumatize the enemy, images meant to appall and demoralize, images designed to replicate themselves endlessly and infect the collective imaginary of global populations.
>
> (Mitchell 2–3)

According to Mitchell's analysis the 9/11 attacks and subsequent invasions of Afghanistan and Iraq employed the image as a key strategic weapon. The television coverage of the Vietnam War effected public opinion in ways that the government could neither predict nor control but the war on terror and 1991 Gulf War deliberately used visual spectacle in the service of political and military objectives. The 9/11 attacks were intended to not only damage the physical infrastructure of American power but to have symbolic and psychological impact through global media. The "shock and awe" campaign of bombing Baghdad was enhanced by television coverage, and the capture and execution of Saddam Hussein served as a powerful narrative of retribution. For Mitchell the terminology of viral infection describes a shift from what Benjamin called "the age of mechanical reproduction" to what he calls "the age of biocybernetic reproduction"; that is, a shift from Fordist industrial mass production to the technological control of genetic and digital information. Mitchell links terrorism to the bioinformatic model:

> Terrorism is so routinely analogized to things like sleeper cells, viruses, cancers and autoimmune disorders that one is tempted to say that, at the level of imagery and imagination, all terrorism is bioterrorism.
>
> (Mitchell 20)

Lifton's diagnosis of massive psychic numbing might be seen as belonging to the era of broadcast television and as reproducing the "hypodermic" model of mass communications in which a central source of information directs a message at a receptive audience: media as a narcotic. Mitchell's metaphors of viral contamination describe the new logic of digital information

networks. Digital technology has shifted the discourse of immunity but we must not accept its metaphors at face value but see how they reproduce biopolitical hierarchies of race and species.

Immunity and the "Dangerous Supplement"

Foucault explained how the biological and medical extension of political power developed primarily through the struggle against infectious disease. This required the physical isolation of specific individuals and groups. Disciplinary society multiplied the places of confinement—schools, factories, hospitals, asylums and prisons but also neighborhoods, slums and ghettos— and thereby stratified and compartmentalized the population. Esposito proposes that all of this should be seen as part of the framework of immunization. Life is preserved by the defense mechanisms of the body which must protect itself from contamination, degeneration and death. For centuries society has been represented by the image of the body politic. In Hobbes's *Leviathan* the state is compared to a machine, a form of artificial life that supersedes the biological body. The state is an immunized body:

> not only does it survive the death of its members, it even periodically derives its reproductive energy from them, like an organism first nourished with the life of all the parts that compose it and then additionally with their death.
>
> (*Immunitas* 115)

In the nineteenth century biologists began to use the analogy of the state to explain the workings of the natural body. The body was no longer conceived in terms of a single life force but as composed of a multiplicity of cells. The body was seen as less like a traditional monarchy ruled by the head than a modern democracy with cells corresponding to individual citizens. The idea of the cell, however, also deconstructs the individual into an "infinitely plural community" (133) that, in turn, undermines the claims of liberal democracy. The modern biopolitical conception of society as a population makes the individual body the foundation and object of power. The state derives its legitimacy from the well-being and survival of all of the individuals that it governs. As Foucault put it, the body was no longer a juridico-political metaphor but the object of biological knowledge and medical intervention. Individuals no longer sacrificed their lives for sovereign power. Instead their biological survival became the basis of sovereign power and it was now those individuals deemed a biological threat who needed to be eliminated.

Esposito argues that there is both an etymological and historical link between the concepts of community and immunity. The Latin *munus* means an obligation or duty that defines membership in a community. *Immunitas* means exemption from these obligations or duties. All communities need forms of immunity to establish the limits of their obligations and duties to

others and to protect them from exterior forces that threaten their survival. Modernity introduced a new biopolitical conception of immunity due to the breakdown of earlier forms of sovereignty such as theological world orders and monarchy. The removal of the limits that previously defined human identity and community creates new problems for establishing immunity. Modern individuals and societies must continually locate new threats in order to constitute an identity. These threats operate according to the logic of what Jacques Derrida called supplementarity, which complicates the hierarchy between two opposed terms. The first, or privileged, term establishes self-identity. The second term appears as an external threat that is posited in the same gesture as it is incorporated as also a feature belonging to the privileged term. The other is defined and excluded only by way of associating it with qualities or properties that are also possessed by the self.

We can see such a logic at work in the mediation of terror. The population must survive and survivors have to live through and cope with traumatic experiences. The image of catastrophe and violence threatens the psychological well-being of the individual. The media apparatus that records, preserves and transmits those images both induces shock and protects against trauma. As Pieter Vermeulen puts it, trauma discourses and, we could add, media representations are "technologies that mobilize the negativity of trauma in a mitigated form for the sustainment of life" (150). For example, in an interview conducted after 9/11 Derrida spoke of the "compulsive inflation" (Borradori 89) of the events. Giving 9/11 a special "traumatic" status distracted attention from the many other comparable instances of violence and terror, including those perpetrated by the American state. The inflation of 9/11 to the status of iconic trauma of the twenty-first century is very much a product of the media apparatus that assigns news value to particular events while downplaying or ignoring others. The negativity of trauma was converted into a positive value reaffirming American identity.

The danger of Mitchell's claim that the 9/11 attacks were "designed to traumatize a nation" (21) is that it reproduces the conception of the events that was propagated by the American media. Terrorism is described as a viral threat because it is what Derrida called the "dangerous supplement" that is made to appear as an external enemy when it actually serves the claims to self-identity of the inside group. Indeed the supplementary logic of immunity informs the entire discourse around catastrophe and trauma. Mitchell's account of terrorism as a biological threat only makes explicit a biopolitics that has long been operating behind a rhetoric of universal human rights. Because the destruction of the World Trade Center was so spectacular, the traumatic effect of the images needed to be explained as psychological warfare perpetrated by the terrorists. But the alleged trauma suffered by the American population was something that was not designed by foreign agents but had already been constructed over decades by America's own intellectuals and media.

The iconic instance of the "traumatic event" transmitted by media—the liberation of the Nazi death camps—was unprecedented due to the physical

distance of the colonies from Europe and the media censorship that pre-
vailed for most of the two world wars. Earlier atrocities and genocides in the
Americas and Africa, the Japanese "Rape of Nanking," the Armenian genocide
in Turkey, the famines resulting from Stalin's collectivization of agriculture,
had for the most part been kept invisible to the public. The camps showed
the mass death of civilians in concentrated, spectacular forms. Hiroshima
and the Holocaust came to be spoken of as traumas for all humanity because
they showed not only that modern states were genocidal but that weapons
of mass destruction could cause extinction for the human species. What was
exceptional and traumatic was now the "norm"; the destruction of civilian
populations was now shared by everyone as a threat and a trauma that nev-
ertheless preserves collective immunity. This immunity from destruction did
not extend to those populations in Southeast Asia and the Middle East that
continued to be terrorized and destroyed by weapons of mass destruction.

Catastrophe is the norm that sustains the immunity of empire. Allen Feldman
has explained how images of the 9/11 attacks, the Shock and Awe campaign
in Iraq and the torture of detainees in Abu Ghraib prison functioned as part
of this biopolitical apparatus. As Feldman puts it: "Bio-political threats are
projected onto a multiplicity of world screens in order to hygienically filter
and *screen out* negating penetrations from viruses to terrorists" (165). The
media apparatus attempts to manage and control external threats and levels
of risk. This requires identifying social enemies imagined as viral threats
within the host body of the nation:

> As technologically structured images of catastrophe take on a life-
> form and agency of their own they cease to merely report threat and
> become productive and reproductive mechanisms, specifying both the
> limits and programmatic targets of sovereignty and governmentality.
> (Feldman 167)

The classification of those deemed a threat to national security as "micro-
biological infiltrators" (169) sustains an image of the body politic as living
without social inequality, political dissent or competing historical narratives.
Feldman argues that the presentation of the World Trade Center catastrophe
as televisual spectacle sought to remove it from the political and historical
struggles that caused it. Even a catastrophe occurring on home territory
could be turned into an image of sovereignty justifying military response
and the declaration of a political state of emergency. For Feldman the "com-
pulsive" repetition of images of 9/11 was a means of reconstituting the
protective shield, reestablishing domestic order and reasserting geopolitical
dominance. The dialectic of shock and numbing forms part of a therapeutic
role that media assigns itself at moments of catastrophe. Trauma narratives
reconstitute a people as a wounded body politic united by the threat of
physical suffering and destruction, thereby filling the void left by the disap-
pearance of the rational and politically engaged citizen.

The empire, however, is not as invulnerable as it appears. Derrida identifies three moments of what he calls the "autoimmunitary process ... where a living being, in quasi-*suicidal* fashion, 'itself' works to destroy its own protection, to immunize itself *against* its 'own' immunity" (Borradori 94). The first moment of suicidal autoimmunity is that the terrorists who executed the 9/11 attacks were trained within and/or by the United States. The second moment is that the attack presented the possibility of further and possibly worse attacks in the future. The new vulnerability of America reawakens the nuclear anxiety. The nuclear stand-off with the U.S.S.R. was supposed to guarantee security but the post–Cold War environment turns this autoimmune system into a potentially suicidal weapon that might be appropriated by any number of enemy groups. The third moment is that the retaliatory strikes by the American military against Afghanistan and Iraq will always generate further military and terrorist counterattacks. The computerized information networks upon which Western military dominance depends may yet be effectively infiltrated and turned against it. Feldman's proposition that the spectacular trauma of 9/11 ultimately reinforced the image of America's geopolitical status may be true, but Derrida points to anxieties that exceed this reassertion of identity, such as the possibility of a virus that could destroy the immune system altogether. Media images of catastrophe may themselves be used to neutralize and deflect the threat of actual destruction for viewers, but this immunity can never be complete. The very dependence on shock and numbing creates the possibility that the image as weapon can be turned against its user.

Immobilized Life

The immunity of empire requires the immobilization of humans and images that pose a threat to imperial power. Transnational flows of people and digital information make it difficult to prevent the military-communications-security system being turned against the purposes of the dominant group. The biopolitical apparatus attempts to capture and disempower those who challenge its mechanisms of control. The 9/11 attacks were designed for maximum global visibility. The public display of prisoners at Guantánamo or the images of torture from Abu Ghraib responded to this challenge by sending messages about American power. Images of violence, abuse or destruction are no longer scandals that need to be concealed but form part of larger strategies intended to intimidate and/or humiliate the enemy. The suffering of human bodies is a form of biopower that is harnessed by media technologies. For this reason a superstitious fear surrounds the image's apparent ability to grow and mutate as it moves through different environments and comes into contact with different bodies.

Those who executed the 9/11 attacks were prepared to sacrifice their lives to produce a spectacular challenge to American power. The display of prisoners at Guantánamo Bay represents the power of the state to neutralize

a biopolitical threat. Just as sovereigns once put to death their subjects as a spectacular display of power, so today the state must demonstrate its power to maintain and control life and to immunize the body politic. Images of prisoners in Guantánamo show bodies in orange jumpsuits, their faces hidden by goggles and masks. There is no visible evidence of their individuality and they are deprived of sensory awareness of their environment. They are living bodies who can no longer be recognized as individuals and who cannot experience or act in the world: they have been reduced to the most rudimentary existence. These prisoners, however, are not killed but kept alive. The public display of the prisoners, along with the suspension of their political rights, their potentially unlimited detainment, and their prolonged physical abuse, demonstrates the sovereign power of the United States.

Mirzoeff suggests that the greater policing of national borders and the surveillance and detaining of large numbers of internationally mobile people is itself partly a response to global flows of digital information. Digital technologies and networks appeared to promise a global society without frontiers. The greater mobility of capital in the global economy allowed investors and speculators to accelerate their accumulation of wealth, but this depended on the practical incarceration of millions of low paid workers to produce consumer goods and new communication technologies. The Internet's promise of unlimited access to information prompted a political reaction involving the intensified policing of borders (121). The 1990s also saw much higher levels of incarceration in Western nations. Prisons and camps have followed the trend toward privatization, with government contracts going to private security firms.

Agamben argues that sovereign power establishes its rule not primarily through the exercise of law but through the suspension of law. This suspension is usually thought to happen in situations of emergency as a temporary measure before order is restored and the normal (benign) balance between the state and the governed is reestablished. Agamben, however, sees this capacity of the state to override law as not the exception but the rule, underpinning the everyday operation of power in apparently liberal democratic societies. The capacity of sovereign power to declare a state of exception means that any population at any time may be reduced to a condition of bare life, able to be disposed of by the state. The plight of stateless refugees is not an unfortunate by-product of war or civil conflict but an intrinsic feature of modern politics. The concentration camp, often seen as embodying the radical evil of Nazism, is for Agamben "the fundamental biopolitical paradigm of the West" (*Homo Sacer* 181).

Agamben's arguments have been widely discussed during a period when the detention camp at Guantánamo Bay has become a potent symbol of American power. In this camp hundreds of prisoners from various countries (principally Afghanistan), many of whom have committed no crime, have been incarcerated without normal legal rights. The 9/11 attacks are the justification for this state of exception in which political rights are suspended in

the interests of national security. Those detained at Guantánamo Bay have been routinely tortured and subject to physical and psychological abuse. Joseph Pugliese has described how prisoners at Guantánamo are treated as lower than animals and are forced to follow the commands given to dogs (93–94). Prisoners have also been used as guinea pigs to test new drugs (131).

The war on terror made the camp a central feature of seeking control over potentially hostile populations. Those suspected of terrorism were detained outside American territory where they could be denied political and legal rights. The detainees are not prisoners of war or political prisoners but biopolitical enemies, posing a general threat of potential harm. Detaining people without trial has been a central strategy in the American occupation of Iraq. In Abu Ghraib prison detainees were tortured by being stripped naked and held in cold, dark cells for over thirty days at a time, bound in stress positions, subject to sexual harassment, and intimidated by dogs. All of these activities were photographed by U.S. soldiers. Like the Muselmann in the Nazi camps, the detainee in Abu Ghraib or Guantánamo is suspended in a kind of living-death. Agamben comments that "no one wants to see the Muselmann" (*Remnants* 90) because the condition of bare life embodies what must be excluded in order for life worth living to be maintained and preserved. The camp inmate is the necessary product of biohumanity. The public has seen the leaked images of detainees tortured and humiliated in Abu Ghraib along with the prisoners in hoods, goggles, earphones and orange jump suits kneeling in the sand at Guantánamo Bay. Whereas biometric systems identify specific physical features of an individual in order to classify his/her risk to the community, the images of the detainees in Abu Ghraib and Guantánamo are more often hooded and anonymous. They are nonpersons, deprived of freedom of movement and sensory awareness of their physical environment. Their world has been reduced to senseless, helpless pain.

The Afterlives of Images

The convergence of microbiology and digital information has prompted a turn to imagining communication technologies as a form of life. As Hayles has shown, this tendency began with cybernetic research in the 1940s and '50s. With the emergence of the Internet in the 1990s a new rhetoric of cyberspace, conceptions of artificial intelligence and posthuman life became more widely discussed. The war on terror revealed a new set of political implications of the new imaging technologies and information networks. Established news and entertainment media no longer had a monopoly of control over which images of violence and death were available to the public. The release of images of torture and execution on the Internet has been a key factor in the war on terror. We must see the convergence of this politics of the image with the vitalist rhetoric of cybernetics as a symptom, rather than an illumination, of the biopolitics that underlies these various discourses.

Mitchell proposes that we need to attend to the ways that images "live and move, how they evolve and mutate, and what sorts of needs, desires, and demands they embody" (Mitchell xix). Nicole Shukin has responded critically to such claims and proposed that Mitchell's picture theory reveals the dangers of engaging with image fetishism in ways that "minimize questions of political economy in favor of making room for the irreducible mystery and alterity of things" (137). Shukin is right to insist that image vitalism needs "to be interrogated as an effect of power" (137). For example, Mitchell compares images to animals that cannot speak but nevertheless constitute a form of life that we must try to understand. Shukin criticizes this analogy as perpetuating the fetishizing of animal life in the capitalist economy. As she explains, animal signs "endow the historical products of social labor to which they are articulated with an appearance of innate, spontaneous being" (3). To endow images with an animal-like life is to ascribe to them an agency and to direct our attention away from the complex materiality of their technological mediation.

As we saw in Chapter One, there are a number of historical convergences between developments in visual media and the observation and harnessing of animal life as biopower (including through their slaughter and consumption as meat). Marey produced the first moving pictures recording the movements of animals, and the first experiments in behavioral control by electroshock were conducted on animals. Both the study of nervous reflexes along with the spectacle of industrial slaughter of animals informed the development of cinema. The exploitation of animal life as biopower and the harnessing of viewer attention through visual spectacle were related through the materialities of capitalist production and consumption. The industrial slaughter of animals has formed part of the increasing invisibility of animal life in consumer societies and provoked a compensatory fetishization of pets and a fascination with the visual spectacle of wildlife. The association of the digital image with animal life extends this fetishization and disavows the materiality of image technologies and networks and is more usefully understood as a symptom of what Agamben calls bare life. What the living, mutating, moving image reveals is too often a living body subject to the limitless exercise of power and violence or threatened by catastrophic destruction. Our supposed belief in the vitality of images is a compensatory investment provoked by the ever present possibility that our own lives will be constrained, impoverished, immobilized or simply disposed of.

Pasi Väliaho comments that the animistic conception of images found expression in the American government's refusal to release photographs of the dead body of Osama bin Laden after his assassination in 2011. Barack Obama explained in a television interview that such graphic images posed a risk of inciting further violence or being used by the enemy for the purposes of propaganda. Väliaho rightly points out that such an argument is hardly consistent with the release of many graphic images of other victims. It was as if the ghost of bin Laden continued to pose a threat to American power.

We do not need, however, to resort to superstition about the afterlives of images in order to explain the withholding of these pictures (if indeed they existed at all). The crucial motivation in this incident is that bin Laden's body needed to be killed and disposed of so that he could not be seen as a martyr who sacrificed his life for his God and his people. That is, to paraphrase Agamben, bin Laden needed to become *homo sacer*, to be killed but not sacrificed.

Photographs of others who died in the same raid in which bin Laden was killed were able to be released because these victims were "nobodies" who had been disposed of. Bin Laden was an icon of political struggle for millions and his assassination doubtless elevated him to the status of martyr for many of his supporters. The withholding of bin Laden's image lends support to Sigrid Weigel's suggestion that the counterfigure to *homo sacer* made visible in Abu Ghraib and Guantánamo is the martyr, as in the case of the suicide bomber who sacrifices his/her own life. Bare life may be killed but not sacrificed but "the suicide bomber embodies a life that sacrifices itself *in order to kill*" (32).

The suicide bomber cannot leave an image of his/her own martyrdom except for the explosion into which his/her body disappears. The suicide bomber becomes a martyr for sacrificing his life for his God and his people, and thereby reasserts an alternative sovereignty to the image economy that produces bare life.

In the case of the 9/11 attacks the disappearance of the individual body of the hijacker was reversed by the international visibility of the events in news media and other information networks. Although the martyr aims to restore sovereign power through the act of self-sacrifice, his or her act is nevertheless absorbed by a biopolitical media system in which death no longer holds any sacrificial value. The afterlife of images is always a form of bare life in the capitalist media economy. The glorious afterlife of the martyr is transformed into the perpetual living-death of the technological image. In a similar way the decapitation videos produced by ISIS and other groups, although they symbolically restore the traditional sovereign power of Islam, appear in a mediascape in which orange jumpsuits have an association of bare life. The decapitation video turns the image-weapon of the Guantánamo jumpsuit against the American empire. The controlled violence of the decapitation, however, loses its symbolic challenge to Western secular capitalism by intervening in an image market and competing for viewer attention.

Neville Bolt has shown how the new media terrorism has its origins in nineteenth century anarchism and the Propaganda of the Deed (POTD): acts of political violence that were used to goad the state into using excessive force and thus losing legitimacy in the eyes of the public. In the 1970s the IRA and PLO exploited the possibilities of television coverage for drawing international attention to their political struggles. After 9/11 the game changed. The new objective is to create "a media event capable of energizing populations to bring about a state revolution or social transformation" (2).

The new mode of communication is social media with its networks connecting populations dispersed and displaced by economic globalization. Images of violence can crystallize collective grievance and become nodal points of collective memory. Insurgents can use new information technologies to bypass the censorship imposed by corporate media and thereby subvert its hegemony over the violent image.

Today, argues Bolt, POTD "has become a sales tool" (36) applying techniques similar to advertising. The increased use of branding and image by mainstream political parties since the late 1970s has formed part of the redefinition of citizens as consumers. But insurgent groups such as Al-Qaeda, the Taliban and ISIS also use such techniques. Insurgents construct heroic narratives of collective identity and images of violent struggle that function as icons or logos in the global media market. These narratives and images challenge the official histories propagated by the state, including the biopolitical hierarchies in which the Western consumer subject embodies the life that is worth living while other populations can be incarcerated or killed.

In 2004 American businessman Nick Berg was videotaped being executed in Iraq. In this video Berg was dressed in an orange jumpsuit and surrounded by hooded men. He was forced to kneel and a knife was used to cut off his head. Before American news media had decided how to react, the video was already circulating widely on the Internet.[4] Zelizer cites one commentator (*About to Die* 282) who complained that American media had long made available explicit images of the John F. Kennedy assassination and the execution of a Viet Cong in the streets of Saigon, so why should the American public then be shielded from witnessing the execution of these American citizens abroad? Aside from the political agendas and military alliances that determine these choices, one explanation may be that throat cutting is associated in Western nations with the killing of animals. Over the past century the industrialized killing of animals has been made invisible in the West at the same time as killing by gun became an everyday feature of mass entertainment. The public could be asked to view the killing of Kennedy as a national martyrdom or the killing of a Viet Cong as an inevitable consequence of war. The beheading of an American, however, defies the biopolitical caesura that defines Western individuals as fully human. In response to this challenge Western viewers are asked to view those who engage in ritualized slaughter as barbaric or medieval.

Animal slaughter, once presented as visual spectacle and entertainment, was gradually made less visible in the society of industrialized mass production and consumption. Similarly, actual human death has become a less visible feature of social life. C. Scott Combs explains that the rate of people dying in hospitals and nursing homes, their heart beats and life systems monitored by electronic machines, rose steeply throughout the twentieth century. As it disappears from social visibility both real and simulated death has proliferated in media recording and representation. This tendency for mediated death to replace direct encounters with actual death partly

explains the tendency to ascribe a life to the image. As Benjamin once commented in another context: "What draws the reader to the novel is the hope of warming his shivering life with the death he reads about" (3 156). The social isolation of the reader of a novel looks to the lives of fictional characters to give their own life meaning: s/he consumes it like a flame consumes wood. Today we consume the image of real death in the media because we have become more physically isolated in front of our screens.

Media provide cinematic, electronic and digital substitutes for witnessing death as part of lived experience. The simulation of life on the screen has included the visual presentation of death as entertainment or information. But the visual consumption of death is subject to its own policing of borders. The real deaths of Western citizens captured and executed in the Middle East constitute a new limit case in this biopolitical economy. The image of the Western biohuman being subject to ritual slaughter both challenges the production of non-Western populations as disposable life and the invisibility of mass animal slaughter in Western consumer societies. At the same time the execution videos made in Pakistan, Iraq and elsewhere participate in the multiplication and rapid mobility of images made possible by digital media.

The "otherness" of the decapitation video is a self-conscious and deliberate intervention in the global economy of image consumption. These videos appear as part of the simulation and presentation of life and death as everyday spectacle. Like any other form of visual information or entertainment they compete with other images for viewers' attention and have their own "life" circulating through the various channels of communications media. So these images are less usefully understood as weapons designed to traumatize the public—a concept that reproduces the West as potential victim of a biopolitical threat—and more usefully seen in terms of changing conceptions of life defined by biopolitical thresholds, boundaries and borders. To see these images as traumatic makes them extraordinary when they participate in a general economy of life/death images that are a normal part of everyday spectacle in consumer societies.

To watch a decapitation video is to see a human individual alive and then dead. Each time the video is screened that transition from life to death is repeated. This logic of animated death made possible by moving images contradicts the solemn execution of enemies by sovereign power. Sovereign power takes life in order to reconstitute its absolute authority over a people and a territory. The video recording of an execution paradoxically restores the one who was killed to the appearance of life. By endlessly repeating the act of execution the video never achieves the finality that is the essence of traditional sovereign power. The reassertion of national and religious sovereignty that the decapitation acts out is transformed through digital technology into a form of biopolitical media. Media technologies and information networks have produced forms of simulated life and death that exceed the governance of human societies. The biopolitical hierarchies that have divided the globe into advanced and primitive, civilized and savage,

democratic and fanatical populations are being rearticulated. Media images are not living entities but they are produced, transmitted and consumed for the purposes of capturing attention, monitoring physical appearance and movement and physically destroying human life. We should approach images not with superstitious fear or veneration but with attention to their capacity to have power over our lives.

Notes

1. "Obama: Osama bin Laden Dead." Web. 5 July 2015. http://www.youtube.com/watch?v=m-N3dJvhgPg.
2. "Obama dedicates 9/11 memorial museum." Web. 5 July 2015. http://www.youtube.com/watch?v=4BOe3BOwpMw.
3. For a useful summary of this research see Randall D. Marshall et al., "Relative Risk Appraisal, the September 11 Attacks, and Terrorism-Related Fears" and Yuval Neria, Laura DiGrande, and Ben G. Adams, "Posttraumatic Stress Disorder Following the September 11, 2001, Terrorist Attacks."
4. "Nick Berg (died)." Web. 5 July 2015. http://www.liveleak.com/view?i=299_1320002757.

Works Cited

Agamben, Giorgio. *Homo Sacer: Sovereign Power and Bare Life.* Trans. Daniel Heller-Roazen. Stanford: Stanford UP, 1998.
———. *Remnants of Auschwitz: The Witness and the Archive.* Trans. Daniel Heller-Roazen. New York: Zone, 2002.
Arendt, Hannah. *The Origins of Totalitarianism.* San Diego, New York, London: Harcourt Brace Jovanovich, 1973.
Bolt, Neville. *The Violent Image: Insurgent Propaganda and the New Revolutionaries.* New York: Columbia UP, 2012.
Borradori, Giovanna. *Philosophy in a Time of Terror: Dialogues with Jürgen Habermas and Jacques Derrida.* Chicago and London: U Chicago P, 2003.
Combs, C. Scott. *Deathwatch: American Film, Technology and the End of Life.* New York: Columbia UP, 2014.
Dillon, Michael. "Security, Race and War." *Foucault on Politics, Security and War.* Eds. Michael Dillon and Andrew W. Neal. Hampshire, New York: Palgrave MacMillan, 2008. 166–205.
Dillon, Michael, and Julian Reid. *The Liberal Way of War: Killing to Make Life Live.* London and New York: Routledge, 2009.
Esposito, Roberto. *Immunitas: The Protection and Negation of Life.* Trans. Zakiya Hanafi. Cambridge: Polity, 2011.
Feldman, Allen. "On the Actuarial Gaze: From 9/11 to Abu Ghraib." *The Visual Culture Reader* (3rd ed.). Ed. Nicholas Mirzoeff. London and New York: Routledge, 2013. 163–180.
Finn, Jonathan. *Capturing the Criminal Image: From Mug Shot to Surveillance Society.* Minneapolis and London: U Minnesota P, 2009.
Gates, Kelly A. *Our Biometric Future: Facial Recognition Technology and the Culture of Surveillance.* New York and London: New York UP, 2011.

Hardt, Michael, and Antonio Negri, *Multitude: War and Democracy in the Age of Empire*. London: Penguin, 2006.

Hayles, N. Katherine. *How We Became Posthuman: Visual Bodies in Cybernetics, Literature and Informatics*. Chicago and London: U Chicago P, 1999.

Hoskins, Andrew and Ben O'Laughlin. *War and Media: The Emergence of Diffused War*. Cambridge: Polity, 2010.

Kittler, Friedrich. *Optical Media: Berlin Lectures 1999*. Trans. Anthony Enns. Cambridge: Polity, 2010.

Lasswell, Harold D. *Propaganda Technique in World War I*. Cambridge, MA, and London: MIT Press, 1971.

Lemke, Thomas. "The Risks of Security: Liberalism, Biopolitics and Fear." *The Government of Life: Foucault, Biopolitics and Neoliberalism*. Ed. Vanessa Leman and Miguel Vatter. New York: Fordham UP, 2014. 59–74.

Lifton, Robert Jay. "Americans as Survivors." *Crimes of War: Iraq*. Ed. Richard Falk, Irene Gendzier, and Robert J. Lifton. New York: Nation, 2006. 427–431.

———. *Home from the War: Vietnam Veterans: Neither Victims nor Executioners*. New York: Simon and Schuster, 1973.

Marshall, Randall D., et al. "Relative Risk Appraisal, the September 11 Attacks, and Terrorism-Related Fears." *American Psychology* 62.4 (2007): 304–316.

Mirzoeff, Nicholas. *Watching Babylon: The War in Iraq and Global Visual Culture*. New York and London: Routledge, 2005.

Mitchell, W.J.T. *Cloning Terror: The War of Images, 9/11 to the Present*. Chicago and London: U Chicago P, 2011.

Neria, Yuval, Laura Di Grande, and Ben G. Adams. "Posttraumatic Stress Disorder Following the September 11, 2001, Terrorist Attacks: A Review of the Literature among Highly Exposed Populations." *American Psychology* 66.6 (2011): 429–446.

Pugliese, Joseph. *State Violence and the Execution of Law: Biopolitical Caesurae of Torture, Black Sites, Drones*. New York: Routledge, 2013.

Rothberg, Michael. *Multidirectional Memory: Remembering the Holocaust in the Age of Decolonization*. Stanford: Stanford UP, 2009.

Shukin, Nicole. *Animal Capital: Rendering Life in Biopolitical Times*. Minneapolis and London: U Minnesota P, 2009.

Tal, Kali. *Worlds of Hurt: Reading the Literature of Trauma*. Cambridge: Cambridge UP, 1996.

Väliaho, Pasi. *Biopolitical Screens: Image, Power, and the Neoliberal Brain*. Cambridge, MA, and London: MIT Press, 2014.

Vermeulen, Pieter. "The Biopolitics of Trauma." *The Future of Trauma Theory: Contemporary Literary and Cultural Criticism*. Eds. Gert Beulens, Sam Durant, and Robert Eaglestone. New York and London: Routledge, 2014. 141–155.

Vickroy, Laurie. *Trauma and Survival in Contemporary Fiction*. Charlottesville and London: U Virginia P, 2002.

Weigel, Sigrid. *Walter Benjamin: Images, the Creaturely, and the Holy*. Trans. Chadwick Truscott Smith. Stanford: Stanford UP, 2013.

Zelizer, Barbie. *About to Die: How News Images Move the Public*. Oxford and New York: Oxford UP, 2010.

Index